50 Fast Digital Camera Techniques, 2nd Edition

KEVIN L. MOSS

50 FAST DIGITAL CAMERA TECHNIQUES

2nd Edition

WILEY

Wiley Publishing, Inc.

50 Fast Digital Camera Techniques, 2nd Edition

Published by
Wiley Publishing, Inc.
111 River Street
Hoboken, NJ 07030-5774

www.wiley.com

Copyright © 2006 by Wiley Publishing, Inc., Indianapolis, Indiana

Published simultaneously in Canada

Library of Congress Control Number: 2005926045

ISBN-13: 978-0-7645-9806-7

ISBN-10: 0-7645-9806-6

Manufactured in the United States of America

10 9 8 7 6 5 4 3 2 1

2K/RX/RQ/QV/IN

For general information on our other products and services please contact our Customer Care Department within the U.S. at 800-762-2974, outside the U.S. at 317-572-3993, or fax 317-572-4002.

For technical support please visit www.wiley.com/techsupport.

Wiley also publishes its books in a variety of electronic formats. Some content that appears in print may not be available in electronic books.

Trademarks: Wiley and the Wiley logo are trademarks or registered trademarks of John Wiley & Sons, Inc. and/or its affiliates in the United States and other countries, and may not be used without written permission. All other trademarks are the property of their respective owners. Wiley Publishing, Inc. is not associated with any product or vendor mentioned in this book.

WILEY

To my wife Amy, the most beautiful woman in the world,
making me the luckiest man in the world.

To our children, Amanda, Emily, and David,
who bring us joy each and every day.

PREFACE

This book has been written to be a fun book to read and to use as a continual source of information for taking better photographs with a digital camera. If you enjoy photography and you have or plan to have a digital camera, this book is for you. If you don't yet have a digital camera, this book can still be valuable to you, thus enabling you to buy the right camera for your needs the first time.

Not all that long ago, skilled professionals such as woodworkers, jewelers, sculptors, and other creative or skilled professionals learned their trade by becoming an apprentice. As an apprentice, a person learned the body of knowledge needed for a profession by working right next to a master on real projects. For example, if you were an apprentice to a furniture maker, you might first build a small, simple piece of furniture, and then build increasingly larger and more complex pieces until you learned what you needed to know to make just about any kind of furniture you wanted to make.

Undoubtedly, being an apprentice and working with a master was a real luxury that is not often available today. However, the notion of working with a master on specific projects is the basis of this book and others in this series. The premise is that you can effectively and quickly learn how to take great photos by following step-by-step techniques — just as you would do if you were working as an apprentice next to a master photographer. After you have successfully completed 20 or 30 techniques in this book, you'll be amazed at the "body of knowledge" you will have gained and how much better your photos turn out.

ACKNOWLEDGMENTS

I would first like to thank Mike Roney at Wiley Publishing and Gregory Georges — the author of the previous edition of this book — for giving me the opportunity to participate in this project. I would also like to thank Laura Lewin and the folks at Studio B for introducing me to the fine people at Wiley Publishing. I also thank the hard-working editorial crew led by Sarah Hellert, whose help throughout the project is greatly appreciated. Lastly, I thank my wife Amy, for taking care of the family as I stayed up late into the night writing.

CONTENTS AT A GLANCE

CONTENTS

CHAPTER 1: GETTING THE MOST FROM YOUR DIGITAL CAMERA 1

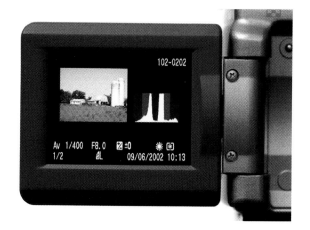

TECHNIQUE 1
LEARNING ABOUT YOUR CAMERA 3

TECHNIQUE 2
CHOOSING IMAGE-QUALITY SETTINGS 9

TECHNIQUE 3
CHOOSING AN APPROPRIATE SHOOTING MODE 19

TECHNIQUE 4
TAKING AND REVIEWING PHOTOS 25

Chapter 2: Taking better photographs 35

CHAPTER 3: USING ADVANCED FEATURES 71

Chapter 4: Increasing the quality of your photos 95

CHAPTER 5: TAKING PICTURES OF PEOPLE AND PETS 123

TECHNIQUE 21

CHAPTER 6: PHOTOGRAPHING NATURE 157

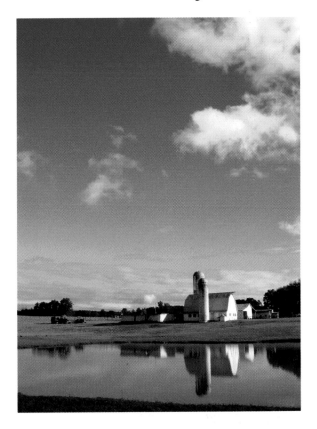

Chapter 9: Displaying and taking care of your digital images 233

CHAPTER 10: BECOMING A BETTER PHOTOGRAPHER 259

INTRODUCTION

Today's compact digital cameras have a simple side, and they have a complex side. If you currently shoot in one of the many "auto" modes, you know that they are simple and easy to use and that you generally get reasonably good photos. However, most compact digital cameras are loaded with sophisticated features that you can learn to use not only effectively, but also to get outstanding photos! Even understanding how to use a half-dozen of these more sophisticated features can dramatically improve your picture-taking skills.

How do you currently shoot? Do you usually shoot with one of the auto modes? Are you aware of, and do you use many of the more sophisticated features your camera offers? Do you really understand the relationship between ISO settings, f-stop, and shutter speed? Do you change shooting modes based upon the subject you are shooting? Do you use several different metering modes, change focal points, or use exposure lock? If not, you will be excited to see how much your picture-taking skills will improve after you read and put into practice even a few of the 50 techniques that this book offers.

WHAT KIND OF CAMERA SHOULD YOU HAVE TO COMPLETE THE TECHNIQUES IN THIS BOOK?

Unlike most of the photography books on the market, this book has been written specifically for those using digital cameras — not film cameras. It has *not* been written for one specific brand or model of camera; rather, it has been written for *all* digital cameras. In this book, you learn how to take specific kinds of photographs using specific camera features. Often, when you read about a camera feature in this book, you will have to read the documentation that came with your camera to see whether your camera has that feature and how it has been implemented on your camera. The combination of this book and the documentation that came with your camera will be all that you need to consistently take good photographs.

You can purchase compact digital cameras for as little as $70 and for as much as $1,300 or more. At the time this book was published, digital SLRs and advanced "prosumer" (professional/consumer-level digital cameras) were available for less than $800.

WHAT DIGITAL CAMERA SHOULD YOU BUY?

One of the most frequently asked questions in online digital photography forums and from friends sending e-mails to the authors is, "What digital camera should I buy?" Another common and even more difficult question to answer is, "Which digital camera is the *best* digital camera?" If you look throughout this book you will not find the answers to either of those questions. The only person who can answer them is you — but only after you really understand what types of pictures you want to take, gain some knowledge about various camera features, and establish a budget. Then and only then can you determine which camera you should get and which one is best for *you*.

After you have a budget and an idea of the features you want in a camera, take a few minutes to visit Phil Askey's Digital Photography Review Web site (`www.dpreview.com`). This incredibly useful resource offers unbiased reviews on just about every digital camera that has ever been made. You can even view actual photos that were taken with most camera models. Besides the reviews and detailed specs, you can join one of the many forums and learn more about the cameras you are considering from those who are already using them.

HOW SHOULD THIS BOOK BE USED?

This book is not one that you must sit and read from the first page through to the end. You should read the first three or four chapters, and then you can read the techniques that you are most interested in. Afterward, you can go out and shoot to practice what you have learned. In preparation for shooting photos of a specific subject, you can also read one or more of the techniques on related topics to help you take better photos. Technique 1 suggests that you complete a detailed two-page worksheet that will force you to learn about all the features that are available on your camera. The effort you take to complete this worksheet will be well worth the time it takes. You can use Technique 5 as a "pre-shoot" checklist to make sure you know your camera well enough to shoot an important event or to simply remind you what you should check before you shoot to avoid using the wrong settings. The rest of the techniques you can read as you choose.

A FEW WORDS ABOUT THE PHOTOS USED IN THIS BOOK

Some of the 50 techniques in this book start with an "original" and an "edited" photo. The first photo is the original photo as it was saved by the camera. The second photo is one that has been digitally edited with an image editor, such as Photoshop or Photoshop Elements.

One of the things many photographers do not realize is that most photographs are not exposed properly — whether they were taken with a film camera or a digital camera. When you drop off your film at a photo-processing lab, the lab technicians are the ones who do all the work of correcting color casts, fixing image contrast, or improving exposure. When you shoot digitally, you are responsible for those fixes! No matter how good

you get with your digital camera, just about every photo you take can be improved with some digital image editing, as you will notice when comparing the "original" photos with the "edited" images in this book.

Editing digital photos is a huge topic in itself and so it has been excluded from this book. If you want to learn more about how to edit your digital photos, consider purchasing *50 Fast Digital Photo Techniques,* by Gregory Georges, author of the previous edition of this book, or *Photoshop CS2 and Digital Photography For Dummies,* by Kevin L. Moss, the author of this book.

CHAPTER 1

GETTING THE MOST FROM YOUR DIGITAL CAMERA

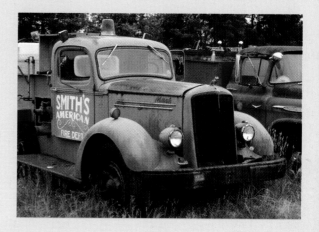

Today's digital cameras are both rich in features and highly capable of helping you get good photos when used in one of many auto modes — without requiring you to know much about your camera or photography. However, learning how to use your digital camera and its many features enables you to get even better photos and do things you never even imagined could be done. Technique 1 helps you get familiar with your camera. You then find out how to select important image-quality settings in Technique 2. Technique 3 shows you how to select an appropriate shooting mode. Being able to review photos is a significant benefit of using a digital camera, and Technique 4 shows you how to get the most from the review features on your camera. Technique 5 helps you figure out how to change settings quickly so that you don't miss getting the photos you want due to having the wrong settings.

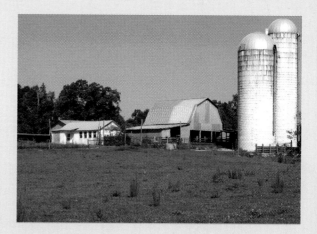

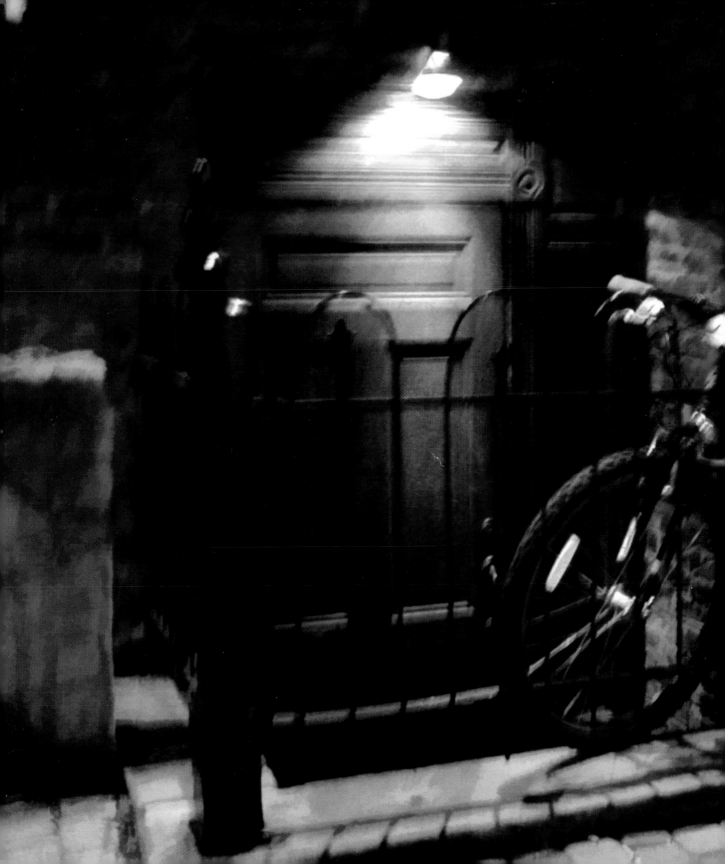

1

LEARNING ABOUT YOUR CAMERA

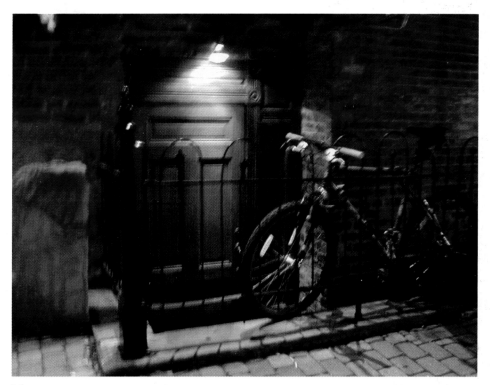

1.1

ABOUT THE IMAGE

"Backdoor to the Club" Nikon Coolpix, hand-held, zoom set to 50mm (35mm equivalent), f/2.6@1 second, ISO 320.

If you were to come upon the scene shown in the photo in Figure 1.1, which shows the backdoor to a nightclub in Richmond, Virginia, what camera settings would you use? If you did not have a tripod, would you even consider taking a photo of this scene, which has such a low light level? Would you trust automatic focus to focus in the dim setting? Would you use a low or high ISO setting? What exposure mode would you use? Would you consider using other features your camera offers, such as noise reduction, exposure bracketing, a built-in flash, or maybe even a vivid image effect? Or would you simply shoot in auto mode and hope for the best?

Because you're reading this book, I'd bet that you're fairly serious about photography, and about taking the best photos that you can take. Many factors contribute to your ability to get the photos that you want. The features your camera has, when to use them, and how to properly use them are three of the most important things you can learn to improve your picture-taking skills.

Although this technique twice recommends the obvious — that you read the written documentation that came with your camera — it also provides a valuable digital camera feature and specification checklist that can help you learn more about your digital camera. By now, you may be thinking to yourself, "Thanks, but I'll just skip this technique and move on to the next one!" However, please don't — you'll have much more success with the rest of the techniques if you spend just an hour doing the exercises that are suggested in this technique.

Incidentally, the photo shown in Figure 1.1 has been edited with Photoshop Elements. The intent of the editing was to further increase color saturation and overall contrast. Because the camera was hand-held (instead of being mounted on a tripod), the photo is slightly out of focus, making the image soft, which adds to the dreamlike feel of the photo. When printed with an Epson Photo printer on a fine art paper such as Epson's Archival Matte paper, this photo made a nice print.

STEP 1: READ (OR GLANCE THROUGH) YOUR MANUAL

Most digital camera users have proven over and over that they can take good pictures without reading most of the written documentation that came with their camera; some never read any of it at all — ever! Not reading the documentation that came with your camera when you get the camera is okay. Not reading it at all just means that you can't take advantage of the many cool and useful features your camera offers. Not only does reading the manual help you to more

fully enjoy your camera, but it also enables you to take better pictures. You will quite likely be more than compensated for your investment in time because your effort may help you avoid missing good shots of those important events that you get only one chance to shoot.

If you're somewhat familiar with cameras, when you first get your new camera, you can just go shoot with it. You bought it for taking pictures, so take them. After you have taken a couple dozen pictures so that you have a basic understanding of what your camera can do and where some of the controls are, then read your manual. Using your camera first helps make reading the manual easier and more useful than if you were to just pick up the manual and read it.

As the cost of printing manuals increases and as product life cycles shorten, digital camera vendors are increasingly providing some or all of the written documentation in electronic form on a CD-ROM or on their Web site. To read the documentation, you usually need to have Adobe Acrobat Reader installed. This free software application is available at `www.adobe.com` and is more often than not included on the CD-ROM provided by your camera vendor. After installing Acrobat Reader, you can read the documentation on your computer screen. Figure 1.2 shows a screenshot of Acrobat Reader displaying a page from the manual for a Sony Cyber-shot P150 digital camera.

STEP 2: SHOOT A FEW PHOTOS

After you have had a reasonably good read of the documentation that came with your camera, shoot a few more photos. Take a few photos of nearby objects, such as your foot, the pet at the other end of the room, books on the bookshelves, or any people who may be walking by. Try using a few different settings. Flip through the menus on your LCD monitor if you have one. Take a photo with a built-in flash if you have one. If you're inside, walk outside and take a few more photos.

1.2

STEP 3: COMPLETE THE CAMERA FEATURES AND SPECIFICATIONS FORM

If you're just getting started with photography, if you have only used a simple point-and-shoot camera, or even if you have a reasonable amount of experience with your digital camera, you're likely to find filling out the form shown in Figure 1.3 to be useful. Notice that on the right side of the form is a column for writing the page number of the manual where you can find the feature discussed. Completing this form helps you learn about the features your camera offers as well as any limitations it has.

TIP

If your camera vendor provides an electronic version of the documentation, for example PDF or DOC file format, consider printing out pages that contain key information. Menu settings, information displayed on the LCD monitor, or descriptions of shooting mode icons will be of interest. Place these pages in your camera bag for easy reference. If you just have printed documentation, check the vendor's Web site: You may be able to find electronic versions along with updated documentation, drivers, or additional software.

Digital Camera Features / Specifications Checklist

Manufacturer: _____ Model #: _____ Page #

Serial Number: _____

Image Characteristics

Maximum Resolution: _____ x _____ pixels Megapixels: _____ _____

Other Resolutions: _____, _____, _____, _____ _____

Compression Level settings: o Yes o No Settings: _____ _____ _____

Image Formats: JPEG quality settings: _____ _____
TIFF: o Yes o No 16-Bit RAW Acquire: o Yes o No _____

ISO Sensitivity Settings: Auto o Yes o No _____ _____

White Balance Settings: Auto o Yes o No _____ _____

Other Exposure modes (sepia, B&W, etc.): _____ _____

Photo Storage Media

Image Storage Media: o Compact Flash o SmartMedia o Floppy Disk o CD-ROM _____
o Memory Stick o: xD-Picture Card o: Other_____ Maximum Capacity: ___ MB _____

View Finder / LCD

LCD: o Yes o No _____
View Finder: o Yes o No View Finder Adjustment: o Yes o No _____

Image Review

Image Review Modes: _____ _____
Histogram: o Yes o No Playback Zoom: o Yes o No Video Out: o Yes o No _____

Lens

Lens Aperture: o Fixed o Optical Zoom : _____ mm to _____ mm _____

Digital Zoom: o Yes o No Range: _____X to _____ X _____

Shutter speeds: _____ to _____ Maximum Manual Shutter Speed: _____ seconds _____

F-stops: _____ to _____ Increments: o 1/2 o 1/3 o 1 stop _____

Metering

Metering Modes: o Evaluative/Matrix o Center-weighted o Spot o Other: _____ _____
Exposure Compensation: o Yes o No _____
Increments: o 1/2 o 1/3 o 1 Range (Stops): _____ _____

Exposure Modes (auto, shutter-priority, portrait):_____ _____
Manual Mode : o Yes o No _____
Auto Exposure Bracketing: o Yes o No _____

Focus Features

Auto Focus Settings (continuous, 1-point, 3-point):_____ _____

Focal Points: _____ Selectable: o Yes o No _____
Manual Focus: o Yes o No Focus Range: _____ inches to Infinity _____

Macro Mode: o Yes o No Macro Focus Range: ____ inches to ____ inches _____

Continuous Shooting: o Yes o No FPS: _____ _____

Flash

Built-in Flash: o Yes o No Flash Shoe: o Yes o No Sync Socket: o Yes o No _____
Flash Compensation: o Yes o No _____

Flash Modes (auto, red-eye, etc.): _____ _____

Battery

Battery type: _____ Rechargeable: o Yes o No Proprietary: o Yes o No _____

Other Features

Video Mode: o Yes o No Movie Size(s): _____ _____

Movie Clip Maximum Time: _____ seconds Sound: o Yes o No _____

Self Timer: o Yes o No Maximum Shutter Time: _____ _____
Remote Shutter Control: o Yes o No _____

Connection to Computer: o Yes o No _____
Connection Type: o Serial o USB 1.0 o USB 2.0 o USB FireWire _____

Time Lapse Shooting: o Yes o No Panorama Mode: o Yes o No _____

Printer Capabilities: o DPOF o Direct Print o Other: _____ _____
Other Features:

Available Accessories

List optional accessories: _____

STEP 4: READ YOUR MANUAL AGAIN

"Yeah right," you're probably saying out loud to yourself. "Read the manual again — fat chance!" You're not likely to read the manual again right away, but as you use your camera, or when you have not used your camera for a while, you will find that going back and looking over the manual periodically is useful. Today's digital cameras are complex and feature-rich, and learning how to use all the features takes time and effort. Even if your objective is not to learn all about your camera, a periodic glance at the manual helps you to learn more about those features that you often use.

One of the reasons I enjoy reading manuals is that I always seem to find "surprise" features. Surprise features are features that I didn't know about, but that can help me take great photos in new ways. I have known many people who have had a digital camera for months and were not able to get the photos that they wanted. When I point out a feature that they have on their camera — that makes it easy for them to get the shots they always wanted — they are both surprised and pleased! That's all you'll hear from me for now about reading manuals.

Later in this chapter and throughout the book, you find out more about the features listed on the form shown in Figure 1.3 and how to use many of them. For now, just concentrate on getting the correct information on the form and note the page number where you can find more information in the documentation that came with your camera.

CHOOSING IMAGE-QUALITY SETTINGS

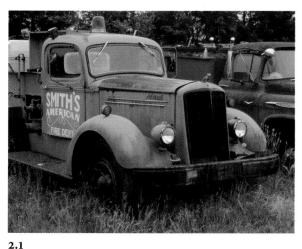

2.1

2.2

I
n Technique 1, you learned about a multitude of features that are available on your digital camera. Many of these features are user-controlled, and depending upon what you want to shoot, how you plan on using the images, and where you shoot, one setting can be a much better choice than another. In this technique, you find out how to choose the most appropriate setting for seven of the more important and common image-quality settings as well as how to make sure your digital photo storage media is ready to use to take photos like the ones shown in Figures 2.1 and 2.2.

As you go through the steps in this technique, consult the form you completed in Technique 1 and the documentation that came with your digital camera. Be aware that you may have a digital camera that does not have one or more of the settings mentioned in this technique. Also, you may find that your camera has useful settings not mentioned here that you can set, too.

STEP 1: SET DATE AND TIME

The world is full of VCRs set to the wrong time and date. They are owned by people who either don't know how to set them, or by people who don't need to set them. Unlike VCRs, where a correct date and time is not often needed, setting the date and time correctly on your digital camera is more than worthwhile.

Each time you take a picture with your digital camera, a digital image file is written to the digital photo storage media in your camera. This file contains the picture, plus it contains *metadata*, which is a fancy term that means data or information about the picture. Most digital camera vendors conform to an industry standard; the cameras write this metadata in the EXIF format in each picture file.

In addition to writing precise time and date data, most cameras also write dozens of camera settings used for each photo, which means you can read these settings while the digital photos are in your camera, or later when you open up an image file with any one of many software applications that allow you to read the f-stop, shutter speed, exposure mode, and whether you used a flash, as well as lots of other information that you can use to learn how to shoot better photos. EXIF data can also become useful when you begin managing your digital image collection with an image management application such as Photoshop Elements or ACD Systems' ACDSee (`www.acdsystems.com`).

To read EXIF data, open the image in an application that can read EXIF data. For example, when you view a file in the Photoshop Elements File Browser, shown in Figure 2.3, Elements displays EXIF data in the Metadata tab. You can also view EXIF data by choosing **File ➢ File Info** in Photoshop Elements, which opens the file information dialog box shown in Figure 2.4.

If you set the date and time correctly, you can sort all your photos by date and time, or even search for photos taken on a specific day and at a specific time. If you don't set the date and time on your digital camera, you'll miss out on this valuable capability.

STEP 2: SET IMAGE RESOLUTION

In digital photography, not only are you faced with the traditional trade-offs between shutter speed and aperture size, but you also must choose from a number of settings that determine file size (which ultimately is a trade-off between files that take less space to store and less computer processor cycles to edit) and image quality. The five major factors determining image file size are image resolution, image format, compression level, ISO setting, and the subject. You can control the first four of those five factors with user-selectable settings that allow you to optimize image file size with image quality to meet your needs.

Almost all digital cameras offer user-changeable settings for image resolution. For example, a typical 7-megapixel digital camera will have an approximate maximum image size of 3,072×2,304 pixels. The same camera will have image resolution settings of 2,592×1,944 pixels or 2,048×1,566 pixels. Table 2-1 shows each image resolution setting, the total pixel count, the type of file, and the optimal print size.

So, the question remains: What image resolution setting should you use? The answer depends entirely on what you plan to do with the image, how much in-camera storage and computer storage space you have, and how important image quality is to you. Image resolution is costly in terms of file size — the higher the resolution, the more space required to store a single digital photo, and the more computer processor cycles required to edit it.

To make the best and largest print possible, always use the highest image resolution setting your camera offers. If you have a 4- or 5-megapixel or larger camera, you may not always want to use the highest image

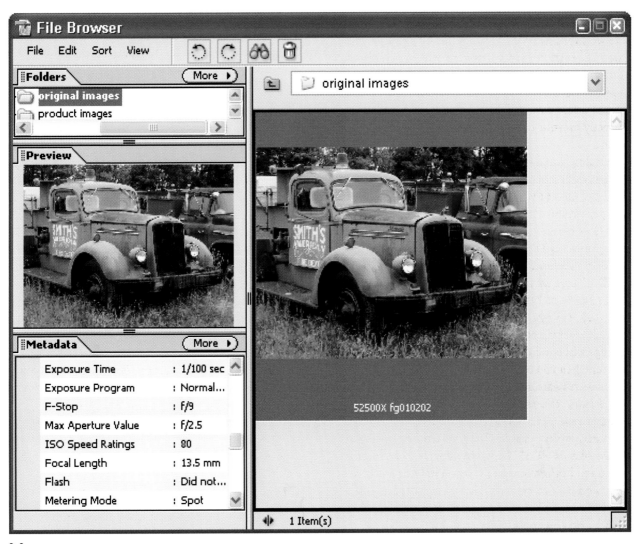

2.3

resolution setting if you intend to print only 4×6 photos. Choosing a lower image resolution allows you to get more images on your digital photo storage media, and editing these smaller image files requires less computing power than larger images do.

Additionally, smaller images require less storage and backup space on your hard drive or removable media. So, when possible, a lower resolution setting is a good choice. To find out more about the different resolutions and their resulting file sizes, and the number of images that you can store on a specific digital photo storage media card, check the documentation that came with your camera — vendors usually provide a table with this information.

2.4

TABLE 2-1:

DIGITAL CAMERA IMAGE SIZES

IMAGE RESOLUTION	NUMBER OF PIXELS	TYPE	OUTPUT SIZE
3,456×2304	7.9 million	Large	Large prints of 13×19, 16×20, or larger. Great image detail for complex landscapes and portraits.
3,072×2,304	7.1 million	Large	Large prints of 8×10 to 11×14. Excellent image detail for complex landscapes and portraits.
2,592×1,944	5 million	Medium	Excellent 5×7 or even 8×10 prints.
2,048×1,566	3.2 million	Small	Excellent 4× 6 or even 5×7 prints.

One reason against using any image resolution other than the maximum size is that a larger image may allow you to crop an image to show exactly what you want. Figure 2.5 shows a photo of a five-lined skink that was taken with a Canon PowerShot at the maximum resolution of 2,200×1,704 pixels. Although the full-size image makes the skink look very small, the square in the figure shows that the skink and all of his beautiful blue tail won't fit in an 800×600 pixel image (see Figure 2.6), which is a very large image for a Web page or for display on a computer screen. If a smaller resolution image had been used, this cropping would not have been possible and the resulting image would feature a tiny skink.

With that information as a guide, set your image resolution on your camera to meet your requirements. You usually change image resolution settings via a menu or button shown on the LCD.

> **TIP**
>
> Using resolution settings of 3 or 4 megapixels can still produce stunning 8×10 inch or larger prints, depending on the quality of the image and image sensor used in the digital camera.

> **WARNING**
>
> After you learn how to change the image resolution setting, be careful! I once drove with a photographer friend for several hours to get to a remote place where we had heard there were some rare butterflies. After several hours of shooting in the hot sun, my friend noticed that he had far more room on his digital photo storage media than he should have had considering the number of photos that he had already taken. A quick look at the image resolution setting showed why. A day earlier he changed the setting to shoot images for a Web page and had forgotten to change the settings to the maximum image resolution. All of his wonderful shots of these rare butterflies were unprintable because he had been shooting 1,536×1,024 pixel images — not nearly enough for the 8×10 prints that he wanted to make. The lesson to be learned is that you should always check your settings before you start shooting.

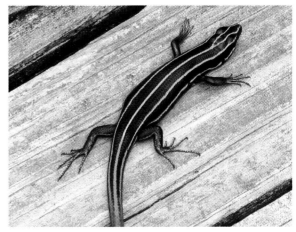

2.5

2.6

STEP 3: SET FILE FORMAT

Depending on your camera model, you can likely choose from two or more different file formats. Three basic types of file formats are offered on compact-level digital cameras: JPEG, TIF, or a proprietary raw format. The most frequently used format is the JPEG format, which is a compressed file format. To make the image file smaller, a mathematical algorithm is applied that simplifies the image, thereby making it smaller. Simplifying an image also means that there is some decrease in image quality.

Proprietary *raw* formats are file formats that are unique to a single vendor, such as Nikon's nef format, or Canon's crw format. Both are compressed, raw file formats. Unlike non-raw formats, where an image is taken and the camera processes it to get optimal results, a raw format image file is written to the digital photo storage media as it was captured on the image sensor without any additional processing. The advantage to these raw files is that you can use Photoshop Elements, Photoshop, or special software to adjust the original image parameters such as white balance, contrast, sharpening, saturation, and so on. Because both NEF and CRW file formats have the additional advantage of also being compressed files, they take up less storage space than an uncompressed file such as TIF, which is a common uncompressed file format found on digital cameras.

On those occasions where you want to maximize image quality and you have plenty of digital photo storage media space, you should select "raw," if it is available on your digital camera, or TIF format. Besides being compressed, raw and TIF use 16-bit images instead of 8-bit images — meaning that they contain much more picture information, which can be useful if you edit the image with an image editor that can work with 16-bit images. The downside of using a proprietary format such as raw is that these files are typically larger than JPEG files.

So, pick the JPEG format unless you're seeking to get the best possible image quality that your camera can produce, and you plan on and are prepared to use an image editor to edit a TIF or proprietary image file. Be aware that the choice between a JPEG format, raw, and an uncompressed format like TIF is a decision between a relatively small file and a much larger file. Image quality can be better but not necessarily significantly better.

For example, a photo of trees in front of an abandoned farm house shot with a Nikon D70 using the best (least compressed) JPEG setting is 3MBs. The same image shot in Nikon's raw format (nef) is 5MBs; when it's opened up as a 16-bit image, it's a whopping 35.2MBs! The abandoned farm house raw file has been converted from its nef format using the Photoshop Elements Raw converter shown in Figure 2.7. Unless you're using the Raw conversion software supplied to you by your camera manufacturer or Photoshop Elements, you won't be able to open the nef file.

STEP 4: SET COMPRESSION LEVEL

If you chose the JPEG format in Step 3, you may want to check to see whether your camera allows you to choose different compression levels. A moderate amount of JPEG compression can dramatically reduce file size while only slightly reducing image quality; in fact, you may not notice any image degradation at all relative to a noncompressed TIF or raw format. As compression level increases, file size decreases, as does image quality to some extent. Once again, you're faced with the trade-off between file size and image quality. On those occasions where you have limited photo storage capacity, you may want to increase the compression level so that you have room to take more photos. Otherwise, you should use a setting that applies the least amount of image compression.

STEP 5: SET ISO SENSITIVITY

Technique 3 explains the trade-offs between shutter speed and f-stop, two of the three variables that determine the amount of light that exposes the image sensor (the equivalent counterpart to film in a film

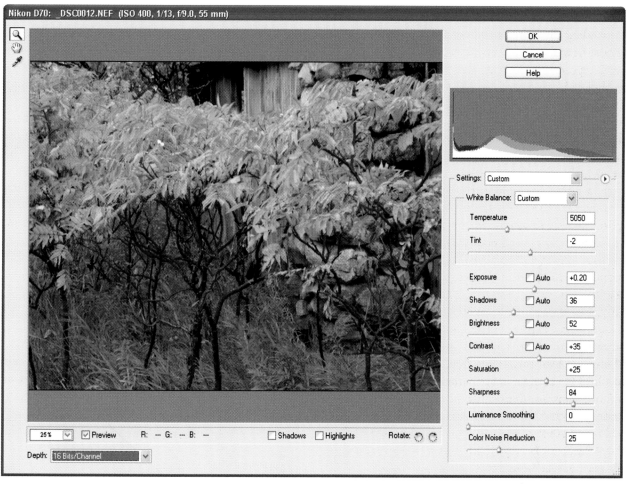

Nikon D70: _DSC0012.NEF (ISO 400, 1/13, f/9.0, 55 mm)

2.7

camera). The third variable is the ISO setting, which in earlier days was known as the ASA film speed. You could then, and you can now, still purchase film that has ISO (or ASA) ratings from 50 to 800 or even 1,600 or 3,200. The higher the ISO rating, the more sensitive the image sensor is to light. Changing the ISO sensitivity setting is like so many of the other settings on a digital camera — it offers trade-offs, some of which you may like, and some, depending on what you want to achieve, you may not like. The lower the ISO sensitivity (50 or 100), the less digital noise (the equivalent to *grain* when using a film camera) your

photos will have. As the ISO rating goes up, your photos will have more digital noise.

You can make a decision on what ISO setting to use by answering these four questions:

■ Do you want to avoid having digital noise in your photo, or might it be considered a feature of your photo?

■ Does your scene or subject have enough light to use a low ISO setting?

■ How much digital noise does your digital camera create at different ISO settings?

■ Can you stop movement in the image and shoot without camera movement to avoid blurring the image, or is an intentional blur with a lower ISO setting something that you want?

Before making a final decision on which ISO settings are too grainy for your photos, take a few shots with different ISO settings and compare them yourself. After you've answered these questions, you'll know what ISO setting to use.

STEP 6: TURN ON FILE NUMBERING

One more useful feature many digital cameras offer is an automatic file (and sometimes folder) numbering feature. You realize how valuable this feature can be after you start storing and archiving your digital photos. If you have the option, I recommend that you set automatic file numbering to "On." When this feature is on, image files will be sequentially numbered — even when you remove the digital photo storage media and use a new one. The camera remembers the number of the last photo regardless of which digital photo image media was in the camera last.

If you don't have or don't use this feature, you will find that you have files with the exact same filename! Each time you remove a card and download the images to your computer, the digital camera starts numbering at 1 again. This means that you have to rename files if you want to put them in the same folder with another file with the same name. Additionally, sequentially numbered files just make keeping track of when you shot particular photos easy.

STEP 7: SET IMAGE SHARPNESS AND CONTRAST

Digital photos are inherently "soft" (as opposed to being "sharp"), because the image is represented by pixels, or "dots," instead of a smooth tonal range as in analog or traditional photos. But that's okay because you can sharpen an image and increase contrast in many ways. You can sharpen a photo by editing it

> **TIP**
>
> Generally, you should use the lowest ISO setting possible to get the most "digital-noise-free" and highest-quality photo that can be taken with your camera. The use of a tripod can help you to use a lower ISO setting by allowing you to shoot with a slower shutter speed that allows a lower ISO rating. Digital noise is not always bad: If you can't avoid it, use it as a design feature. Many photographers intentionally use high-ISO-rated settings or film speeds to add grain to their images.

with an image editor such as Photoshop or Photoshop Elements, or if your digital camera has an in-camera sharpening process, you can turn it on to increase the perception that an image is sharp. Likewise, you may find your digital camera has an in-camera contrast feature, too.

Before you use either of these features, you need to carefully consider how you intend to use your photos, and you ought to experiment with the features before using them to shoot photos for an important event. If you don't plan on using an image editor to sharpen your photos, you may find that the sharpness and contrast features in your camera help you get better prints when you print on some printers. If you plan to use an image editor to edit your photos, I suggest that you not use either of these features because you'll have much more control over your image in the image editor.

STEP 8: FORMAT DIGITAL PHOTO STORAGE MEDIA

The prior seven steps discussed the many important settings that you need to set before you begin shooting. Besides taking care of these and possibly other settings, you also ought to consider formatting your digital

photo storage media in your camera — formatting your memory cards (after you have downloaded previous images and backed them up) is the preferred method of preparing memory cards for use. Remember, formatting your memory cards erases all images remaining on the card.

If you use a digital photo storage media reader to download your digital photos to your computer, the media card appears as one more "hard drive" to your computer's operating system. This means that you can rename a folder or images, delete or add files, or even format your photo storage media card with your computer. However, if you use your computer to add, change, or delete files on your photo storage media card, your digital camera may not recognize these files or changes or possibly may not even be able to read and write to the media. After you download photos to your computer, you should format the photo storage media card with your digital camera by selecting **Format** in one of the camera's menus. This formatting ensures that your camera has access to all the storage space contained on the media.

WARNING

You should always format your digital photo storage media with your digital camera. This is the best way to make sure that your media is able to store your photos as you and your camera expect. Making changes to or formatting a photo storage media card with your computer can cause problems that could cost you either storage space or lost photos. To prevent any problems and to keep your digital photo storage cards ready for recording, format them with your digital camera.

3

CHOOSING AN APPROPRIATE SHOOTING MODE

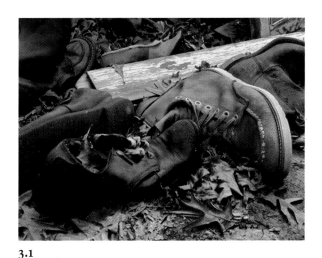

3.1

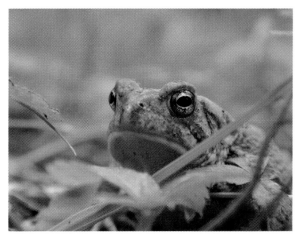

3.2

"Old Leather Boots" Nikon Coolpix, hand-held, 53mm (35mm equivalent), Fine image-quality setting, f/2.9@ 1/51, ISO 80.

I f you came upon the old leather work boots shown in Figure 3.1, or the frog shown in Figure 3.2, what shooting mode would you use? Would you select one of the automatic modes, such as shutter priority or aperture priority? Or would you choose one of the other modes your camera offers? In this technique, you learn how to choose from among the various exposure modes your camera offers to get a photo that matches your vision of the photo you want.

STEP 1: DETERMINE OBJECTIVES

Before you can choose an appropriate exposure mode, you must first determine what you want the photo to look like. It sounds simple, but visualizing how a photo should look before you take it is a skill that must be acquired. Those who have this skill take better photos than those who don't. If you don't have it yet, don't worry; keep reading and keep shooting.

All cameras (digital or film) expose either an image sensor or film with light. Light entering the camera is controlled in three important ways: the amount of time the shutter is open, the size of the lens opening, and the ISO setting. The role of the ISO setting was discussed earlier in Technique 2. The larger the lens opening, the faster the light exposes the image sensor or film. The corollary is the smaller the lens opening, the longer the shutter must be open in order to allow the same amount of light in to expose the sensor or film.

The size of the lens opening (or aperture) is referred to as the *f-stop*. Most compact-level digital cameras have f-stops ranging between f/2.0 and f/11.0. Understanding f-stops can be a bit confusing because the number is actually the denominator of a fraction with 1 as the numerator. In other words, f/2.0 is really 1/2.0 (or 1/2) and f/8.0 is really 1/8.0 (or 1/8). These fractions represent the opening size; so, f/2.0 is a larger opening than f/8.0.

> **NOTE**
>
> Larger aperture numbers (f/8.0 or f/11.0) result in more depth of field than smaller aperture numbers (f/2.8 or f/4.0). Longer shutter speeds (1/60 or 1/30) are more likely to be blurred than shorter shutter speeds (1/250 or 1/400). When you're shooting low-light scenes, increasing the ISO setting (say, from 50 ISO to 200 ISO) allows the image sensor to capture more light more quickly, allowing the use of a faster shutter speed, or a smaller aperture setting. This increased ISO setting increases the amount of digital noise. These are the fundamental trade-offs of all cameras, film or digital.

When thinking about this concept, you may wonder why photographers care so much about which combination of f-stop and shutter speed they use if different combinations result in the same level of light entering the lens. Photographers care because a small opening results in more depth of field than a large opening. *Depth of field* is a term that describes the area from near to far that is in focus; in other words, it describes how much of the image is in focus.

Furthermore, because a smaller opening requires that the lens be open longer to get the same amount of light as a larger opening, an image has an increased chance of being blurred if the camera or the subject moves during exposure. In this case, a camera support would be recommended. So, the trick is to get the proper depth-of-field and the desired degree of image sharpness with the available light.

The photo of the old work boots shown in Figure 3.1 is a good example of having to deal with the trade-offs between f-stop and shutter speed — you'll find you can't always choose the settings you want. Because the objective was to have as much of the photo as possible be in focus, the choice of f-stop was near the maximum f-stop available on the Nikon Coolpix, such as f/8.0. However, because no tripod was available and not much light was in the barn where the boots were laying, the smallest f-stop that could be used was f/2.9. This setting was just about the worst setting that could be used to maximize the depth of field, but it worked! If a tripod had been available, the camera could have been set to f/8.0 and the photo would have been entirely in focus.

Figure 3.3 shows a photo of a small frog. The objective here was exactly the opposite of the photo of the old work boots — it was to have as shallow a depth of field as possible. Notice how the right eye of the frog is clearly focused and the left eye and everything further from it is blurred. Likewise, the foreground

leaves are also blurred. Given the chance to shoot this photo again, I would try to shoot with a slightly smaller f-stop (for example, f/8.0 instead of f/4.0) so that both eyes would be in focus. The problem then would have been to hold the camera still enough to avoid causing image blur due to camera movement at the resulting slower shutter speed.

You should also now understand the importance of deciding what your photo should look like before shooting. Otherwise, how can you set the camera settings? You can shoot with an automatic setting, or you can choose your settings carefully for each shot you take. Often, many of photography's trade-offs and limitations make getting the photo that you want challenging and that is why some photographers are better than others. The good ones learn to envision a shot, and choose the best settings based upon the constraints and trade-offs that face all photographers.

With that quick and possibly overly simplistic overview of f-stop and shutter speed, the discussion

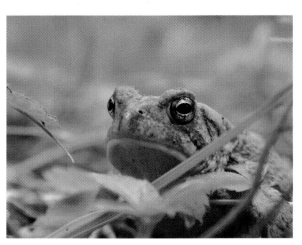

3.3

of the resulting effects that different combinations can have on image blur (due to subject movement or to the photographer's inability to hold the camera still while shooting), and the nuances of depth of field, you can understand the challenges of capturing a photo as you envision it!

STEP 2: CHOOSE BETWEEN AN AUTOMATIC OR CREATIVE EXPOSURE MODE

In an effort to compete, as well as provide lots of control to users of digital cameras, camera vendors have created a wide variety of different exposure modes. All of these modes fall into one of four categories: automatic, creative, manual, or special.

When you use an automatic mode, the camera chooses both f-stop and shutter speed for you based upon its attempt to optimize exposure for a particular type of subject. Besides choosing f-stop and shutter speed, some automatic setting modes also control the ISO setting based upon the available light, or white balance. They can automatically turn on a built-in flash if it is needed, or make other settings for you automatically. One drawback of using some automatic modes is they do not let you modify some settings such as exposure compensation, automatic exposure bracketing, or the light metering or focus methods. A creative exposure setting allows you to choose either f-stop or shutter speed, and then the camera attempts to choose the other settings for you based upon your initial choice. If there is not enough light, or there is too much light to get a good exposure, your camera may not let you even take a photo! Using a manual setting, you get to set everything yourself, which means that you can do all kinds of creative things like over- and under-exposures without having to fight with the camera in any way.

Special modes include modes optimized for doing panoramas, movies, night scenes, or other special effects. Most digital cameras offer an exposure mode dial like those shown in Figures 3.4 and 3.5. These exposure dials are from a Canon PowerShot and a Nikon Coolpix, respectively.

With all these choices of exposure modes, how do you decide which one to use? Because of the sophisticated and usually accurate light metering on many digital cameras, you can often get excellent results by using one of the automatic modes. Just make sure to pick one that is appropriate for your subject! For example, if you're shooting a portrait and your vision is to have a sharply focused face or faces against a soft blurred background, you can use a portrait mode. Most automatic portrait modes are designed to have a shallow depth of field, which results in a soft background. If you want an even shallower depth of field, then you have to choose another exposure mode that allows you to change the aperture setting.

TIP

One of the advantages of compact-level digital cameras is that they have an extremely deep depth of field — that is, they can be used to take photos of subjects where the entire image is in focus. This is partly due to the small image sensor size. The downside is these same digital cameras are limited in their ability to take a sharply focused subject with a soft blurred background. To get a good idea of how much control you have over depth of field with your camera, try shooting a row of small objects, such as pencils or leaves on a bush, while varying the aperture from the smallest f-stop to the largest f-stop. Try again by varying the distance between the objects and the camera. Using a tripod for this exercise is best, if you have one.

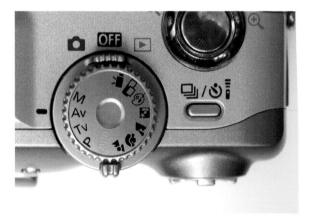

3.4

3.5

If you want to shoot a landscape with everything in focus, try using a landscape mode. Or you can use one of the automatic modes or creative modes that allow you to change the aperture setting, too. The more you learn about the relationships between f-stop and shutter speed, the more likely you are to want to have control over your settings instead of leaving it up to your camera to choose for you.

Before you go on to Step 3, carefully read the pages in the manual that came with your camera that describe each of the exposure modes on your camera. You need to understand what each mode has been designed to do and what settings you can change while in that particular mode.

> **WARNING**
>
> If you're using an automatic (auto) exposure setting, make sure to read the documentation that came with your camera to find out whether auto exposure settings also automatically change the ISO setting. Significantly more digital noise exists in photos taken with the higher ISO settings, such as 400 or 800 ISO. Be aware of whether your camera automatically changes to a higher ISO setting if there isn't enough light. If you want to avoid using these higher ISO settings, use another exposure mode or shoot with a flash.

STEP 3: CHOOSE F-STOP OR SHUTTER SPEED

After you've chosen a specific exposure mode, you may then need to make additional changes to either the f-stop or shutter speed. If you have chosen one of the automatic modes that selects all the settings for you, you may not be able to make any changes. If you have selected one of the creative modes, an automatic mode that allows changes, or the manual setting, now is the time to make changes to the f-stop or shutter speed to get the results you want.

> **WARNING**
>
> One of the common mistakes made by those new to photography is to use one of the creative modes, like aperture or shutter priority mode, and simply shoot without considering what the results will be. Although these modes are automatic, meaning that the aperture priority mode automatically sets the shutter speed, you still have to set the right aperture. Similarly, the same thing applies to the shutter priority mode. You set the shutter speed to be what you want and then the camera sets the aperture to get the right exposure. If you don't choose these settings, you're simply using the setting that the camera was last set on.

TAKING AND REVIEWING PHOTOS

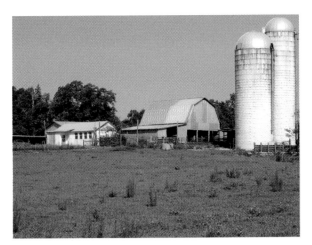

4.1 *Original image*

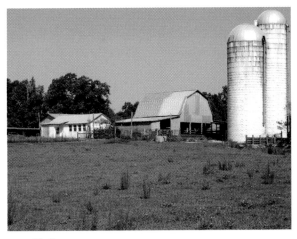

4.2 *Edited image*

"North Carolina Farm Buildings" Canon PowerShot, mounted on a tripod, 102mm (35mm equivalent), Super-Fine image-quality setting, f/8@1/320, ISO 50.

Being able to take a photo and immediately see it is one of the more significant benefits of using a digital camera. If you want to take the best possible photos, you need to learn about those features your camera offers for both previewing and reviewing photos to assess the technical as well as compositional aspects of your just-taken photo. After you get used to using these features, you'll have one more reason why you want to shoot with a digital camera instead of a film camera!

The photo shown in Figure 4.1 was actually the third of four photos that were taken of the North Carolina farm buildings. Figure 4.3 shows how the camera was set up on a tripod with the LCD monitor set to preview the image of the farm buildings. Each time the shutter release button was pressed, a review screen displayed the image settings and the captured image for two seconds. Several additional shots were taken with different adjustments to the settings based upon the information on the review screen.

To make sure that one of the images was exposed properly, the Canon PowerShot was put in review mode and the exposure histogram (you learn more about this in Technique 11) was examined to determine that the photo in Figure 4.1 was the best shot and that it was exposed correctly. The photo in Figure 4.2 is the result of some basic image editing in Photoshop Elements to improve image contrast, exposure, and image sharpness.

In this technique, you learn how to get the most from the preview and review features your digital camera offers, so that you can take better photos.

STEP 1: SET PREVIEW AND REVIEW FEATURES

Digital cameras have many different features to preview and review photos. There are also many different ways in which you access these features. A *preview* feature allows you to take a look at an image on an LCD monitor before you press the shutter release button and to have a quick visual check of the camera settings and composition.

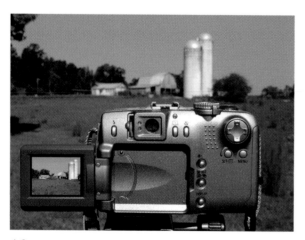

4.3

A *review* feature allows you to look back or to review an image after the photograph has been taken. Some of the new Minolta and Sony digital cameras have gone one additional step forward — they actually allow you to view "after" image and exposure information before you've taken the photo! This means that you can make all the settings adjustments you want to get the photo you want, before taking a single photo!

Depending on your camera model, the differences between the preview and review features can be substantial. Once again, you should consult the documentation that came with your camera. Look for features that "replay," "preview," or "review" images. Also, check to see whether your camera offers a histogram. I have known many digital camera owners who have had their cameras for months and were not aware of the many useful features that could be used to substantially improve their photos. Don't be a part of this group! Check out your documentation.

Assuming that you have sufficient battery power and that your camera has a review feature, set it to display an image for a couple of seconds after a shot has been taken, as shown in Figure 4.3. This quick review is good enough to get an idea of how close you were to getting the shot you wanted. Usually, these review modes also let you read a few other important camera settings on the monitor as well as the number of photos you've taken and the number that you can take based upon current camera settings. Not every digital camera allows you to preview a photo until you change to a preview mode, which takes you out of shooting mode.

If your camera has a review mode, you should also check to see whether it has alternative review modes. Some are simply views of the image, while other modes show shot information on the screen, too.

> **WARNING**
>
> The use of some LCD monitors can rapidly drain power from batteries. Consider turning off any automatic review features that your camera may have when you need to conserve battery power.

STEP 2: DETERMINE OBJECTIVES AND SELECT APPROPRIATE SETTINGS

Step 1 in Technique 3 discussed the importance of visualizing how you want your photo to look before you take it. After you have decided, you should then, and only then, choose the most appropriate settings to get the shot you want. Selecting focal length, exposure mode, metering mode, aperture, and shutter speed are just a few of the many settings that you are likely to want to set.

STEP 3: COMPOSE IMAGE AND TAKE PHOTO

After you have set all the necessary settings to get the photo you want, you're ready to compose your shot. Most digital cameras offer two ways to view and compose your photo — you can either view the scene on an LCD monitor or through an optical viewfinder.

If your camera has an optical viewfinder, you need to be aware that it may not provide you with an accurate view of the photo that you're taking. Most compact digital cameras with optical viewfinders have what is known as the parallax phenomenon. This phenomenon is due to the physical separation between the viewfinder and the lens. The closer your subject is to your lens, the less your photo is likely to look like the view you see when looking through the viewfinder. Some of the newer cameras have electronic viewfinders, or ELFs. These viewfinders are actually high-resolution LCDs and they show the same image as the LCD monitor.

Optical viewfinders do have two advantages. First, they do not consume battery power like LCD monitors, which can be important if you have limited battery power. Second, viewfinders can often be easier to use in bright daylight because light can wash out the image on an LCD monitor. If you use the viewfinder, you should also check to see whether it has a diopter adjustment to adapt to your vision.

When you've composed your shot as you want it, press the shutter button to take a photo. If you have a preview feature and it has been turned on, you should now be able to get a quick two-second view of the image you just shot.

STEP 4: REVIEW IMAGE AND CHECK SETTINGS

If you want to look more carefully at the shot you've just taken (or earlier shots, too), you probably need to change to a review mode. You usually do so using the same dial that allows you to change exposure settings. Check your documentation to learn how to change to a review mode and to learn about the various review modes that are available. Some digital cameras allow you to view up to 16 small thumbnails on the LCD monitor so that you can quickly find the photo that you want to examine. Many cameras also have options for how much shooting data is displayed on the LCD monitor in addition to the image.

Figure 4.4 shows the detailed review screen in the LCD monitor of the Canon PowerShot. This is just one of two display settings offered on the digital camera. From that screen, you can see that aperture was set to 1/400, f-stop was set to f/8.0, no exposure compensation was used, white balance was set to daylight, metering mode was set to evaluative, image resolution was set to the maximum resolution, and the lowest level of compression was used. You can also read the date and time, plus the image file number and folder number. Equally important is that you can also see the exposure histogram, which gives you excellent insight into how well your photo was exposed (even more so than what you can determine from looking at the image).

> **TIP**
>
> To avoid having to look at a washed-out LCD monitor in bright sun, consider getting an LCD hood. These hoods shield LCD monitors from bright sunlight, allowing you to view your LCD in those conditions. You can find these accessories at `www.hoodmanusa.com`.

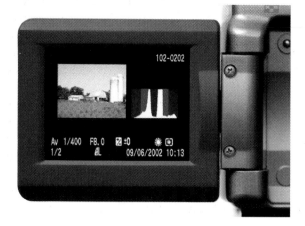

4·4

To determine whether your image is in focus, check to see whether your camera allows you to zoom in on the displayed photo. A zoom feature not only helps you to check an image to see whether it's in focus, but it also helps you check on subject details such as eyes to see whether they blinked or have red-eye.

As you review your images, you can also delete those that you don't want to keep. Deleting images gives you more space for more photos and reduces the amount of time you spend later when you download your photos to your computer.

STEP 5: SHOOT AGAIN IF NEEDED

After you have reviewed your photos, you can decide whether you have the shots you want. If not, compose your picture again with new settings, and then, once again, press the shutter button to take another photo. If you're not sure you have what you want, try a few other settings and take a few more photos. In Technique 12, you learn about *exposure bracketing* — a great technique for ensuring that you have the exposure you want.

> **WARNING**
>
> Although you may be tempted to review and delete all the photos that you think you don't want while shooting, you may end up tossing out shots that you would like to keep. As useful as the LCD monitors are, they are quite small and you may not be able to see as much as you think you can. Photos that look like they are in focus or exposed may not be. If you have enough space on your digital photo storage media, you're usually better off deleting images on your computer because you can view them full-size on your computer monitor before making any deletions.

CHANGING CRITICAL SETTINGS QUICKLY

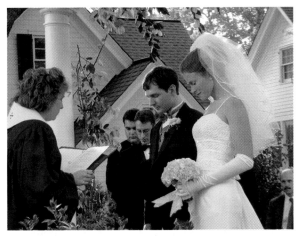

5.1 *Original image*

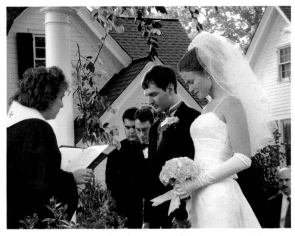

5.2 *Edited image*

ABOUT THE IMAGE

"A Garden Wedding" Nikon Coolpix, hand-held, 103mm (35mm equivalent), Fine image-quality setting, f/3.9@ 1/58, ISO 80.

"The picture of a life-time." "Capturing the perfect moment." "Capturing the decisive moment." These are just a few of the many often-used phrases that vividly refer to the fleeting moment where a photo ought to be taken! So many of the perfect moments for the perfect photo are either missed or are badly taken! Many reasons exist for why the moment was not captured as it should have been. The two most common reasons are that the wrong camera settings were used, or the appropriate settings were not set quickly enough.

So, how do you avoid these problems? Learn how to reset your camera, and how to select the correct settings quickly. How do you make sure you select the right settings in time to take a photo? After you've learned about each setting, practice changing them so that you can quickly get the settings you want, and learn where on your camera you can check the current settings. If you know where to check the settings and can make the setting changes quickly, you're more likely to get the perfect shot.

This technique has eleven steps that take you through each of the most critical camera settings that you should know how to change instinctively. But don't panic because it has eleven steps — this technique is more of a "pre-flight" or "pre-photo" checklist, rather than an informative technique where you'll learn how to do eleven things with your camera. Use it when you have not used your camera for a while or when you want to make sure you're ready to shoot an important event like the wedding shown in Figures 5.1 and 5.2.

STEP 1: LEARN HOW TO READ CURRENT CAMERA SETTINGS

The more features your digital camera has, the more likely you are to find yourself shooting with the wrong settings; that is, unless you know how to read the settings and you're compulsive about checking them before you shoot. There is a reason why I know this!

A few years ago, I took photos at a friend's wedding, the day after I had shot still-life photos inside a kitchen. Because of the incandescent lights in the kitchen, I had changed the white balance setting to incandescent. The next day, the wedding day, I shot with the incandescent light setting even though I was shooting outside in daylight. All the wedding photos had a horrible blue cast! The good news was that the images were easily fixed with Photoshop, and I was not the hired wedding photographer! Maybe, with this story in mind, and this technique, you can avoid a similar experience. Figure 5.1 shows the original wedding photo with an awful blue color cast. Figure 5.2 shows the photo after Photoshop Elements was used to enhance the photo and correct the color cast.

The best way to avoid using the wrong settings is to learn where and how to read the current settings on your camera. Camera settings can be shown in more than one place. On the Canon PowerShot, they can be found on a display panel, shown in Figure 5.3. You can check the exposure mode by looking at the exposure mode button. You change some of the less frequently changed settings via menus on the LCD monitor like the one shown in Figure 5.4. You can view other settings when looking through the viewfinder.

Because of the number of settings and the lack of space to display them, you have to get familiar with quite a few icons. The time you spend learning where various settings are displayed and how to change them is well worth the effort. Take a few minutes now and find out where you can read the settings on your camera.

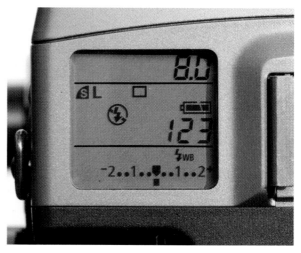

5.3

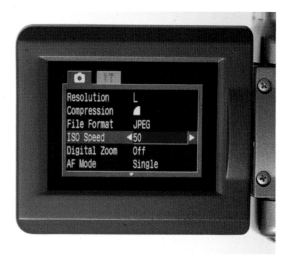

5.4

STEP 2: LEARN HOW TO RESET YOUR CAMERA

Most digital cameras have dozens of settings that can be changed, and when you change settings from their default settings, you may get unexpected results. A good way to start with the default settings is to reset your camera. You may have to read your manual to learn how to do this. Resetting your camera is usually as simple as selecting the right menu function and pressing a button!

STEP 3: CHANGE WHITE BALANCE SETTING

The white balance setting is an important one that you must set correctly to get photos with accurate colors. When you set the white balance setting to match the light source, white is white and all other colors are as they should be. When the white balance setting is not correct, the photos have an unwanted color cast, as was the case with the wedding photos shown earlier.

Most digital cameras offer an auto white balance setting that generally is quite good at minimizing color casts. However, you may find that you get better pictures when you use a specific setting to match the light source in the scene you are shooting. This is especially true if you shoot in a room with fluorescent or tungsten light; in these cases, use a fluorescent or tungsten setting to match the light source. You generally change the white balance through a menu displayed on an LCD monitor that you access with a dial or button.

Because using a correct color temperature (white balance setting) is so important, many vendors are increasing the number of available settings. For example, many current digital camera models offer different white balance settings. Typical white balance settings include Auto, Daylight, Cloudy, Tungsten, Fluorescent, Fluorescent H, Flash, and Custom. Learning about the different white balance settings offered by your digital camera, and using the most appropriate white balance setting for each photo you take, helps you get better photos.

STEP 4: CHANGE ISO SETTING

As explained earlier, ISO is a setting that determines how sensitive the digital camera is to light.

The lower the ISO setting (for example, 50 or 100), the longer it takes for the light to be recorded and, even more importantly, there is less digital noise (similar to a film's grain). The higher the ISO setting (for example, 400 or 800), the quicker the light gets recorded and the more digital noise you find in the resulting photos. The benefit of using a higher ISO setting is that it allows you to get a properly exposed photo in a low-light-level scene. Assuming you want to minimize digital noise, you may want to look at ways to add more light instead of changing the ISO setting, or maybe not even take the photo at all. You can often use a lower ISO setting if you use a camera support as the extra support, which allows you to shoot with a slower shutter speed and still avoid image blur due to camera shake.

STEP 5: CHANGE EXPOSURE MODE

Technique 3 covered the topic of how to choose and use an appropriate exposure mode. Although this setting is an easy one to make, it is one of the most important ones to choose correctly.

STEP 6: TURN FLASH ON OR OFF

Several other techniques in this book help you learn more about using a flash. Besides just turning a flash on and off, your camera may offer many other flash-related features as well. You ought to know how to turn on any built-in flash as well as turn it off. You should also be aware that some automatic exposure modes automatically turn on the flash if extra light is needed to get a proper exposure. If you choose not to use a flash in these situations, you need to learn how

to avoid using the flash by turning it off, or by changing to a more appropriate exposure mode.

STEP 7: SELECT METERING MODE

If your camera is not in manual exposure mode, you're quite likely to be using one of the electronic metering modes to determine the proper exposure. Depending on what you're shooting and how you want to expose the image, one metering mode may be preferred over the other. Typical metering modes are evaluative (also called matrix or program mode), center-weighted averaging, center, or spot. You learn much more about how to pick a metering mode in Technique 13. For now, just find out what modes your camera has and how to change them.

STEP 8: SELECT FOCUS POINTS

The more skilled you become at envisioning a photograph, and then setting your camera settings to get the shot you want, the more you want to learn about how to control focus. All photos must not necessarily be completely in focus. Great photographers are skilled at deciding what should be in focus and what should be blurred and to what degree. Choosing a focus method and focal points is essential for getting the photos you want. In Technique 10, you find out more about how to control focus. Once again, for now, take a quick look at the documentation that came with your manual and learn how you can control the focus.

STEP 9: TURN ON/OFF RED-EYE REDUCTION

When photographing people with a camera that has a built-in flash or one that is directly mounted on top on a flash shoe, the subjects in the picture get red-eye — unless you use a red-eye reduction feature. Learn how to turn on and turn off the red-eye feature if your camera has a built-in flash. This simple setting is one

you'll want to use if you're shooting people up close; nothing affects the quality as much as red eyes on an otherwise wonderful photo.

STEP 10: CHANGE EXPOSURE COMPENSATION

Throughout this book, you learn many entirely different exposure techniques to shoot the same subjects. If you're like me, and you often use exposure compensation, you find that you frequently put yourself at risk of taking a poorly exposed photo because you forgot to reset exposure compensation. If you use exposure compensation, make sure you learn how to adjust it and then make sure you set it back to 0 when it ought to be set to 0. Technique 12 covers exposure compensation in detail.

STEP 11: CHANGE OTHER SPECIAL SETTINGS

If you're someone who likes to use special features (like me), then you need to learn how to use them — and then make sure that you turn them off when they're no longer needed. One of my favorite features, and one that has become a common and widely used feature on many digital cameras, is the panorama mode. I've also been known to experiment with color effects and occasionally use the timed shutter release so that I can be in the photos, too. When you use special features like these, make it a practice to turn them off as soon as you're through using them. Otherwise, they'll be on when you don't want them to be and you may miss getting the photo that you want.

So, are you ready for a quick test to see whether you're ready to shoot an important event? If so, then do the following:

■ Quickly set your camera to a shooting mode suitable for shooting portraits.
■ Turn on the flash to get some *fill flash*, a small amount of light to supplement the existing light.

■ Make sure you turn on the red-eye reduction feature.

■ Set ISO to 100 to minimize digital noise.

■ Set white balance for shooting with flash.

■ Quickly review your settings to make sure they are set as you want and that you do not have a setting that would be contrary to your intentions!

■ Now, set your camera to an exposure mode suitable to shoot a landscape on a tripod in late evening light.

■ Set ISO to the lowest setting (for example, 50 or 100) to ensure a high-quality image. Check to see that your white balance setting is appropriately set.

If you made the changes for both of these photos in less than 20 seconds, you're just about ready for the next chapter! Before you head to the next chapter, allow me to share a quick and true story to reiterate a couple of important points. The weekend before I submitted this chapter to my editor, I attended an old car and airplane show to shoot photos and to enjoy a day away from writing. As I wandered around the airfield, I noticed that far more people were shooting with digital cameras than film cameras. I spoke to about a dozen people shooting with digital cameras and asked a few questions about the settings they were using.

One person was shooting with an incandescent light setting — outdoors in bright sunlight. "Oops!" he said. Another was pleased to have chosen the shutter speed exposure mode because he knew it was important to have a fast shutter speed, but he did not set it — he just shot using the last setting — 1/30 of a second, ensuring all his photos would be blurred. A husband who was proud to have "a wife who reads manuals," told me that she learned how to adjust exposure compensation — so he had been shooting all day with a –1 exposure compensation setting (minus one stop), thereby underexposing many of his photos by a full stop. Another photographer used a one-shot focus setting, making certain that every incoming and outgoing plane that he shot would be blurred. Four out of twelve seemed to have all the settings just right — the four of them were using auto exposure modes. Because it was a very bright day, even these four could have spent their day taking better photos if they knew a little more about their cameras.

The point of this story is that as you learn to use different camera features, also make sure you know when to use them and how to turn them off. After you move away from auto modes and into the creative picture taking world, you have a chance to both get better photos and to really mess them up! The next nine chapters show you much more about how to use your camera well.

CHAPTER **2**

TAKING BETTER PHOTOGRAPHS

Chapter 1 helped you get familiar with your camera and get you ready to take better pictures. This chapter offers lots of tips, ideas, and inspiration to help you make great pictures. Technique 6 offers ideas on where to go and what to shoot. Technique 7 presents composition tips that will help you take better-composed photos. In Technique 8 you will find out about focal length and how to choose a lens. In Techniques 9 and 10, you learn techniques that cover two of the most important factors that can either make or ruin a photograph — getting the proper exposure and getting a sharply focused photo, respectively.

6

CHOOSING SUBJECTS

6.1

6.2

Most photography magazines and books are filled with breathtaking photos that more often than not were taken in some exotic place. However, you don't have to travel to Africa, take an underwater camera to the bottom of the ocean, or visit the Galapagos Islands to get good photographs. You can start in your own home or places you visit regularly, like the mall, the zoo, or even your own backyard. Getting good photographs in common places is simply a matter of learning how to see — and then composing to get interesting photos like the wine glasses in Figure 6.1, or the cat and statue in Figure 6.2.

Many years ago, in my first two-hour chemistry lab, all the students in the class were given a few candles and some matches. After we each lit one candle, we were shocked to find that the lab assignment was to write down 200 or more observations about a burning candle. After thirty minutes of observing and making notes, many of us were surprised to find that it was pretty easy to observe 200 or more different things about a burning candle.

The point of the exercise was to learn how to *see.* The point of this technique is the same — only the objective of this technique is to learn how to *see creatively with a camera* by shooting a couple hundred photos while following the eight steps.

STEP 1: SHOOT INSIDE YOUR HOME

Whether you live in a small apartment, a large home in the country, or a flat 29 stories up in the air, you should be able to find lots of things to shoot inside your home. The real advantage to shooting inside your home is that you're close to your computer. This means you can shoot, download your photos, examine them, shoot some more, and study those, too. This short feedback loop is an excellent way to learn how to take better pictures — quickly! I bet you'll be surprised at how much you can learn shooting a few hundred photos of objects inside your home. Try it and see.

My favorite subjects to shoot inside my home (excluding the three gray cats that own the place) are glass bottles, plants, and a wide variety of food products found in the kitchen. Fruit, vegetables (for example, colored bell peppers, squash, and even potatoes), olive oil bottles, and spices should all be considered as good subjects to be shot. As you shoot, look at the light and see whether you can change it by drawing a sheer curtain, adding lights, or by shooting at a different time of the day. Figures 6.3 and 6.4 are two photos that were taken inside my home.

STEP 2: SHOOT IN YOUR BACKYARD

Because you're so familiar with your backyard, you may not deem it to be a place to go to take photographs. Or maybe you have a beautiful garden in your backyard with 200 acres of pristine forest with a pond surrounded by a waterfall and wildlife, and you know that wonderful photographs are just waiting to be taken. Whatever the case, I suggest that you go out with your camera and accept the challenge to get some good shots.

6.3

6.4

To get practice assessing your photos after you've taken them and reviewed them on a computer screen, try to judge them on three standards: their technical merit, their ability to hold a viewer's interest, and how "artsy" they are. Figure 6.5 shows a photo of one of my gray cats and a statue in my backyard. How would you judge it?

My particularly harsh judgment rates it pretty poorly in terms of technical merit. The cat's head is a bit blurred and I would have preferred that the shot was taken with a slower ISO setting to rid the image of digital noise. Its art merits are not good either as I don't like the retainer wall or the block wall or the choice of background shrubbery. However, I thought the quick shot taken at the perfect moment of my cat mirroring the pose of the concrete cat with wings was quite captivating. Showing the photo to a few others confirmed my thought that it was interesting, so I get a few points for that photo.

After you've judged a few of your photos, open them up with software that allows you to view the EXIF data so that you can learn more about the settings you used to shoot. EXIF (Exchangeable Image File Format) data is information that was recorded when the image file was created by your digital camera. When I opened the cat photo with Photoshop Elements, I learned that the shutter speed was 1/40 of a second — a bit on the slow side to hand-hold with a focal length of 100mm. That explained the blur around the cat's head. It also justified my ISO 400 setting as the blur would have been even worse with a lower ISO setting. Now the question is, "Could I have gotten a better photo using a tripod and a lower ISO setting?" I'll never know because when I went inside and got my tripod and came back, I could never get the cat to sit on the wall again! Through this example, you can understand the importance of being able to shoot, review, critique, and shoot again.

STEP 3: SHOOT IN MACRO MODE

If you feel that you have run out of things to shoot in your backyard, try shooting in macro mode. Macro mode allows you to shoot small things and make them fill up your image, as shown in Figure 6.6. If your camera has a macro mode, try finding a spider, a mushroom, a bright colored leaf, or another interesting subject to shoot. Technique 30 covers the topic of taking macro photos, so I'll leave this topic for now. However, try shooting a few macro shots, because doing so gives you valuable insight that will help you with later techniques. To get good macro shots, don't be timid about getting down on your hands and knees and crawling around. Good photos are made, not taken; you have to work to make them.

6.5

6.6

STEP 4: SHOOT AT A ZOO OR BOTANICAL GARDEN

I've seen many, many good photos of wildlife, and had, up until a few years ago, always assumed that they were wildlife in the wild. Over time, I've learned that many of those outstanding wildlife photos feature animals in captivity. I first believed that such photos were of a lesser quality than those photos taken of wildlife running free. However, because the world's wildlife population is decreasing at an alarming rate, and because it is both the volume of nature photographers and the fact that many of them have a lack of consideration for the animal's natural surroundings that contributes to the problems, I wholeheartedly recommend that you and your camera take a visit to the zoo. You may even see me there!

Rather than include photos of animals that I've taken at a zoo, or plants that I shot at a botanical garden, I suggest that you visit the photo.net Web site, `www.photo.net`. It is a wonderful site for serious photographers who want a place to show their work, get feedback, and to become part of a group through an online forum. Seeing the photos that ordinary, everyday, nonprofessional, compact-level, digital-camera-toting photographers display on that site is amazing! Check it out when you have at least 30 minutes to view photos and explore the site. I know you'll be impressed. The lesson here is that you, too, can shoot photos like these photographers! Professional photographers may get more great photos more often, but even the nonprofessional can get one every now and then. I look forward to seeing your photos on the photo.net Web site.

STEP 5: SHOOT PETS OR OTHER ANIMALS

I don't know for a fact, but I surmise that one of the most photographed subjects besides people are people's pets. I laugh when friends show their photos to me and they have entire folders full of pet photos — because I do, too. Every time I get a new lens or digital camera, I go looking for one of my three gray cats. Figure 6.7 shows one of my cats with a mouse he just caught. Many tales are told about cats chasing mice. An entire cartoon series was even made about a cat chasing one mouse. Yet, have you ever seen a cat catch one? I hadn't until I shot this photo. Incidentally, my cat dropped the mouse right after I took the photo and the mouse escaped into the bushes with just a bad scare.

Out of the millions of things I could have suggested to shoot in this one of eight steps, why pick pets as a subject to shoot? Because some pets can be very patient models and odds are good that you are rather fond of your pet if you have one. You'll learn that the more you enjoy your subjects, the more you will enjoy taking photos of them — and the better your photos will be! The real lesson here is to shoot things that you're passionate about. It will show in your photos.

6.7

STEP 6: SHOOT WHILE IN A MOVING CAR

Please note that this step reads while *in* a moving car, not while driving a car! Please don't try shooting photos while driving as it may necessitate that an insurance agent use a digital camera to document the damage to your car! Why shoot while in a moving car? You will get an excellent sense of movement and of shutter speeds. Being able to show time or speed in a photo adds one more dimension to your photos.

As the car is moving, change shutter speeds between shots from 1/30 of a second (or even slower) all the way up to the fastest shutter speed your camera offers. One thing you can learn from this exercise is that having an image that's blurred can be okay. Not all images have to be perfectly in focus. Some image blur can add drama to a photo as it illustrates movement.

If you don't want to shoot from a moving car, you can stand at the side of a road and shoot moving vehicles. Try panning with the moving vehicle so that the vehicle is perfectly in focus and the entire background is blurred. Shooting fast-moving cars with a digital camera takes some practice, but it is possible, and you benefit from learning the same things as you would learn while shooting from a moving car.

STEP 7: SHOOT IN THE CITY

One of the reasons that so many great photographers have built their reputation from photos in New York City is because large cities are rich with photo opportunities. Take a few hours and go into a city with lots of tall buildings. Getting good lighting is challenging, depending on when you visit, because the tall buildings create lots of shadows, but great photos are just waiting to be taken at every street corner. Figure 6.8 shows a photo of one tall office building in Charlotte, North Carolina, as a reflection in the glass of another building. If you have a chance, take a tripod and shoot after dark as well. The energy of big cities at night is easily captured with a digital camera.

6.8

STEP 8: SHOOT AGAIN!

Consistently taking good photos and getting the photos to look the way you want them to look takes lots of practice. You need to previsualize your shots, learn how to use your camera, and be at the right place at the right time. The more you shoot, the more you learn how to take great photos. Carry your camera as often as you can and shoot whenever you get a chance. When you first begin to take photos with a digital camera, you will see remarkable improvement in your picture-taking skills every couple of hundred photos that you take. Good luck and enjoy capturing the light.

COMPOSING YOUR SHOTS

7.1

7.2

The difference between a person with a camera and a photographer is that a photographer visualizes things that others don't see, and then he composes and captures that image with the camera in a pleasing way. The vision, which is the start of a good photo, is what is really important (the camera is merely the tool to get the photo), and composition is how that vision is presented.

Learning how to compose an image is not something that happens overnight. It is not something that you can learn by following a few guidelines and rules; however, I strongly believe that learning how to think and talk about photo composition is tremendously useful. Learning some guidelines or rules that you can use as ideas or starting points for composing your own photos is also useful: These guidelines apply to subject matter as different as Figures 7.1 and 7.2. After shooting several hundred photos while completing the following eight steps, my bet is that you will be well on your way to understanding the importance of photo composition and be able to compose better, too.

43

STEP 1: SHOOT USING AND VIOLATING THE "RULE OF THIRDS"

By popular usage, the *rule of thirds* must be the most commonly followed rule of photography — and the most often broken one. The idea of the rule of thirds is to divide your LCD monitor or viewfinder into nine areas like those found in a tic-tac-toe grid, regardless of the orientation of the photo. You then use these nine lines to help position important elements in your photo, as shown in the photo of a Maine crab shack in Figure 7.3. When shooting a scene with a horizon, try shooting with the horizon line lined up with one of the grid lines.

The implication is that locating the focal point on one of these intersections is better than placing it in the center of the photograph. Figure 7.4 shows the same subject composed with the focal point in the center and at one of the intersections. Which one do you like best? When it feels right to follow this rule, do so; otherwise, break it!

STEP 2: COMPOSE SHOTS WITH AN EMPHASIS ON LINES, SHAPES, AND PATTERNS

A well-composed photo can hold your interest exclusively due to the lines, shapes, or patterns shown, not

7.3

7.4

because of the subject or scene itself. A detail of an oval ceiling in a museum is shown in Figure 7.5. This is a good example of the beauty of simple curves in an architectural detail that was designed by an architect intent on creating a pleasing detail. In contrast, Figure 7.6 shows a very repetitive, symmetrical "cropped" view of the front of an old Ford truck. As you looked at it, did you first try to determine what it was? Then, did you begin comparing one side with the other to see whether the symmetry was perfect? If so, the photo caught your interest and that is good.

STEP 3: SHOOT TO FRAME YOUR SUBJECT

When possible, look at ways to frame your subject. You may be able to back up a few feet and have the branches of a nearby tree frame a landscape. If you shoot players in a sporting event, look for ways to frame the subject with spectators or other players. These extra people help to place the viewer in the scene. In the photo shown in Figure 7.7 the viewer gets the feeling of looking through the front window of one old truck to see others. Being able to have a view inside one truck helps you to imagine what the other old trucks are like, thus giving the viewer much more information than if you were to just shoot a photo of the outsides of the trucks.

7.6

7.5

7.7

STEP 4: SHOOT TO CAPTURE OBJECTS OR BACKGROUNDS

Shoot to capture objects and backgrounds — what is the point of that you may wonder? If you already use an image editor like Photoshop Elements, Photoshop, Paint Shop Pro, or one of the many other image editors, you already know the answer. An image editor allows you to combine parts of one image with another image.

Many times you find an absolutely outstanding sunset or sunrise, but you aren't where you can shoot something interesting to go with the beautiful sky. At other times, you find a great scene with a horrible sky. Maybe the sky is nothing but deep blue sky without clouds, or maybe it is the dreaded "bright white" sky that not only offers little to the scene, but makes shooting difficult as well. Using an image editor, you can take a good sky and combine it with a good scene with a bad sky! So, when you get a chance, shoot just for the objects or skies, knowing that you can use them in another photo later. Figure 7.8 shows a photo of a sky that was later used as the background for a new image created with an old farmhouse.

When you take photos just for the objects or to be used as a background, think carefully how you should take those photos so that they work with other photos. For example, the sky in Figure 7.8 was rich in color, yet fairly dark. Such a dark photo might be too dark to combine with many other photos, so four extra shots were taken with successively increased exposure to lighten the sky.

STEP 5: SHOOT TO TIGHTLY CROP THE SUBJECT

The natural inclination is to shoot an entire subject. If the subject is a clown, the most obvious shot is of the entire clown, or the top half of the clown. Consider tightly cropping your subject as shown in the photo in Figure 7.9. Likewise, when taking a photo of a banjo player, also consider a tightly cropped shot of just his hand and part of the banjo, as shown in Figure 7.10. Sometimes, seeing less is actually more!

7.8

7.9

STEP 6: SHOOT WITH DIFFERENT CAMERA ORIENTATIONS

Much to my surprise, I rarely find beginning photographers turning their cameras 90 degrees to shoot in "portrait" mode, where the long side of a photo is vertical. You have many good reasons to shoot this way when it is appropriate. Many subjects or scenes are "vertical" ones, and so you should shoot them vertically — just as some subjects are more horizontal in nature and should be shot horizontally. Besides shooting in vertical or portrait mode, you can also tilt your camera at any other angle, too. Figure 7.11 shows a photo of a '56 Ford Thunderbird in front of a fancy home. I liked the idea of trying to shoot vertically, but I did not want the car to get too small relative to the whole picture, so I shot vertically and tilted the camera so the entire car still fit in the photo. For more on shooting in different orientations, check out Technique 20.

7.10

7.11

NOTE

Your choice of a camera orientation can substantially impact how your photo can or cannot be used. If you have aspirations or opportunities to have your photographs placed on the cover of a magazine, you ought to shoot vertically. Likewise, if you're shooting photos for a possible calendar, make sure you know in advance what the format will be. If in doubt, take the picture both horizontally and vertically so you have a photo to meet any requirement.

STEP 7: SHOOT USING DIFFERENT VANTAGE POINTS

The majority of the time that you view the world, it is from a point approximately five and a half feet up from the ground (depending on your height.) This view is considered to be the normal view — it's most common and familiar — and hence, it can be the most boring vantage point. When you shoot, consider using a different vantage point so that you shoot with a less common perspective. Try lying down on your side (to shoot from a worm's-eye view) and shoot up at the subject. Or find a way to shoot down on your subject (from a bird's-eye view). The photos shown in Figures 7.12 and 7.13 show how much a simple change in vantage points can alter the perspective. Which one do you like most?

STEP 8: SHOOT AND DEVELOP YOUR OWN COMPOSITION IDEAS

If you completed the previous seven steps, you may have already begun to formulate your own set of ideas for composing photos. Your ideas may be based upon quality of light, the distance to the subject, the amount of distortion of the subject, the angle of view, depth-of-field, or any one of ten million other ideas. The more ideas you have and the more you shoot, the more you're likely to develop a style of your own and to get good photographs — photographs that are not likely to be termed "cliché photos."

I hope you've enjoyed this technique and found it to be a useful one. The more you learn to previsualize each photo, the better your photos will be.

> **NOTE**
>
> Photography is becoming a passion for a rapidly growing number of people with the financial resources to buy the latest and greatest digital photography gear. To make your photographs stand apart from the others, learn to see and shoot common subjects and scenes differently from and better than other photographers. The photographer and his or her skills — not the gear — are still the most important factors in making great photographs.

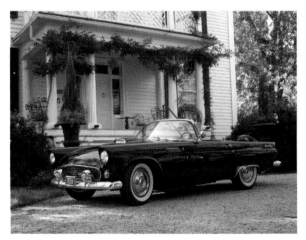

7.12

7.13

SELECTING FOCAL LENGTH

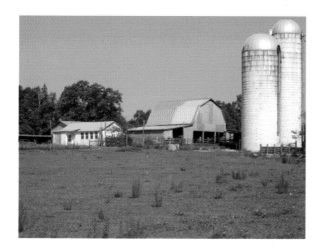

8.1

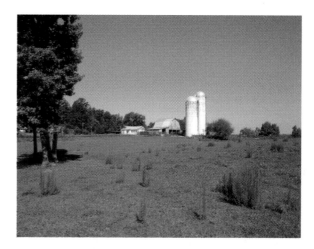

8.2

ABOUT THE IMAGE (8.1)

"Two Silo Farm Complex"
Canon PowerShot, mounted
on a tripod, zoom set to
102mm (35mm equivalent),
f/8.0 @ 1/320, ISO 50.

Focal length, image sensor size, depth-of-field, aperture setting, magnification factor, and many other such photographic terms and concepts can be difficult to comprehend because they all are interrelated. The objective of this digital camera book is not to attempt to explain such complexities in detail; rather, it is to provide readers with enough basics and "feelings" for their cameras so that they can get good photographs. However, in order to accomplish this goal, you need to have a reasonable understanding of focal length. Plus, a good understanding of focal length allows you to discuss photos, like the one shown in Figure 8.1, with others by saying, "It was shot with a 102mm lens." Figure 8.2 shows the wide-angle view.

STEP 1: UNDERSTANDING FOCAL LENGTH

In simple terms, focal length is similar to a magnification factor. The longer the focal length (the larger the number in millimeters), the closer it will

appear that you are to your subjects, and the narrower the view will be. A short focal length allows you to see a wider-angle view and makes it appear that you are farther away from your subject.

Focal length in technical terms is the distance in millimeters between the surface of the image sensor and the center, or emergent nodal point, of the lens. It is also a number that specifies the amount of magnification you get when you look through your camera. If you have used a 35mm film camera, you may be familiar with the 28mm, 50mm, 100mm, or possibly even the 400mm lenses. If you have used several lenses with different focal lengths with your 35mm film camera, you may have developed a pretty good sense of the angle of view or the degree of magnification you get with each lens. You use this sense to pick lenses and to pick the place where you want to stand to shoot each photo.

Unfortunately, digital cameras have image sensors that are usually smaller than 35mm film. In order to project an image on a smaller area, the lens focal length must be shortened by the same proportion. This means that you will have to get familiar with an entirely new set of focal lengths — maybe even a different set for each digital camera you use!

For example, the Canon PowerShot G6 has a zoom lens with a focal length ranging from 7.2mm to 28.8mm. Canon publishes the 35mm equivalent as being 35mm to 140mm. If you divide 35mm by 7.2mm, or 140mm by 29mm, you get a multiplier of 4.86. Why do you care? You will only care if you are used to thinking in terms of the equivalent 35mm focal lengths and you want to know what they are. You may have noticed in the descriptions of the first photo in each of the techniques in this book that the camera's focal length has been converted to the 35mm equivalent. Also, when you read the EXIF data found in the image files, the listed focal length is the actual focal length — not the 35mm equivalent. After

you have computed the multiplier for your camera, you can easily convert these actual focal lengths to the 35mm equivalent focal length if they are more meaningful to you.

Depending on your digital camera, you may have one or more ways to change focal length. Many inexpensive digital cameras have a fixed focal length lens. If you have one of these cameras and you want to be able to change focal length, you need to find out whether the vendor or any third-party lens manufacturer offers add-on lenses for your camera. If they don't, you will have to purchase a new camera to be able to change focal length.

Most compact digital cameras today come with a built-in zoom lens, which allows you to change the focal length between a minimum and maximum length. An increasing number of manufacturers also make supplemental lenses. *Supplemental lenses* are add-on lenses that you add to an existing fixed or zoom lens. The last way to change focal length is to use a digital zoom feature if your camera offers one. You learn more about digital zoom in Step 5 of this technique.

Okay, so much for definitions. The purpose of this technique is to get you familiar with the view you get with your digital camera and any accessory lenses you may have. This familiarity is essential if you want to know where to stand and what lens or accessory lens to use to get the shot you want. It is also important to learn about the implications of using different focal lengths.

If your digital camera is a fixed focal length camera (that is, it does not have a zoom feature), you can skip to the next technique because you will not be able to complete these steps. If you have accessory lenses such as a wide-angle, telephoto, or fisheye, then you should shoot with them also. In order to get good images that are easy to compare, you should use a tripod if you have one.

STEP 2: SHOOT WITH MINIMUM FOCAL LENGTH (WIDE-ANGLE VIEW)

Adjust your lens for the widest possible angle of view, and then take a photograph. The photo in Figure 8.3 shows a photo taken with a Canon PowerShot set to its minimum focal length, which provides a maximum wide-angle view.

STEP 3: SHOOT USING MID-RANGE FOCAL LENGTH

Now adjust your lens to shoot halfway between the minimum and maximum focal length and take another photo. The photo in Figure 8.4 shows another photo taken with a Canon PowerShot set halfway between the minimum and maximum focal lengths.

STEP 4: SHOOT WITH MAXIMUM FOCAL LENGTH (TELEPHOTO MODE)

Set your lens to its maximum focal length to zoom in as far as possible, and then take one more photo.

Figure 8.5 shows a photo with the Canon PowerShot set to its maximum focal length. While your camera is still set to its maximum focal length, remove it from the tripod and shoot while changing the shutter speed to 1/60 of a second or even less if it is possible under the existing light conditions. Later, when you can look at the images on your computer screen, carefully look to see how the slower shutter speeds

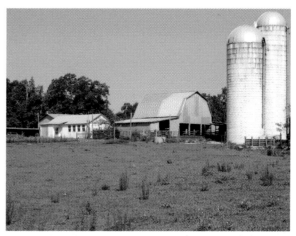

8.4

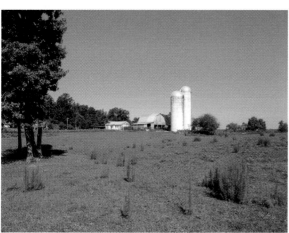

8.3

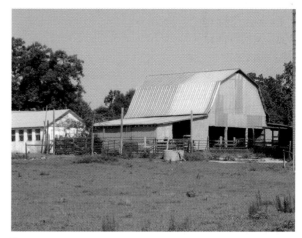

8.5

can negatively impact the image sharpness when shot with a long telephoto lens.

STEP 5: SHOOT USING DIGITAL ZOOM

Unlike optical zoom, which occurs as a result of the changing of the optics in your lens, digital zoom occurs digitally. Optical zoom maintains the image quality of the camera, whereas digital zoom uses a mathematical algorithm to magnify a portion of the image to increase image size. This process of mathematically interpolating picture information is the same as making up picture information where previously none existed. The results are that you get a magnified view — but one that is of a much poorer quality.

Figure 8.6 shows a photo that was taken with a Canon PowerShot using a digital zoom. Having the capability to capture an image with the extra magnification using digital zoom is wonderful — just be aware that the picture quality is considerably less good than if you used optical zoom.

TIP

Remember that you likely will get a blurred image if you hand-hold your camera when using a slow shutter speed. What is a slow shutter speed? It depends on how carefully you hold the camera and the focal length of the lens you are using. Doing some tests to determine when you *must* use a tripod and when you can get by without one is worthwhile.

NOTE

If you want a panoramic photo, you are not limited by the minimum focal length that your camera offers. Many digital cameras offer panorama modes so that you can take a series of overlapping photos that you can later digitally stitch together into one single photograph. If your camera does not have a panorama mode, you can still shoot overlapping photos and digitally stitch them together with software made for that purpose, such as Photoshop Elements. See Technique 36 to learn more about creating panoramic photos.

8.6

STEP 6: SHOOT WITH WIDE ANGLE AND CHANGE PERSPECTIVES

Once again set your camera to the maximum wide angle. Take a few pictures of distant scenes as well as up-close subjects, like the chessboard shown in Figure 8.7. Depending on the quality of your lens and on how wide an angle it is able to capture, you may find some image distortion. Notice how the chessboard seems to wrap under your feet. As long as you have straight lines where straight lines should be — you have a good lens.

TIP

Many lenses suffer from "barrel distortion" or the "pincushion" effect. Barrel distortion causes an image to bulge out of the middle, while pincushion distortion makes an image look like it has been squeezed in the middle. These effects are noticed most when a lens is used with a maximum wide angle. If you want to correct this distortion, consider using Photoshop CS2, which now includes a lens correction filter that can be used to fix a wide variety of lens shortcomings.

8.7

GETTING THE EXPOSURE YOU WANT

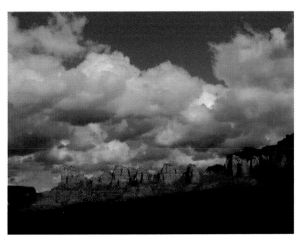

9.1

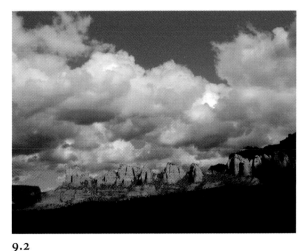

9.2

One of the two most frequent complaints about photos is that they are not exposed properly; the other is they are "out of focus." Photography has often been described as the art of capturing light, and so learning how to get a properly exposed photo is essential — as well as challenging, as was the scene shown in the photo in Figure 9.1! In this technique, you learn six steps you can take to help you get the "right" exposure — as shown in Figure 9.2 — as often as is possible. Before getting into these six steps, I first need to correct a few misconceptions and give you some suggestions for finding good light.

MISCONCEPTION 1: YOU CAN ALWAYS GET THE EXPOSURE YOU WANT

Many people who are just starting with photography, as well as those who have been taking photos for years, believe that they should be able to always

get a good photo. When they don't, they fault them-
selves or their cameras. However, they shouldn't. You
can always take a photo, but you won't always have
the right light to get the exposure you want.

Getting a well-exposed photo in some shooting
conditions is simply not possible. Three of the most
common problems are that the subject is bathed in
too much bright light, not enough light is around to
properly illuminate the subject, and too much differ-
ence exists between the brightest bright and the dark-
est dark. In each case, you have to accept the fact that
you won't get a good photo unless you can modify
the light. Sometimes you can modify light by using a
flash, bouncer, diffuser, filter, or even clouds (because
they can block the sun), and create the best possible
shooting conditions.

Figure 9.3 shows a photo of a black 1942 Packard.
Unfortunately, the day I was able to take a photo of it,
the sun was very bright. After taking a few shots, I
found that the shiny or bright parts of the car were
captured as "blown-out" highlights and I knew that
getting the quality of shot that I wanted was impossi-
ble with the bright white skies and the dark black
paint on the car. Just as I was packing up my gear, I
got lucky. A fairly dense cloud blocked the sun, creat-
ing a temporary, yet ideal shooting condition. I got
the photo I wanted!

The photo of the shiny chrome Packard hood orna-
ment shown in Figure 9.4 is an example of too much
bright light. When the exposure was set for the bright
ornament, it was still blown-out to almost pure
white, plus the car no longer looks black. Figure 9.5
shows a photo of the inside of a wonderful old
church. In this case, there is not enough light to light
the interior walls even with a camera mounted on a
tripod and when a higher ISO setting is used. The
ceiling is too high to use a camera-mounted flash. It
is simply a bad environment for getting a good
photo.

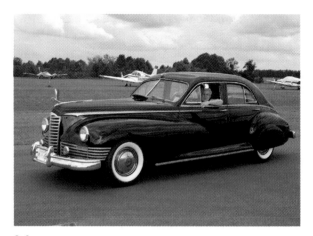

9.3

9.4

The photos in Figures 9.6 and 9.7 are good examples of a scene that requires more exposure latitude than can be captured with today's digital cameras (or film cameras either). As strange as it seems, getting a good shot of a fun hole at a nearby golf course was not easy to do in the after-sunset light. Figure 9.6 shows the results of exposing for the green grass on the fairway and the green, which results in a washed-out sky. The photo in Figure 9.7 was exposed for the sky, which resulted in an overly dark fairway and green.

If you have the flexibility to choose the time and place to shoot, ask yourself whether the lighting conditions make getting a well-exposed photo possible, or is there a better time or place to shoot? Many times, you will just have to shoot anyway. Whenever possible, pick a time when the light works with you, not against you.

9.6

9.5

9.7

> **TIP**
>
> When faced with extreme exposure latitude like that found in Figures 9.6 and 9.7, you can make a good exposure by combining the two photos with an image editor like Photoshop. Alternatively, you can use a graduated neutral density filter on your digital camera lens to achieve a similar effect.

MISCONCEPTION 2: CAMERA EXPOSURE METERS ALWAYS EXPOSE PROPERLY

One other common misconception is that sophisticated modern exposure meters in digital cameras always give you a properly exposed photo — nothing could be farther from the truth! This isn't true for a couple of reasons. First, some scenes are inherently difficult for anything but a human brain to get correct. The most difficult scenes for automatic exposure meters to expose correctly are the "white-on-bright" or "black-on-dark" scenes. Examples include a mostly white snowman in the middle of a pure white field of snow, or a black cat sitting on a pile of coal. Logically, if you think about it, the only way a digital camera could expose these images correctly is to be able to recognize the subjects as a snowman and a cat, and know that they were white and black, respectively.

The second major reason why an exposure meter will not get a correct exposure has to do with you! You, the camera user, may not be using the exposure meter features correctly. You learn more about how to use a variety of exposure meter features correctly later in this technique and in Techniques 11, 12, and 13.

MISCONCEPTION 3: CERTAIN TYPES OF LIGHT ARE ALWAYS BAD

Have you ever been told that midday light or "high-noon" light is horrible light and that you should avoid it? Or have you been told you can't shoot in low light levels? Or that shooting in haze or fog is awful? These examples are just a few of some of the rules that are too-often repeated that are not always correct. It is true that midday sun is usually bright, and because it is straight up overhead, few shadows are cast that you can use to emphasize detail in a subject or scene.

No question about it, shooting in deep haze or in thick fog can more often than not be more of a hindrance to getting a good photo than it can be of help. However, every time you believe that these rules apply all the time, you will miss many good opportunities to get great photos. Figure 9.8 shows a photo taken in the evening fog in the Great Dismal Swamp in North Carolina. Although this particular swamp offers many entirely different photographic opportunities year round, one of my favorite times is in early winter when extreme temperature changes cause lots of fog!

FINDING GOOD LIGHT

As you get better using your camera and developing your personal vision, you'll find ways to get good photos from not-so-good light conditions. Now let's look at a few guidelines for finding good light. The *golden hours* of photography are the hour around sunrise and the hour around sunset. The reason they are considered "golden" is because they can be filled with a rich warm glow of light that helps to make awesome photographs. This time is also good to shoot because the light comes in at a low level and it casts wonderful shadows — the opposite of what you find at high noon. If you want to take front-lit, side-lit, and silhouette shots, these are the best hours to get these kinds of shots, too.

9.8

Days with clear rich blue skies and a few puffy white clouds are also days where you should be photographing when you can. The blue sky is remarkably easier to shoot than that of the more common bright white sky. Depending on where you are shooting, you can have lots of blue days and few white days, or you can have the reverse. For example, the strong trade winds that always blow over the Hawaiian Islands make for lots of blue days. In contrast, there are times where I did not see a blue day at all for months at a time when I lived in England. Yet, the English sky was rarely too bright and it generally allowed for wonderful photographs.

Moderate to violent weather conditions can also create superior lighting conditions. Many landscape and nature photographers have taken their best photographs in such bad or changing weather. The sky opening up after a thunderstorm, or distant lightning in an otherwise dark cloud cover make good photos even if you have to stand in the rain and hold an umbrella to protect your camera gear. Just because the weather is bad, don't stay inside. Use caution, but take advantage of the wonderful light you can find during less-than-perfect weather.

Having dismissed these few misconceptions and having considered when and where to find the best lighting conditions, you're now ready to look at a six-step process to get good exposure with a digital camera.

STEP 1: DETERMINE HOW YOU WANT YOUR PHOTO TO LOOK

There is no such thing as the "perfect" exposure, only the "perfect" exposure to capture a specific vision of a photo. My vision for the photo shown in Figure 9.2 was to expose to make the shadow in front of the mountains as black as possible and to capture as much of the detail in the white puffy clouds as possible. Someone else standing next to me may have an entirely different vision. Maybe she would want to expose to show as much detail in the mountain as possible while having a much subtler color in the sky. Once again, you learn why it is so very important to first have a vision for what you want your photo to look like. Only then can you begin to choose various camera settings to get the exposure that is "perfect" (if it is possible) for that vision.

STEP 2: SELECT AN EXPOSURE MODE

Most of today's compact digital cameras offer a variety of exposure modes. Rather than offer just a manual mode, where the user must choose every setting manually or use whatever the last setting was, they offer different exposure modes where numerous settings are optimized for a particular kind of photo. Not only do these automatic exposure modes automatically choose the right combination of shutter speed and aperture settings, but they also choose one or more other settings, too. Examples of some of the settings that may be changed automatically are auto flash, red-eye removal, continuous focus mode, type of metering mode, possible ISO setting, and more.

The advantage of having a choice of exposure modes is that they give you varying degrees of control over your camera and how it takes photos. Or you could also say some of the exposure modes provide users with guidance (camera-chosen settings) when they are not sure what settings to use. In some exposure modes, you will find that the camera won't even let you take a picture if it thinks the exposure is not good, based upon the built-in "rules" for that exposure mode.

However, the downside of using many of the automatic modes is that they use camera-based "rules" to determine the settings without having any idea of what the subject or scene looks like. This is why you can usually choose better settings after you begin to understand what settings are available on your camera and how they work. Or you can choose one of the exposure modes that takes a first try at choosing the settings, but lets you make modifications to those settings. Following are the general descriptions of a few "generic" exposure modes. To learn about the exposure modes on your camera, you need to consult the documentation that came with your camera. More specifically, look for a table that shows what functions are available in each shooting mode, and look for descriptions of each shooting mode.

■ **Auto mode:** Two kinds of "auto" modes exist — one that allows you to make changes to the settings and one that doesn't. Choose one of the auto exposure modes when you just want to get a well-exposed photo easily and without much thought. Although I'm not a big fan of using an auto exposure mode, I know many other photographers who use them almost all the time and they get excellent photographs. If you were to use an auto exposure mode for most of your shots, too, you would be quite pleased with them. Could you get better photos if you used one of the other exposure mode settings, such as aperture or shutter speed priority mode? That question is one you'll have to find out for yourself by trying after you understand the many photography variables and how to control them with your camera settings.

WARNING

When you choose to use one of the automatic exposure modes, make sure you know what other settings besides shutter speed and aperture settings it will choose for you. For example, you may not want to use a flash, but the camera flashes when you use a portrait mode. Or, you choose an auto exposure mode and because there is not sufficient light to get a good exposure, the camera automatically changes from ISO 50 to ISO 400, which will give your photo considerably more digital noise. Consult the documentation that came with your camera to learn more about each exposure mode to avoid being surprised when you shoot.

■ **Aperture mode:** Aperture mode allows you to select the aperture setting, and then the camera automatically chooses the best shutter speed to give a good exposure. If you're concerned about precisely controlling depth-of-field, this setting is good to use.

■ **Shutter priority mode:** Shutter priority mode allows you to select the shutter speed setting, and then the camera automatically chooses the best aperture setting to give a good exposure. This exposure mode is good to use when you're shooting moving objects or when you want to control image blur. For example, if you're shooting a moving subject where the movement can be stopped by using a shutter speed of 1/500 of a second, just set the shutter speed to 1/200 and let the camera choose the aperture setting. Or maybe you want to pan the camera with a moving subject to blur the background while getting a sharp subject. In this case, you may want to choose a shutter speed of 1/30 or 1/60, and then let the camera choose the aperture setting.

■ **Other "creative" modes:** Other "creative" modes include exposure modes like portrait, sports, or landscape modes. When you choose one of these settings, you allow the camera to have the first choice of settings; then, if you don't like these settings, some of these modes allow you to manually make changes. If you're taking a portrait, using a portrait mode will get you started with "pretty good" settings for taking one kind of portrait. If you want to shoot creatively, you may want to try using aperture exposure mode.

When you make the move away from one of the creative modes like the sports mode to a mode such as shutter speed exposure mode, you do lose the benefit of the camera making essential settings for you. For example, if you last shot in "one-shot" focus mode and you decide to shoot a sports event with the shutter speed exposure mode, you'll have to remember to manually change to the "continuous focus" mode if your camera offers one.

■ **Manual mode:** When you want full control of all camera settings, use the manual exposure mode. Although you may not think this mode is one you will use much, you find out in later techniques that using the manual exposure mode and the histogram offer you extensive control over your camera, and in some cases, it is the only mode to use.

STEP 3: SELECT A METERING MODE

Many digital cameras have more than one metering mode. Changing between metering modes allows you to more specifically control where the camera reads the light in your scene. All digital cameras usually have one relatively sophisticated "matrix" or "evaluative" metering mode, which generally does an excellent job at reading and averaging light from all parts of the scene. I know many good photographers who almost always use the evaluative metering mode.

When evaluative metering doesn't work as you want it to, or when you want to have more control over where a reading of light is taken, then consider using one of the other metering modes if your camera has them. Another common mode is "center-weighted" metering. This mode does just what it says it does — it reads the light from all over the scene, but it places more importance on the light found at the center of the scene. This feature is useful when you have a subject at the middle of the image that you want to make sure you expose correctly, and the surrounding areas or background has a highly different light level.

Another useful kind of metering mode is the "spot metering" mode. Using a spot metering mode, you

can read the light found on only a very small part of your scene; usually it is at the center of the scene, or some cameras allow you to set the spot metering around a selectable autofocus point.

Although these are good recommendations for different types of "generic" metering modes, you should carefully read the descriptions of any metering modes that your camera has. Learning how to use these modes well greatly help you to more quickly and more accurately get the exposure you want.

If you choose to use spot metering, you may also want to learn how to use exposure lock, which is covered in detail in Technique 13. Technique 12 shows you how to use exposure compensation, and it covers exposure bracketing. Both of these techniques are essential techniques if you want to have full control of your camera's ability to control exposure.

STEP 4: SHOOT THE PHOTO AND ANALYZE THE RESULTS

After you've set what you think are the right camera settings, take a photo. After looking at either a quick review image, or by looking longer at a more detailed view of the image in a review mode, you can learn how the photo turned out relative to what you wanted. One of the most useful features to help you get a good exposure is a histogram like the one shown on the LCD monitor of a Canon PowerShot shown in Figure 9.9. Of all the features on my digital cameras, I find the histogram to be one of the most valuable. I look at it just about every time I take a photo. To learn more about the histogram and how it can help you to get a good exposure, read Technique 11.

Some digital cameras also have a detailed display mode where the overexposed parts of an image flash, showing you where the overexposure is occurring. This information can be very valuable when you have to decide how to further adjust your exposure. Check to see whether you camera offers this feature.

> **TIP**
>
> When you take the time to change to a review or playback mode, consider deleting the photos that you don't want as you review the photos you've taken. Doing so frees up space on your digital photo storage media for more photos and saves you time later when you download the photos to your computer and have to review all of them.

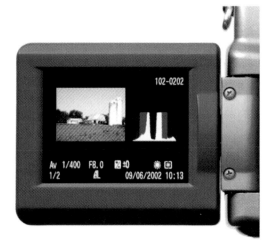

9.9

STEP 5: ADJUST EXPOSURE

The significant advantage of using a digital camera is that you can shoot, review the photo and the EXIF data, and then make changes to the camera settings to get the exposure you want. After you learn what additional exposure changes are needed, you can make them. Many digital cameras offer additional advanced features that help you to make these changes. Two of the most useful are exposure compensation and spot metering using exposure lock. Technique 12 covers exposure compensation in detail and Technique 13 shows you how to use spot metering and exposure lock. Both of these advanced techniques are well worth learning.

WARNING

When determining exposure, choose settings that prevent highlights from being overexposed. Any portion of an image that becomes pure white contains no detail. A much better approach is to expose to show detail in the highlights and use an image editor to bring some detail out of the underexposed parts of the image. Obviously, this approach would not be correct if you were trying to create a "high key" photo where the intent is to "blow out" most of the detail in an image and show only subtle shadows.

STEP 6: SHOOT AGAIN

If, after reviewing your prior shot, you find that you need to make some adjustment to the camera's settings, then do so, and shoot again. You may need to repeat these steps a couple of times until you have the shot you want. Don't be conservative in how many photos you take, because it costs nothing to shoot. Shoot again and again!

TIP

When you're shooting a subject or scene that changes too rapidly for you to do the shoot-review-adjust-and-shoot-again routine, consider shooting in an auto exposure bracketing mode. In this mode, the camera automatically changes the exposure within a user-chosen set range to take three exposures after you press the shutter button. Find out more about this feature in Technique 12.

TAKING SHARPER PHOTOS

10.1

10.2

ABOUT THE IMAGE

"Award-winning Chicken" Nikon Coolpix, hand-held, zoom set to 78mm (35mm equivalent), f/3.4@1/30, ISO 80.

In Technique 9, you learned how to avoid (as much as possible) taking badly exposed photos. In this technique, you learn how to avoid the second most common photo problem — a photo that is not "in focus" or seems to be blurred. Or, more importantly yet, you learn what variables you can control to create blurs such as for a softly focused photo, or a blurred subject or background.

The photo in Figure 10.2 is an excellent example of how you can be shooting in all the worst possible conditions for getting a well-exposed, yet sharply focused photo. The chicken was shot inside a dimly lit barn. The objective was to use as large an aperture opening as was possible to blur out the ugly roof behind the chicken while still keeping all the chicken's face perfectly focused. Using a low ISO setting of 80 was also critical to avoid adding digital noise to the image.

Because of the low light level and the necessity of using an aperture setting of f/3.4, a shutter speed of 1/30 of a second was required, which is slow for a quick-moving subject. One further complication was the chicken's

erratic and sudden movements, which made using a tripod impossible, because the award-winning pet never ceased moving. If you have watched the movement of a chicken as it does the chicken walk and while clucking, you know what I mean.

After a few practice shots and a quick check on the exposure on the LCD monitor, the photo shown in Figure 10.1 was taken with a flash; it is as focused as you can get!

In sharp contrast to the chicken photo is the photo of the Chincoteague pony shown in Figure 10.3. For this photo, the digital camera's shutter speed was set to 1/47 of a second and the aperture was set to f/6.4. The speed and movement of the horse are revealed through the well-planned blur that was achieved by panning the camera with the horse. The point here is it was a design decision to have a blurred — not sharply focused — photo.

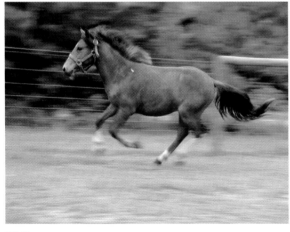

10.3

FACTORS DETERMINING IMAGE SHARPNESS

Many factors determine how sharply focused or blurred a photo will be. Understanding each of these factors is important if you want to control the level of image sharpness. This technique briefly looks at seven factors you need to be aware of:

- **Shutter speed setting:** Shutter speed is the amount of time that the shutter is open; a faster shutter speed (for example, 1/500 or 1/400 instead of 1/60 or 1/30) reduces the chance of getting a blurred photo. As the shutter speed gets slower (that is, the shutter stays open longer), the better the chance for blur to occur, because the image sensor will have more of a chance to record some or all of the subject or scene in more than one place on the image — thereby causing blur.

- **Aperture setting:** As mentioned previously, you can use a fast shutter speed to minimize blur. However, there is a trade-off because shutter speed and aperture setting are inversely related. An increased shutter speed means that a larger aperture size is required to get the same exposure. A larger aperture size means a shallower depth-of-field and more chance for part of the image to be out of focus. Understanding this trade-off is essential if you want to choose the optimal settings to get a photo that meets your objectives.

- **Stillness of camera when shooting:** Another major factor determining the sharpness of an image is how still the camera is while the shutter is open. A hand-held camera set to a slow shutter speed is more likely to produce blurred images than one that is securely mounted on a tripod or other form of camera support.

■ **Subject movement and distance from camera:** The speed of any moving subject and the direction it is moving are what ultimately determine what camera settings you must use to either freeze the movement or to allow a controlled amount of blur. The farther away a moving subject is from the camera, the less distance it moves on the image sensor, which means it will be less likely to record as being blurred than it would if it were closer to the camera.

■ **Focal length:** The longer the focal length, the closer a subject appears to be to the camera, which therefore records more movement in terms of distance on the image sensor than if a shorter focal length were used. This is why using a tripod is important when using a long focal length lens.

■ **Use of flash:** Although the most common use of flash is to add light to a subject or scene, you can also use it to "freeze" or slow the movement of a subject. Because of the short duration of the flash light, it can freeze motion caused by both camera shake and subject movement to create sharp images if it is the main source of light.

■ **ISO setting:** As ISO setting determines how sensitive an image sensor is to light; changing from a lower ISO setting to a higher ISO setting enables you to use a faster shutter speed, which helps minimize image blur. The downside is that a higher ISO speed setting increases the amount of digital noise shown in the photo.

With that background, now look at eight steps you can take to get the optimal setting you need to get the photo you want. Notice that I didn't say to get a sharply focused photo — as it is just one aspect of being able to control image sharpness or blur. Although eight steps may seem like too much to go through each time you take a photo, you'll find that you can skip most of them unless you are working on getting a particularly difficult shot.

TIP

Whenever you shoot with the objective of getting maximum depth-of-field and maximum image sharpness throughout the photo, use a tripod. Many photographers who value deep depth-of-field and image sharpness rarely ever shoot without using a tripod.

TIP

The ISO setting determines how fast the image sensor in a digital camera records light. An ISO setting of 50 or 100 records light less quickly than a higher ISO setting of 200 or 400. Unfortunately, the higher the ISO setting, the more digital noise you will have in your image. If you're unable to shoot with a fast enough shutter speed to meet the objectives of your photo, then using the lowest ISO setting your camera offers is always best — that is, unless you want digital noise to be part of your photo.

STEP 1: DETERMINE OBJECTIVES

By now you're probably getting used to the fact that the first step in many of these techniques is to determine objectives. Until you decide how you want your photo to look, deciding how to choose the most appropriate settings is hard. Earlier in this technique the point was made that all blur is not bad. In fact, you can often control it in such a way that it can make an okay photo into an exceptional photo. So the first step is to decide how sharp or blurred you want your photo to be.

STEP 2: CHOOSE EXPOSURE MODE

After you have determined the objectives for the photo you're about to shoot, choose an appropriate exposure mode. If your objective is to get a sharply focused image, choose an exposure mode that allows you to select a fast shutter speed, or you can choose an exposure mode that allows you to choose a maximum aperture setting (for example, f/8.0) to maximize depth-of-field.

Besides using aperture mode or shutter speed mode, you may also want to consider shooting using sport or landscape mode if your camera has one of these modes and if it is suitable for your shot.

STEP 3: CHOOSE APERTURE OR SHUTTER SPEED SETTING

If you choose an automatic aperture mode in Step 2, make sure that you set the aperture priority setting to give you the results you want. Likewise, if you choose shutter speed priority mode, make sure to set the shutter speed to give you the results you want. Otherwise, the settings will simply be set to the last setting that was used!

If you choose to use one of the creative exposure modes such as landscape, sports, or portrait mode, you may find that the lighting conditions will not allow you to shoot with the camera's default settings.

If this occurs, you may have to change exposure modes to a mode that allows you to change shutter speed or aperture to get the picture that you want.

STEP 4: CHOOSE AUTOFOCUS SETTING MODE AND FOCAL POINTS

Depending on what features your camera has, you may have several that will help you to more easily and more reliably focus on a specific subject or scene. Some digital cameras allow you to select the area in the viewfinder or LCD monitor that is used to set the focus. Also, some cameras allow you to choose between a "single shot" or "auto-focusing sequential shooting" mode. After reading this step, check the manuals that came with your camera to see which of these features your cameras has, how they work, and when to use them.

FOCUS FRAME SELECTION

Many digital cameras allow you to choose an autofocus frame, which is an area of the composition where the camera focuses. The default focus frame is in the center of the LCD monitor or viewfinder. This center focus frame works just fine when you want to focus on a subject that is the center of the composition. However, if you want to focus on a subject to the left or right, or anywhere else, another approach is required.

Check to see whether you can change focus frames with your digital camera. Usually, on those cameras that allow the focus frame to be changed, you get a choice of three focus frames: left, center, and right.

USING FOCUS LOCK

Many digital cameras have a focus lock button for locking the focus. This valuable feature is one that you ought to know how to use. I cover it in detail in Technique 14.

SHOT MODE

Some digital cameras allow you to choose between a "one-shot shooting" mode and a "continuous focus" mode. In one-shot mode, your camera hunts to get focused once — then it locks the focus even if the subject is moving. When you use a continuous focus mode, the camera continues to focus until you press the shutter button.

The one-shot shooting mode is the best choice for subjects that don't move. Using it with moving subjects is a good way to guarantee getting an out-of-focus picture. Some digital cameras will not even allow a photo to be taken when it is not focused. Use the auto-focus sequential shooting mode when you take photos of moving objects.

USING MACRO FOCUS

When you take macro (or close-up) photos while using auto-focus, your digital camera may have a hard time getting focused — this situation is known as hunting. The camera zooms in and out until it can focus on the subject. Due to the nature of macro photography, this hunting can take time because the lens focuses from one extreme to the other. If you have a macro focus mode, these extremes are limited so that the hunt for focus takes much less time. You discover more about taking macro photos later in Technique 30.

USING MANUAL FOCUS

Relying on autofocus is generally okay. However, times come up where you will want to override your camera's autofocus capabilities. Choosing a manual focus mode allows you to focus manually. If you have a digital camera that allows you to choose a manual focus mode, then after you do so, use a ruler and set the camera the correct distance away from the subject. With this method you can get a perfectly focused photo by making sure that the subject is exactly the correct distance from the lens.

Most LCD monitors and viewfinders found on compact-level digital cameras are not large enough for you to get an accurate view of the subject that you want to focus on. Therefore, manual focus is mostly used for more creative things, like making soft, blurred backgrounds or out-of-focus images.

> **TIP**
>
> You may have a situation where your camera only has a center focus frame or your currently selected focus frame is the center. If you want to focus on any other area of the composition, then use a focus lock feature if your camera has one. Just point your digital camera so that the area that you want to be focused is in the center of the LCD monitor or viewfinder and press the focus lock button. Recompose your image and shoot.

> **WARNING**
>
> Don't always expect autofocus to get a precisely focused photo. Autofocus may not work well in the following situations:
>
> ■ When a subject is moving quickly
>
> ■ When a close object and a far away object appear side by side in an image
>
> ■ In low light level environments
>
> ■ Where little contrast exists in the focus area
>
> In these situations, you may want to shoot a couple of photos when possible, or even try manually focusing the camera if you have enough time.

STEP 5: USE CAMERA SUPPORT WHEN NEEDED

After you determine the shutter speed setting, you can decide whether you'll need a tripod or other camera support. When shooting with a 35mm film camera, a useful rule to follow is not to hand-hold your camera when the shutter speed is less than 1/60 of a second. However, the mathematics behind the optics in the new compact digital cameras makes this rule less useful. The wise thing to do is to experiment with your camera and learn when you ought not to shoot without using a tripod. Or you can do as I do — shoot using a tripod whenever possible. Your pictures will often be better if you do.

STEP 6: USE A SELF-TIMER OR A SHUTTER RELEASE

When shooting macro photos, or when shooting with long focal lengths, or when using slow shutter speeds, you may find that you cause camera shake when you press the shutter release even if it is mounted on a tripod. In such cases, use a cable release if you have one. If you don't have a cable release, set the camera's self-timer to two or more seconds so that you don't have to press the shutter button to take a photo.

> **TIP**
>
> On occasion, you may find your camera hunting to get focused on a subject that is dimly lit or has too little contrast. In such cases, point your camera at another part of the scene that is the same distance from the camera and use auto-focus lock if your camera has one. See Technique 14 to learn more about autofocus lock.

STEP 7: USE FLASH

You can often use a short bright flash of light from a flash to stop image blur from camera shake or from subject movement. If you can't use the settings you want to get an image without blur, consider using a flash. See Technique 15 to learn more about using flash.

STEP 8: CHANGE ISO SETTING

If light conditions prevent you from using camera settings that allow you to shoot blur-free photos, think about changing the ISO setting. A higher ISO setting allows the image sensor to record light more quickly, thereby enabling you to choose a faster shutter speed.

You've now reached the end of this technique and the end of this chapter. In Chapter 3, you learn how to use some of the more valuable advanced features that are found on most digital cameras.

> **TIP**
>
> Using a self-timer is a good way to avoid causing camera shake when you press the shutter button. However, in some situations the timed delay you get using a self-timer may make it hard to capture the shots when you need to capture them. In those cases, consider purchasing a cable release if you don't have one, providing that one can be used with your camera.

> **TIP**
>
> Although changing to a higher ISO setting such as 200 or 400 ISO allows you to shoot with a faster shutter speed and in a lower light level, the higher ISO setting also increases the amount of digital noise that will show in your image. Unless you choose to have digital noise, the best ISO setting is usually the lowest setting you can use.

CHAPTER 3

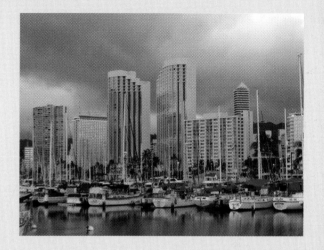

USING ADVANCED FEATURES

The title of this chapter is "Using Advanced Features," but don't let the term *advanced* scare you away from learning about these useful and often essential features. Technique 11 shows you how to read a histogram to determine how close you were to getting the exposure you want. Techniques 12 and 13 cover exposure compensation, exposure lock, metering modes, and focal point selection — important features that you can use to gain more control over exposure. In Technique 14, you learn how to focus on an off-center part of the composition and to use focus lock. In Technique 15, you learn when and when not to use a built-in flash and how to get the best results if you choose to use one.

USING THE HISTOGRAM

11.1

11.2

ABOUT THE IMAGE

"Gargoyle Reading a Book"
Canon PowerShot, mounted on a tripod, zoom set to 92mm (35mm equivalent), f/2.5@1/50, ISO 100.

One of life's many mysteries is why so few people who use digital cameras with a histogram feature don't use the histogram. A histogram is a simple two-axis graph that allows you to judge the brightness range of an image. A quick view of the histogram can tell you how well you have exposed the photo, and if and by how much your exposure may be off relative to what you want. It is a feature that I use just about every time I take a photo — it is one of the benefits of shooting digitally. In this technique, you learn how to get the most out of the histogram so you can decide whether or not you want to take advantage of it.

GETTING TO KNOW THE HISTOGRAM

Figure 11.2 shows the histogram (the graph inside the white square) on the LCD monitor of a Canon PowerShot G2. That particular histogram is for the photo shown in Figure 11.1. The horizontal axis represents the brightness level, ranging from pure black (dark) on the left to pure white (a bright highlight) on the right. The vertical axis represents the number of pixels that exist for each brightness level.

Looking at the histogram in Figure 11.2 you can learn a lot about this photo, which was taken using automatic metering. Because so few points are to the extreme right or extreme left of the graph, you know that no pure whites or pure blacks are in the photo. You can also see that most of the points are in the middle of the graph for an evenly balanced exposure.

Now take a look at what happens when the photo is overexposed by one full stop using exposure compensation (you learn about this feature in the next technique). Figure 11.3 shows the photo, and Figure 11.4 shows the resulting histogram. With a one-stop overexposure, you can see how the brightness level of the entire scene has shifted toward the right. The most important point to note about this graph is that a considerable number of pixels are "near white" or pure white. This means that little detail, or no detail, is in that part of the image. This is one of the reasons why underexposing a digital image is better than overexposing it. Generally, you can bring some detail back into an underexposed image with an image editor like Photoshop, but bringing out detail that isn't in the image file isn't possible.

Now let's look at a third exposure of this photo, only this time it has been taken with a –2 stop exposure. Figure 11.5 shows the photo, and Figure 11.6 shows the resulting histogram. The pixels have been shifted to the left and most of the pixels now show up in the darker range, as you would expect, because the photo is now darker, with some pure black. From these three histograms, you should now have a good idea of how you can use the histogram to determine the overall correctness of exposures.

11.3

11.4

11.5

BLINKING HIGHLIGHTS

Usually, digital cameras that have a histogram feature also have a "highlight alert" feature. This is another exceedingly useful feature. When you look at a review image, "blown-out" highlights blink in the image. A "blown-out" highlight occurs when the brightness level is at a maximum, meaning that it is pure white. If you were able to look at the LCD monitor shown in Figure 11.4, you would notice that a fairly large part of the left side of the image (the lightest areas) would blink on and off, indicating "blown-out" highlights.

Ideally, the only time something in your picture should be a pure white with no tone is when it is a specular highlight. A good example of a specular highlight would be the sunlight glinting off a car bumper, or the flash of a diamond ring. All other whites should have some degree of tone to them. If you check for blinking highlights on a regular basis, you will greatly improve the printability of your difficult shots. Simply reducing exposure slightly can do wonders to return texture to white surfaces and details to the clouds in your pictures.

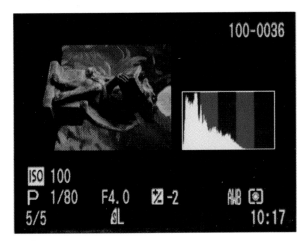

11.6

STEP 1: CHOOSE REVIEW AND PREVIEW SETTINGS

Some of the newer digital cameras allow you to see a histogram before a picture has been taken. This histogram is based upon the current camera settings, and an image based upon the current composition shown on the LCD monitor. This means you can make adjustments to the settings to get the photo you want the first time! Most other digital cameras offer a quick review of the image, but you must change to a preview mode to view the histogram — all after you've already taken a photo.

STEP 2: DETERMINE HOW YOU WANT THE PICTURE TO LOOK

Always decide how you want the picture to look. If you don't know what your photo should look like, you'll have a hard time using a histogram to decide whether you have the right exposure!

> **TIP**
>
> Read the documentation that came with your camera to learn what review and preview settings are available and what you need to do to view the histogram. A histogram is a valuable tool to use in evaluating exposures out in the field.

STEP 3: COMPOSE PICTURE AND PRESS THE SHUTTER BUTTON

Compose the picture and press the shutter button to take a photo. If you have to switch out of shooting mode into a review mode to view a histogram, you may want to change your settings and shoot a couple more photos before changing to the review mode.

STEP 4: REVIEW THE HISTOGRAM, CHANGE SETTINGS, AND SHOOT AGAIN

Switch to the review mode to look at the histogram. Based upon what you want the picture to look like and what the histogram looks like, you can make any necessary changes to the camera settings and shoot again.

You may want to consider using the exposure compensation feature, which is covered in Technique 12, to alter the exposure and the resulting histogram.

> **TIP**
>
> When you review the images with a histogram, it may be a good time to delete those "not quite right" photos to make room on your digital photo storage media space for more photos.

USING EXPOSURE COMPENSATION

12.1 *Original image*

12.2 *Edited image*

"Waikiki Yacht Harbor" Olympus digital camera, hand-held, zoom set to 75mm (35mm equivalent), f/7.1 @ 1/80, ISO 200.

Automatic exposure meters in even today's least expensive compact digital cameras are impressive — they are able to get the correct exposure in more shooting environments than most of the expensive professional film cameras of just a few years back. However, all automatic exposure metering systems can make mistakes and take the wrong exposure at times. In this technique, you learn how to use the exposure compensation feature to either correct a bad exposure, or to get the more "creative" exposure that you want.

The photo shown in Figure 12.1 was taken with an automatic exposure setting — no exposure compensation was used. Figure 12.2 is the same photo after some minor adjustments were made to it using Photoshop.

DECIDING WHEN TO USE EXPOSURE COMPENSATION

The exposure compensation feature is useful when your chosen automatic metering does not get the exposure you want. Exposure compensation actually "compensates" the automatic metering based upon your judgment to get it to more accurately give you the desired exposure. Additionally, you can use exposure compensation to get a creative exposure to suit your artistic view. When you look at Figures 12.3 through 12.9 you can see how much difference a small change in exposure (even 1/3 of a stop) can make to a photo. An exposure compensation feature allows you to enjoy the benefits of the subtle, but important, differences in exposure.

STEP 1: DETERMINE HOW YOU WANT THE PICTURE TO LOOK

The purpose of an automatic exposure meter is to give you a "normal" exposure. Ask yourself the question, what is a "normal" exposure and is it what you want your photo to look like? If it isn't, then you need to modify the exposure.

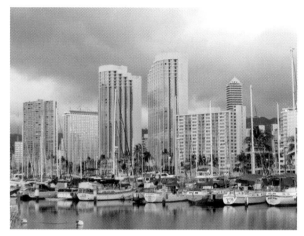

12.4

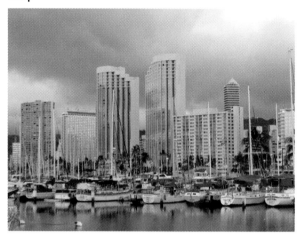

12.5

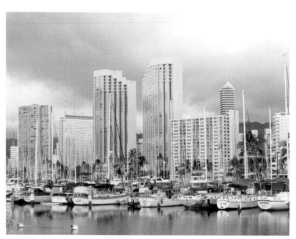

12.3

12.6

12.7

12.8

12.9

STEP 2: SET APPROPRIATE CAMERA SETTINGS

When you make exposure changes with the exposure compensation feature, the camera must either make a change to the aperture setting or to the shutter speed setting to match your request. If you know what you want the picture to look like (you thought about that in Step 1, right?), then you will likely know whether keeping the aperture setting fixed and varying the shutter speed is more important, or vice versa. If you are most concerned about maintaining a specific depth of field, then set the shooting mode to aperture mode. If you're more concerned about stopping movement, then choose the shutter speed mode.

After you've determined which mode to use, either shutter speed or aperture mode, make sure to set the correct setting. For example, if you want to minimize camera shake as you are hand-holding the camera, choose the shutter speed mode and set shutter speed to 1/125 of a second or faster, assuming you're using a focal length of less than 100mm (35mm equivalent). Then, when you change the exposure compensation setting, the camera will automatically change the aperture setting instead of the shutter speed.

STEP 3: COMPOSE AND TAKE A PHOTO

Compose the photo and press the shutter button to take a photo. After taking the photo, you may want to review the histogram feature if your camera has one. The histogram is an excellent tool to use to help you understand how you have exposed a photo. To learn more about the histogram, see Technique 11.

STEP 4: CHANGE EXPOSURE COMPENSATION WITH THE EXPOSURE COMPENSATION FEATURE

Turn on the exposure compensation feature and make a change to the settings. Figure 12.10 shows the LCD monitor of a Canon PowerShot when the

exposure compensation feature is on. Using a rocker button, you can move the slider to the left and right to increase or decrease exposure by plus or minus two stops in 1/3-stop increments.

After making a change to the exposure compensation, go back to Step 3 and shoot again until you have taken all the shots that you want.

USING AUTO EXPOSURE BRACKETING

If you like using the exposure compensation feature but you would prefer a more automated approach, or you need to be able to make the exposure adjustments more quickly due to shooting conditions, consider using auto exposure bracketing. Cameras that offer auto exposure bracketing usually allow you to select the amount of bracketing in 1/3-stop increments up to plus or minus two stops. Some even allow you to choose where the bracketing occurs. For example, you may want a slightly underexposed image and, consequently, you may choose to bracket around a –2/3 stop. After you set the bracketing amount, you simply press and hold the shutter button until three pictures are taken. Figure 12.11 shows the LCD monitor screen on the Canon PowerShot with a plus and minus 2/3 exposure bracketing setting.

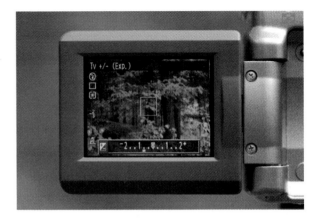

12.10

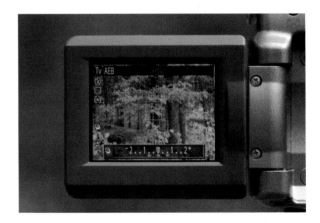

12.11

USING EXPOSURE LOCK, METERING NODES, AND FOCAL POINTS

13.1

13.2

There will be times when your digital camera's automatic exposure will not get the exposure that you want. In Technique 12, you learned how you can "adjust" the automatic exposure determined by your camera by using the exposure compensation feature. However, this feature takes time that you may not always have, and there is a faster, more intuitive way to adjust exposure. In this technique, you learn how to use exposure lock to quickly adjust exposure compensation. You also learn how to use center-weighted and spot metering to more precisely meter your scene or subject.

The example photo used in this technique is a real-world problem that all photographers sooner or later face. A retired friend of mine who enjoys spending his time golfing and doing digital photography likes to take photographs of various holes on golf courses where he has had a birdie (a score of one under par) or an eagle (a score of two under par). More often than not, when shooting holes on a golf course, he gets poorly exposed photos, as you can see in Figure 13.1. The source of the problem is how the automatic exposure feature reads the light in the scene and chooses the exposure. It's easy for a bright sky to fool a camera meter into thinking the subject is lighter than it is, and subsequently underexpose the shot. Using this technique, he was able get the much better photo shown in Figure 13.2.

Before you get to the technique, let's first agree on the definition of a few terms. Although the terms used here are clearly defined, the documentation that came with your camera may use other terms or offer other features. However, if you understand conceptually what these terms mean, you will understand how to use the features regardless of what they are named.

METERING MODES

Almost all digital cameras have a *zone* or evaluative metering mode that is appropriate for standard shooting conditions. Although the logic of such metering modes is complex, the important thing to know is that metering modes generally work quite well and that they determine exposure by analyzing all parts of an image.

In contrast, a "center-weighted" metering mode places a greater emphasis on the center of the composition. For those times when you want even more precise metering, choose "spot metering" if it is available on your camera. Spot metering modes measure exposure from an area as small as a one- or two-degree view of the scene. Not all digital cameras offer these three metering modes, and some offer even more. Check the documentation that came with your camera to determine what modes your camera offers.

NOTE

Most manufacturers base their normal or "evaluative or programmed" exposure on thousands of properly exposed meter settings that have been analyzed by computers. These settings give you a "best guess" exposure as opposed to a user-selectable setting.

FOCUS POINT

You need to understand that most autofocus modes center around a specific focus point. The default focus point is the center of the image. However, some, but not all, compact digital cameras allow you to change the focus point between one or two or even more different points. Having more than a single center focus point allows you to select an off-center focus point to match your composition and your choice of where the camera should focus.

One additional feature on many cameras with selectable focus points is that you can also choose to have the exposure metering "area" centered around the selected focus point or have it remain centered around the center focal point. This feature is valuable because you can focus on and meter off the same off-centered focus point. See Technique 14 for more about off-center focusing.

If you think for a moment about having selectable focus points and multiple types of metering modes, you can have quite a few combinations to meet a variety of compositional needs. Each of these different combinations can give different exposure settings. The next six steps show you how to get the desired exposure for hole #15 — the first time, using the default metering mode and focus point. At the end of the six steps is a discussion of a few other combinations and when you may want to use them.

EXPOSURE LOCK

The exposure lock feature allows you to point your camera where you choose and lock to that exposure setting. You can then recompose and shoot using the exposure that was previously set. You can implement and use exposure lock in a variety of ways. Some digital cameras allow you to lock the exposure by pressing the shutter button halfway down — this often locks many settings such as exposure, focus, and even

white balance. Other digital cameras have a button specifically for exposure lock or they may even require that you access a menu to lock the exposure. Check the documentation that came with your camera to learn how to use exposure lock before doing this technique.

STEP 1: DETERMINE HOW YOU WANT THE PICTURE TO LOOK

As always, the first step to getting a good picture is to decide how you want it to look — you've heard that before haven't you? Otherwise, you can't choose optimal camera settings.

For example, should the photo of hole #15 show a deep blue sky with wispy white clouds, a dark fairway, and dark sand trap? Or should the photo show more detail in the fairway and sand trap at the expense of getting a washed-out sky? Sadly, this is a common trade-off, and you must make a decision or live by the defaults! As the blue sky with the wispy white clouds makes a much better photo, you want to expose to capture the details in the sky and clouds while not making the fairway too dark.

The photo shown in Figure 13.3 shows how making a minor adjustment using Photoshop's Curves tool made much of the fairway and tree detail less visible.

STEP 2: CHOOSE CAMERA SETTINGS

After you've decided on how you want the picture to look, choose an appropriate metering mode and choose a focus point. To take a good photo of hole #15, use the default metering mode (evaluative) and the default focus point (the center one). Because you want to maximize depth of field, choose aperture priority as the shooting mode. Enough light is in this scene if you use a low ISO setting of 100 to avoid digital noise.

STEP 3: COMPOSE THE PHOTO AND EVALUATE THE IMAGE ON THE LCD MONITOR

After your camera settings are correct, compose the photo and evaluate the image on the LCD monitor. In the case of shooting hole #15, you can easily see that the photo will not have any detail in the sky because it is getting washed out due to the averaging logic of the "full image" evaluative metering mode.

TIP

If you plan on using an image editor such as Photoshop to edit your images, you are better off compensating to avoid overexposure. Overexposure pushes near-white parts of the scene into pure white, which means there is no detail whatsoever. If you expose to show detail in the highlights, you can usually edit to recover some details in the shadows. This is because those areas that appear to be almost pure black do, in fact, have detail that you can't see.

13.3

STEP 4: REPOSITION THE CAMERA UNTIL THE EXPOSURE LOOKS CORRECT

To get a better exposure to show the detail in the sky, recompose your camera and point it directly at part of the subject you care most about — in this example, the white clouds. Often you can move the camera just enough to eliminate the source of light or shadow that is fooling the system, and capture exactly the exposure information that will allow your shot to have the detail you desire. As you move your camera, watch the camera settings in the LCD monitor to make sure you are shooting with enough shutter speed to avoid image blur, and that the exposure does not require a shutter speed that is outside the limits of your camera.

STEP 5: LOCK EXPOSURE

After having found a part of the scene that appears to give the exposure you want, and before recomposing, lock the exposure setting using your camera's exposure lock feature.

> **WARNING**
>
> If you access exposure lock on your camera by pressing the shutter button halfway, make sure you understand any other settings the button may also lock. You may find that when you press the shutter button halfway that you are at the same time locking other settings, such as focus or even white balance. On the more feature-rich cameras, this is the case; however, you will also find specific buttons for exposure lock and focus lock so that you control them separately when you want. Releasing the button resets the exposure to normal.

STEP 6: RECOMPOSE THE PICTURE AND PRESS THE SHUTTER BUTTON

Now recompose and take the picture. Your camera will use the stored exposure information that it captured earlier to make this exposure, ignoring the bright sky or other elements that would have fooled it. After you get used to this process, it will only take a few seconds to do it and it will become second nature to you. Soon you will find it easy to handle difficult exposure situations by pointing your camera to get the exposure you want and then recomposing and shooting. After you've taken a photo, don't forget to take a quick look at the histogram.

USING CENTER-WEIGHTED OR SPOT METERING AND EXPOSURE LOCK

In the prior six steps, you learned how to use the evaluative metering mode and the center focus point to find a good exposure. Sometimes, though, you may find that the evaluative metering mode meters too large an area (the entire composition). If you want a more accurate meter reading, narrow the area where an exposure is being taken by selecting either a center-weighted or spot metering mode. Not only can you more precisely select the area where you want to meter, but some digital cameras also let you choose the focus point and where these metering modes are located on the image.

Using a smaller area of the scene to read exposure avoids many of the problems associated with the "weighing" of different areas in an image. If you were to select a center-weighted metering mode, you could point it directly at the clouds in the sky shown in the hole #15 photo to get an exposure that may be perfect to show the desired cloud details.

When you can use exposure compensation, spot metering, and exposure lock together, you are ready for any difficult lighting situation that you may come across.

CONTROLLING FOCUS WITH FOCAL POINT SELECTION AND FOCUS LOCK

14.1

"Mack Truck Bulldog Ornament" Canon PowerShot, hand-held, zoom set to 102mm (35mm equivalent), f/3.2@1/200, ISO 200.

Technique 10 covered the topic of how to take a sharply focused picture. However, the assumption in that technique was that the area of the composition on which the camera was to focus was at the center of the composition. Often, you may choose another portion of the image to use as the area where the camera should be focused. For example, the photo shown in Figure 14.1 shows the bulldog hood ornament on an old Mack fire truck. Because the important part of the image is off-center to the right, the camera needs to be focused off-center to get a sharply focused bulldog and a soft-blurred background.

To accomplish off-center focusing, you can either use focus point selection, focus lock, or a combination of them both. In this technique, you learn how to use one, or a combination of these features to get as focused as you want!

STEP 1: CHOOSE APPROPRIATE CAMERA SETTINGS

After you've decided how you want your photo to look, select the most appropriate camera settings to accomplish your objectives.

STEP 2: COMPOSE THE PHOTO AND PREVIEW THE IMAGE ON THE LCD MONITOR

- Compose the photo as you want.
- Determine from the image on the LCD monitor where you want the camera to focus.

If the area that you want the camera to focus on is off-center, this technique can help you to learn several different ways to handle such off-center focus photo compositions.

STEP 3: SELECT THE FOCUS POINT

The default focus point is the center of the image. However, some, but not all digital cameras allow you to change the focus point to one or two or even more different points. Having a choice of extra focus points allows you to select an off-center focus point to match your composition and your choice of where the camera should focus.

Vendors offer focal point selection features in many variations on different models of digital cameras. The Canon PowerShot G2 offers three selectable focus point positions, whereas the Nikon Coolpix 990 offers five selectable focus points. Some digital cameras even have automatic focal point selection where the camera, such as the Sony F717, determines what portion of an image it thinks should be selected as the area to use to focus the lens! Read the documentation that came with your camera to learn how many focus points you have to choose from and how to choose one — if they are selectable.

STEP 4: AIM THE SELECTED FOCUS POINT AT THE AREA WHERE YOU WANT THE CAMERA TO FOCUS AND LOCK FOCUS

When you've determined where in the composition the camera should focus, center the selected focus point on that area and lock the camera's focus using the focus lock feature.

> **TIP**
>
> If you plan on shooting multiple photos that are composed where an off-center focus point is needed, consider selecting a different focal point if your digital camera has selectable focus points. When none of the selectable focal points match up against the area that is to be in focus, choose the closest one and use your focus lock feature as outlined in this technique.

Focus lock is implemented and used in a variety of ways. Some digital cameras allow you to lock focus by pressing the shutter button halfway down — this often locks many settings such as exposure and even white balance. Other digital cameras have a button specifically for focus lock, or they may even require that you access a menu to lock the focus. If you're lucky, your camera will allow both approaches. Check the documentation that came with your camera to learn how to use focus lock before doing this technique.

STEP 5: RECOMPOSE

When you have locked the focus, you can recompose your photo. When viewing the final composition on the LCD monitor, you should see your image focused, as you want.

STEP 6: TAKE THE PHOTO

If you depressed the shutter button halfway to lock the focus, press it down the rest of the way now to take the photo. If you used a focus lock button or menu, you need to press the shutter button all the way to take a photo.

TIP

If your composition includes a subject or scene that has low contrast, is dimly lit, or has a mixture of close and far objects, you may find that your digital camera has a hard time getting focused. In such cases, look for another object that is the same distance from the camera and use that as the focus area. Lock, focus, and recompose.

USING A BUILT-IN FLASH

15.1

15.2

To flash or not to flash — that is the question. You should ask yourself that question each time you consider using a built-in flash. Unquestionably, a built-in flash serves many purposes and is an often-used feature that you can find on most compact digital cameras — even though a better alternative may exist for modifying the light than using a built-in flash. In this technique, you learn why you may or may not want to use a built-in flash and how to properly use one if your camera has one and you decide to use it.

Figure 15.1 shows a photo of a man and his dog covered in newspaper. The dog is not real, but the man is! He sits there motionless for hours every evening waiting for curious people to see whether he will move. When he doesn't move, many of them put a dollar or more in his jar for not moving, I guess. As I shot a couple of photos of him, I contributed, too. Notice how the newspaper is white as it really is, but not a bit yellow from the streetlights, as it ought to be. Also, notice how black the background street and stores are. The photo is reasonably focused. It does lack shadows, which would add dimension to the picture and so it appears very flat. Most importantly (to me) it reads, "Taken with a flash!"

In Figure 15.2 the built-in flash was turned off. To get a good exposure, the automatic shooting mode automatically changed the ISO setting to 400 ISO, the aperture to f/3.2, and the shutter speed to 1/4 of a second. The differences between this photo and the one in Figure 15.1 are significant. Here you can see a yellow color cast, which was caused by the street lights. The white newspaper is no longer white. The image contains lots of digital noise and it suffers from a slight blur due to the low shutter speed. Additionally, because the entire scene is evenly lit with ambient light, you can see the details of the background and shadows appear where they should appear under the chair and around the dog. These two photos illustrate the dramatic differences a low-powered built-in flash can have on a picture — both good and bad differences.

CHARACTERISTICS OF A BUILT-IN FLASH

Because a built-in flash is at most just a few inches away from the lens, the flash unit creates a flash of light that shines almost straight from the lens to the burst of light. Although the light does light up the subject, it also reduces or eliminates any natural shadows that help to define texture and subject detail.

Notice how the leaves are further defined by the shadows that are beneath them in the photo shown in Figure 15.3 Also, notice how much detail you can see in the bark because of the natural shadows coming from the low-level evening sun. This is a very three-dimensional photo with strong depth and texture.

In the photo shown in Figure 15.4, a built-in flash was used. Because of the strong sunlight and the weakness of the built-in flash that was used to take this photo, there is still a small amount of natural shadow, but the flash has washed out most of it. In particular, the texture in the tree bark has been considerably reduced. Just because a built-in flash was used, this photo is much less interesting than the one shown in Figure 15.3.

15.3

Another disadvantage of the built-in flash is that it can and often does create the dreaded "red-eye" when it is used to take photos of people. Many camera vendors have red-eye reduction features that fire two flashes to minimize red-eye — first a preflash to shrink the iris, and then a flash to expose the photo. Notice that the words reduction and minimize were used, because you can still get red eyes when using such features. There is also a downside to using a red-eye reduction feature, because the first of the two flashes can cause results as unsatisfactory as getting red eyes. Many subjects blink during the preflash, and then the second flash catches them blinking. Or sometimes subjects think that the first flash means the photo was taken and they move and the second

flash fires to capture their movement on the photo. If you were to use a detached or off-camera flash or shoot with existing light only, you would not have either of these problems.

DECIDING WHEN TO USE A BUILT-IN FLASH

So, with those previously mentioned "negatives" about built-in flashes set aside for a moment, take a look at some situations where a built-in flash can be tremendously useful.

■ **Reducing exposure range:** One of the best uses of a built-in flash is to bring your subject's exposure range down to where your camera can capture detail in both shadows and highlights. With the intent of getting a good photo of the inside of a restored Jaguar XKE, the photo shown in Figure 15.5 was taken with a Canon PowerShot G2 mounted on a tripod. The extremely wide exposure range produced by the bright light coming in the windows contrasting with the dark shadows covering the interior of the car made for a wholly unacceptable photo.

15.4

15.5

After turning on the built-in flash, the photo shown in Figure 15.6 was taken. This remarkable difference was made by increasing the light inside the car to more closely match the light level outside the car. With this decrease in subject dynamic range, a good photo was made. Figure 15.7 shows the photo taken in Figure 15.6 after some editing was done with Photoshop.

■ **Using "fill in" flash:** If your subject has some unacceptable dark shadows, you can use fill flash to open them up and reveal details. Be careful not to wash out the texture in the parts of the picture that are lit with natural light — use exposure compensation to achieve the best balance. This approach works really well with backlit subjects as well.

■ **Stopping motion:** The built-in flash on your camera produces its light in a super quick burst that can be very useful for freezing action. You will want to shut off red-eye reduction, because it greatly delays the moment of exposure, and makes it difficult to time the exact moment you're trying to capture. You also can experiment with "slow

sync" mode, which is a long ambient exposure followed by a flash. This can both capture a blur of motion and freeze it, too.

DECIDING WHETHER A BUILT-IN FLASH IS FOR YOU

First, review the pros and cons of using a built-in flash. Using a built-in flash is extremely convenient because it is built in to the camera and is always ready to use when you need it. When you are shooting and you need more light than is on your subject, you can provide that extra light, in a flash! A built-in flash is also wonderful for taking snapshots and quick pictures in low-light environments where capturing the shot takes priority over getting a perfectly lit shot. Taking advantage of the built-in flash also means you won't have to carry extra pieces of equipment, or spend more money to buy them. If your digital camera does not have a hot-shoe (a place to attach a flash) or a synch-socket (a place to plug in an off-camera flash), then using a built-in flash is your only option.

15.6

15.7

The reasons not to use a built-in flash are numerous. Built-in flashes are not very powerful; light range is usually limited to 8 to 10 feet — 15 feet at most. Because the flash comes straight from the camera, you get a flash of light that can eliminate much of the detail and texture on your subject. This direct light can also cause red-eye when you're photographing people.

Many other reasons against using a built-in flash have to do more with the benefits of using an external flash mounted on the camera's hot-shoe or an off-camera flash. External flash units have much more power and they can cover a wider area, as well as subjects that are farther away. Many external flashes can be tilted to bounce light off the walls or ceilings to provide a much more natural-looking light than if the flash is aimed directly at the subject. A considerable number of flash modifiers are made for external flash. When you take people photos, you won't have to worry about getting red-eye if you place the external flash a few feet from the camera.

The final reason not to use a built-in flash is also a reason not to use an external flash, too. Many photographers simply don't like the artificial quality of light that you get with any type of flash — so they never use them. Admittedly, I often find that using a tripod and a long exposure with existing light is usually the way to shoot. This approach avoids the flat harsh light and black shadows that are so typical of flash shots. When there isn't enough light and I can't modify the scene with natural light, then there isn't enough light and I don't take a photo.

Enough of the pros and cons! If you want to use a built-in flash, here are the steps to get the best results.

STEP 1: TURN ON THE FLASH

Depending on the shooting mode you have selected and the light level of the scene you are shooting, your camera may or may not have already turned on the flash. If your flash is not already turned on, turn it on.

STEP 2: SELECT RED-EYE REDUCTION, IF DESIRED

If you have chosen to use a red-eye reduction feature, turn it on now, or if you don't want to use it, make sure it is turned off! There is no sense in leaving the red-eye reduction feature on when you don't need it, because red-eye reduction is accomplished with a preflash that uses up your battery power and delays the moment of exposure.

STEP 3: CHANGE THE FLASH EXPOSURE COMPENSATION, IF DESIRED

Most digital cameras use a default setting of maximum flash when using a built-in flash. Based upon this maximum flash "light," the camera then appropriately adjusts the aperture or shutter speed setting to get a good exposure. However, many digital cameras also allow you to adjust the amount of flash that is used via a flash exposure compensation feature. This feature is very similar to the exposure compensation feature covered in Technique 12.

WARNING

Experiment with your camera's red-eye reduction feature before using it for important people photos to see whether you like the results. If you do use it, make sure you tell your subjects that they will see two flashes and that the second flash is the important one. They must keep still until the second flash has fired, which is when the photo will be taken.

When you use flash exposure compensation, you're really changing the balance between the amount of ambient or existing light and the unnatural light that comes from the flash. Flash exposure compensation can be used to get excellent results as it allows you to *open up* or make more details visible in the shadows, while minimizing the flatness that can occur when full flash is used and all the shadows are removed. Flash exposure compensation is a nice feature to have, but sadly, it is not available on all digital cameras. If you use a built-in flash often, check to see whether you have flash exposure compensation — using it can be a good way to minimize the negative aspects of a built-in flash while providing more light to the scene.

STEP 4: COMPOSE AND SHOOT THE PICTURE

Compose your picture and press the shutter button.

Remember that your flash won't light things that are too far from your camera, and it may have an excessive "light" effect on things that are close. You get the best results when working with subjects that are in the mid-ground area of your pictures — not too close and not too far away.

STEP 5: REVIEW THE IMAGE AND ADJUST THE SETTINGS

After taking a photo, review the photo on your camera's LCD monitor to see whether it is exposed correctly, and check the histogram if your camera has one. To learn more about using a histogram, see Technique 11.

The techniques in Chapters 1 and 2 cover most of the material that you really ought to know to get good results with your digital camera. This chapter covers many useful features, such as the histogram, exposure compensation, auto bracketing, spot metering, exposure lock, focal point selection, focus lock, and using a built-in flash. If you're serious about photography and your camera has these features, then your photography will be much better if you know how to use most of these features. They will undoubtedly make a huge difference in how you shoot and the results you get.

CHAPTER 4

INCREASING THE QUALITY OF YOUR PHOTOS

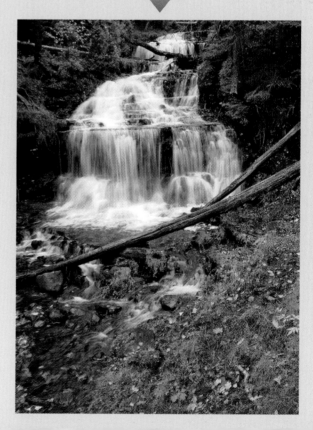

Taking better photos is the objective of every technique in this book. You'll realize the impact to your photos immediately when you add these practices to your everyday photo shooting habits. Technique 16 is the most important technique for taking sharp photographs, using a tripod. In Technique 17, you learn the importance of planning before shooting. Technique 18 shows you how to reduce the noise in photos that often appears when you print images at larger sizes. Technique 19 shows you how to be aware of the different light conditions you encounter and how to make adjustments to your digital camera that best take advantage of those lighting conditions. In Technique 20, you see how shooting subjects in both portrait and landscape orientations provides you more printing and output options later.

USING A TRIPOD

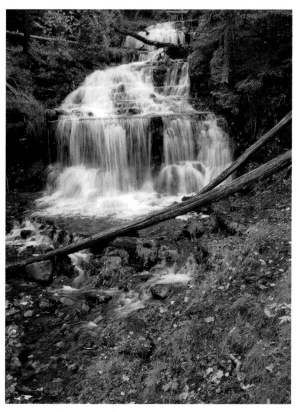

16.1 © 2005 Kevin L. Moss

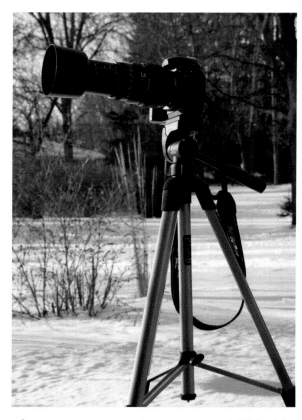

16.2 © 2005 Kevin L. Moss

The first step in increasing the quality of your images is to begin shooting as many photos as possible using a tripod. You just don't want to get the cheapest tripod: You want to get the tripod that best meets your photographic needs. Shooting photos on a tripod like the one shown in Figure 16.2 allows you to capture sharper images at slow shutter speeds while allowing for a precise composition, as shown in Figure 16.1.

If you shoot in low light conditions, a tripod is a must. Movement from your hands and body affects the sharpness of your photographs in most shooting situations. The larger you display your photographs in print or on screen, the more obvious the blur appears if you don't use a tripod.

Consider using a tripod for all your action, landscape, product, portrait, and macro shots, and especially for long-exposure nighttime or astrophotography.

A tripod is needed in many situations in which you're shooting with long telephoto lenses like the one shown in Figure 16.2. The more you zoom in on a subject with one of these long focal length lenses, the more your camera is subject to picking up vibration. Some of the larger pro zoom and telephoto lenses come equipped with tripod collars where you attach the lens to the tripod for better stability.

One of the most difficult decisions you can make when adding equipment to your collection is which type of tripod to get and what type of head to use. Some tripods are sold with the legs only, which means you get to choose which tripod head to purchase. That may be a good thing: A number of different types of tripod heads fit different types of photography styles.

STEP 1: DETERMINE YOUR NEEDS

Making decisions when buying a tripod may be more difficult than when you had to decide which digital camera to buy! The first step in choosing a tripod that's right for you is to first determine your needs:

- **What type of photos do you shoot?** The type of photography that you practice is a large element in determining what type of tripod to purchase. If you shoot mainly in the studio, large sturdy tripods are a good choice because you won't be carrying or moving the tripod often. If you travel, you'll want to consider a lightweight model that folds to a small enough size to fit in your luggage like the tripod shown in Figure 16.3. If you're a landscape photographer and often find yourself on long hikes, look for a model that is sturdy, yet lightweight. Do you shoot sporting events? Consider a monopod like the Manfrotto shown in Figure 16.4. Supporting your camera with one leg is still better than handholding your camera with a large zoom lens attached. Monopods are easily

carried and always set up for quick action during the game or event, allowing the photographer to steady the camera for better quality photos.

16.3 *Photo courtesy of Bogen Imaging*

■ **What kind of digital camera and lenses are you going to be using?** If you're shooting with a large–medium format, professional-level digital camera, the tripod you choose should be able to support the extra weight of these cameras. Digital SLRs are at least twice as heavy as compact digital cameras. That may be a determining factor in your purchase, especially if you plan on using large, heavy lenses. If you're shooting with small, lightweight, compact, or prosumer (advanced digital cameras such as the Nikon 8800 or Canon G6) digital cameras, a lightweight tripod may do the trick. Many of these models come equipped with a tripod head like the Manfrotto shown in Figure 16.5. Always check the recommended camera weight for the tripod you're considering.

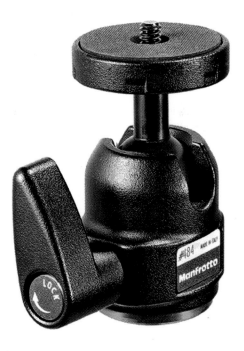

16.4 *Photo courtesy of Bogen Imaging* 16.5 *Photo courtesy of Bogen Imaging*

■ **What features are required for the type of shooting you do?** Aside from general style and purposes intended for the different tripod models available, here are some characteristics to consider when choosing the right tripod for your needs:

■ **Sturdiness:** The purpose of using a tripod is to reduce vibration and movement while shooting photographs. Sturdiness is the most important feature for any tripod.

■ **Weight:** Typically the heavier the tripod, the more weight it can support and the more stable it is. If you shoot in the field, weight is more of an issue than if you shoot in the studio. As a general rule, choose a tripod that's just light enough for your needs but also sturdy enough to help you obtain sharp images.

■ **Maximum and minimum height:** For shooting product shots in a studio, shorter tripods may do the trick, but if you're over 6 feet tall, short tripods are not a good idea. Choose a tripod that you're comfortable with and one that doesn't require you to bend down to use. Your back and your neck will thank you for it.

■ **Height when closed:** If you have to lug around a tripod like many travel, landscape, and location photographers do, the smaller your tripod collapses, the easier it is to carry. If you're doing a lot of traveling, try to choose a tripod that collapses down to a short size. This feature makes the tripod easier to pack in a suitcase or backpack.

■ **Material used in construction:** Nature photographers who practice their craft in northern latitudes know well the problem of using metal tripods in the field. The metal used in the construction of many tripods can get very cold when used outside for even short periods of time. Carbon-fiber tripods are an alternative to metal. They offer the sturdiness of a metal tripod plus do a great job in absorbing vibration. Additionally, your hands won't get as cold touching a carbon-fiber tripod on a cold day as they would touching metal. Carbon fiber is quickly becoming the choice of materials used in constructing some of the high-end tripod models.

■ **Overall construction:** Take the time to inspect the overall construction of the tripod. Are the legs flimsy when fully extended? Do the leg-release levers or *twists* feel tight-fitting without too much play? Does the tripod come equipped with a center column? Center columns offer stability and extra height for your tripod.

■ **Head:** If the tripod you're considering includes a tripod head, make sure it's of good design and quality. Less expensive models often come equipped with a tripod head: Make sure it is adequate for your needs.

STEP 2: CHOOSE A TRIPOD HEAD

If the tripod you choose doesn't come equipped with a tripod head, you have to again evaluate your needs to ensure you're choosing the right tripod head for the job. Figures 16.6 and 16.7 show two popular choices of the Manfrotto model 484 tripod heads. Choosing a tripod head is equally as important as choosing a tripod.

■ **What features do you need for your type of shooting?** Like your tripod, your style should determine your decision as to which tripod head to purchase. There are other considerations to ponder when choosing the right tripod head:

■ **Sturdiness:** One of the most important features of choosing a tripod head is its sturdiness. This is even more important for heavier digital SLRs and for those of you who use your tripod frequently. Having an equally sturdy tripod head to attach to a just as sturdy tripod makes sense.

■ **Type of tripod head:** There are two general types of tripod heads. Pan-tilt heads allow for separate control of three of the most common types of camera positioning: up and down, side to side, and horizontal rotation. Ball head tripod heads let you move your camera freely with one control. Figure 16.6 shows you an example of a ball head.

■ **Quick-release feature:** The popular quick-release heads offer the convenience of attaching and removing your camera quickly with the flick of a thumb lever. Figure 16.7 shows an example of a tripod head with a quick-release feature. Typically a quick-release plate is attached to the camera's tripod socket. This plate fits easily onto the tripod head for easy

16.6 *Photo courtesy of Bogen Imaging*

16.7 *Photo courtesy of Bogen Imaging*

attachment and detachment as shown in Figure 16.8. For most photographers, this feature is a must-have. Screwing and unscrewing a digital camera to a tripod head can become very tiresome during a busy photo shoot.

■ **Shooting vertically:** Most photographers shoot in both portrait and landscape orientations. Make sure your tripod head allows for sturdy and convenient 90-degree rotation of the camera.

■ **Panning ability:** This term refers to being able to accurately *pan* the camera from side to side in a smooth and level manner. A nice feature to have is for your tripod head to be able to provide level panning from side to side. This feature is important when shooting panoramic images.

16.8 © 2005 Kevin L. Moss

TIP

Many photographers own more than one tripod. Get in the habit of carrying one in your car at all times. If you're in the habit of carrying your digital camera with you, having a tripod available during your everyday travels can come in handy. An inexpensive but sturdy tripod makes a great "automobile" tripod.

PREPARING TO TAKE PHOTOS

17.1 © 2005 Kevin L. Moss

17.2 © 2005 Kevin L. Moss

For the most part, casual photographers do little or nothing to prepare for going out and taking photographs. Some people (and I bet some professionals) may just throw their camera in the car, and that works sometimes, having done that myself. The main thing is to grab the camera, and then point and shoot. That's the typical scenario.

I want to make the most out of the time I spend capturing images. Other photographers, professionals or not, prepare every time when practicing the art of photography. I want to make sure contingencies that can arise are covered.

Whether I'm shooting corporate portrait sessions, weddings, or nature, or driving to the city or to the mall for some new shots, I spend time going through my preparation checklist. The image in Figure 17.1 was successful because I planned for the photograph in advance. I purposely stopped down the lens with an aperture of f/22 to gain depth of field and to blur movement. I set up the shot and waited until the people walking through the frame were in the exact spot I wanted them to be. I didn't get the blur I

wanted but I did get some dramatic lighting and shadows when the sun popped through for a minute.

If I'm scheduled to shoot portraits on location, I lay out all my equipment and make sure it's clean, as well as check that batteries are charged, flashes are operational, and all my stands and umbrellas are ready to go. I check the other essentials, too: formatted flash cards, clean lenses, and manuals. Figure 17.2 shows my equipment layout before packing up to shoot some location portraits.

For professional work I use my digital SLR, which means I take test shots to ensure there isn't any dust on my sensor. I turn on my camera, set my aperture priority ahead of time, and review all my menu settings. If I'm shooting in low light, I make sure I bump up the ISO setting and attach a fast lens to my camera. If I'm shooting flash, I make sure my white balance is set accordingly.

STEP 1: CHECK BATTERIES

■ I always have at least one spare battery charged and ready in my camera bag. I always make sure I've recharged the in-camera battery as well. For flashes, I use rechargeable batteries, rotating about nine sets in all. Regardless of the condition of the batteries in the flash units, I always swap them out for a newly charged set, putting the old batteries in the "charge me" box I keep next to the charger.

TIP

Most digital camera batteries provide a full day or more on one charge, but that capability declines as the batteries get older. For the cameras I use frequently, I actually replace the batteries every year or so. Always have a charged spare in your camera bag.

STEP 2: CHECK MEMORY CARDS

■ Before I venture out, I check *all* my memory cards to make sure that I've downloaded and backed up any images that may still be on them, and you should do the same. You never know when you'll come across a subject that you'll take a number of photos of just to get it right. You want to make sure your card is formatted. Try to make it a habit of taking enough cards with you to handle three times the number of images you're planning on shooting. If you figure on taking 100 photographs during your shoot, take enough memory cards to shoot 300 photographs. Format all your cards with your camera and you'll be ready to quickly swap them out and shoot some more.

STEP 3: INSPECT AND CLEAN THE LENSES, SENSOR, VIEWFINDER, AND LCD

■ Make sure your lenses, viewfinder, and LCD are clean and free of dust before venturing out. If you use a digital SLR, make sure the sensor is clean. I always do some test shots and then zoom them in on my viewfinder to make sure no dust landed on the sensor since I last changed lenses.

WARNING

Never use compressed air to clean dust off of the digital SLR sensor. Most manufacturers have specific procedures for removing dust, and most procedures are different. Consult your owner's manual for your specific dust removal instructions.

STEP 4: SET UP THE CAMERA

■ Check all your camera settings before you arrive at your location. Sometimes when you arrive you are hit with an unexpected event or problem that throws off your routine. Make sure the shooting mode, aperture, shutter speed, ISO, and white balance are set in your digital camera and ready to go when you arrive.

Some photographers don't use auto white balance for a reason; sometimes, it just doesn't work right. Make sure you set the white balance for the job. If it's outdoors and cloudy, set the white balance for cloudy. If it's sunny, set the white balance for sunny. If you're indoors under fluorescent lighting, set the white balance for fluorescent. Take a few test shots when you get to the location and view the results on the LCD, changing the setting until the results look correct.

STEP 5: CHECK THE FOCUS

■ Recently while shooting still-life and macro photos, I turned off my autofocus to focus manually on different aspects of my subject. The next day I went out to shoot some photos. All was going well until I discovered my autofocus was turned off, resulting in a number of photos that were taken out of focus. Make sure your setting for autofocus is turned on and correct for the type of shooting you'll be doing. If you're going to be shooting action, set up your camera for continuous focus.

STEP 6: DOUBLE-CHECK YOUR CAMERA BAG

■ For those of you who have one, make sure your camera bag is packed properly. Lenses need to be isolated and protected from other equipment. Memory cards, batteries, and the user manual should all be in the right spot.

STEP 7: SCOPE OUT THE LOCATION

■ If possible, check out a location before you begin shooting. If you're a landscape photographer, having previous knowledge of the area helps you plan where you want to go and when according to the light. Professional landscape photographers often scope out a location in the middle of the day (when the light is too harsh to shoot) and then come back later in the evening or early the next day to take their photographs. If you're shooting onsite for a business or at someone's home for portraits, try to visit the location before your scheduled shoot just to view the lighting, areas, and backgrounds where you will be photographing the subjects.

TIP

Packing a small flashlight (with a fresh battery) in your camera bag can come in handy. When you're shooting at night, a flashlight is always a welcome tool to light up those adjustments on your camera or tripod so you can see what you're doing. A flashlight is a necessity when you change lenses, or try to find something in your camera bag in the dark.

DETERMINING PROPER ISO SETTINGS AND REDUCING NOISE

18.1 © 2005 Kevin L. Moss

18.2 © 2005 Kevin L. Moss

I shoot 100 percent digital now, but back when shooting film, my landscapes were always shot at the lowest ISO rated transparency (slide) film I could get — Fuji Velvia rated at ISO 50. I shot at a low ISO knowing in advance that my shutter speeds would be slow due to the reduced light sensitivity. I wanted the saturated colors and virtually no grain in my landscapes. If I wanted to shoot indoors, I purchased film at ISO ratings of 200, 400, or even 800, but had to live with increased grain in my shots.

As with film cameras, digital cameras also have ISO ratings that indicate their sensitivity to light and subjectivity to image noise (or a similar "grain" effect in film cameras). A digital camera set to an ISO level of 100 has comparable light sensitivity to a film camera loaded with ISO 100 film. Most digital cameras today have a standard ISO setting of 100. Some digital cameras even offer the lowest ISO at 50, and others have the lowest available ISO at 200, like the camera used to shoot the photo illustrated in Figure 18.1. Though the camera was set to ISO 200, it still produced a crisp noise-free image. If the image is taken at a higher ISO setting of 800, increased noise results, as shown in Figure 18.2.

When you increase the ISO in digital cameras, the sensor electrical output is amplified to allow for less light. The amplification (or sensitivity) that occurs when you increase the ISO setting has a side effect — image noise. Longer shutter speeds will also increase noise in your images. Figure 18.3 shows a photo taken at a low ISO setting, but a slower shutter speed. Figure 18.4 is a section of the scene that shows the resulting image noise.

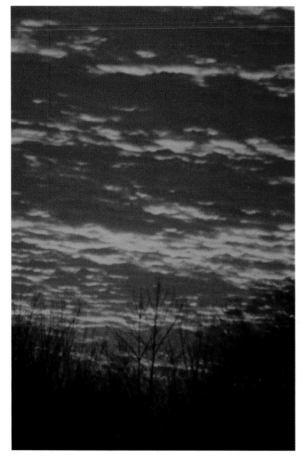

18.3 © 2005 Kevin L. Moss

18.4 © 2005 Kevin L. Moss

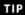

As you can see in Figures 18.5 and 18.6, image noise increases as you change the ISO to higher settings.

You can take steps to reduce noise in your images, either while shooting by using the lowest ISO setting your camera offers, or afterward while processing your images using Photoshop Elements 3. To reduce image noise in Photoshop Elements, follow these steps:

TIP

Wherever possible, set your camera to the lowest ISO you can for the best possible image quality. If you're shooting in low light situations or shooting fast action, you'll need to increase the ISO in order to achieve the shutter speeds needed, but doing so may increase the amount of image noise in your photos.

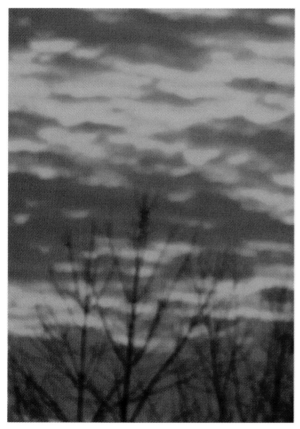

18.5

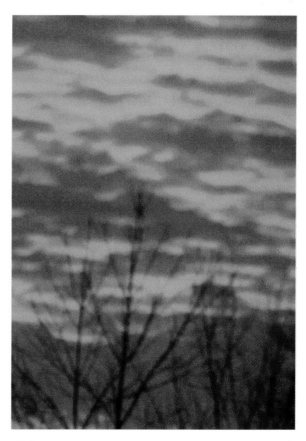

18.6

STEP 1: OPEN AN IMAGE IN PHOTOSHOP ELEMENTS 3

■ Open an image either using the **File ➢ Open** command or browsing thumbnails of your images using the File Browser. You can open the File Browser by choosing **File ➢ File Browser**.

STEP 2: CREATE A BACK-UP LAYER

■ Because not making any changes to the original image contained in the background layer is the best practice, duplicate the background layer by choosing **Layer ➢ Duplicate Layer**. Rename the layer to reflect the adjustment you're about to make — reducing noise — by typing the new name of the layer as shown in Figure 18.7. The settings shown are for a cropped portion of the sunset photo.

STEP 3: CHOOSE THE NOISE REDUCTION FILTER

■ Access the Noise Reduction filter by choosing **Filter ➢ Noise ➢ Reduce Noise** as shown in Figure 18.8.

STEP 4: REDUCE NOISE

■ From the **Reduce Noise** dialog box shown in Figure 18.9, move the **Strength** slider to the right to a setting of **8** or **9**. (For some photos, a setting of **6** or **7** may be sufficient.) Move the **Preserve Details** slider to about **50**. Increase or decrease **Preserve Details** until you see the desired result of reduced noise but while still retaining detail in the image. Moving the slider too far to the left results in a reduction of detail. Moving the slider too far to the right diminishes the reduction of noise you're trying to achieve. I usually leave the **Reduce Color Noise** slider in the middle. Figure 18.10 shows the reduced noise in the zoomed preview window.

18.7

18.8

18.9

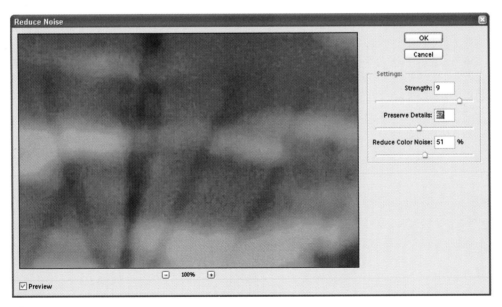

18.10

As with many image adjustments, you will have to experiment until you gain optimal results. Figure 18.11 shows the original image and the cropped

photo of the sunset before the Reduce Noise filter was applied. Figure 18.12 shows the image after the Reduce Noise filter was applied.

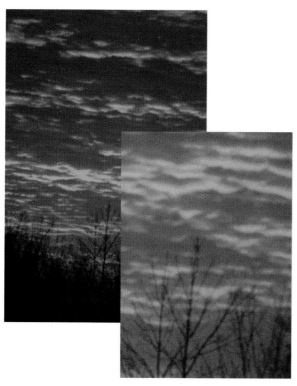

18.11

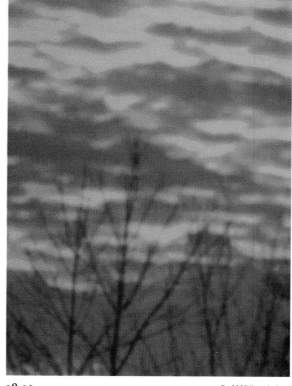

18.12

BECOMING AWARE OF LIGHT

19.1 © 2005 Kevin L. Moss

19.2 © 2005 Kevin L. Moss

If you ask the best photographers how they mastered their craft, the answer you hear most often will be mastering light. After all, photography is the art of mastering light. One of the hardest things to do in photography is to get the lighting just right for a subject.

I know landscape photographers who consistently get great results in any weather or conditions. They have mastered outdoor lighting. Ask the same outdoor photographer to shoot portraits in a studio and he may not come close to what an experienced portrait shooter could do. The same could be said for portrait photographers who have mastered the art of indoor flash, but may not be as proficient dealing with a lot of outdoor challenges like shooting with the midday sun, as shown in Figure 19.1, or at dusk, as shown in Figure 19.2.

OUTDOOR LIGHTING

Outdoor photographers prefer to do their shooting early in the day, late afternoon, or early evening. Colors are more enhanced than during midday, shadows are more prominent, and colors don't get washed out (or dull) from too much light. By taking photographs outdoors early or late in the day, you can take advantage of how the sun illuminates subjects from lower angles, creating interesting colors and casting shadows that make for great landscape photos.

The following are some common techniques used to take advantage of the optimal lighting situations for outdoor and landscape photography:

- **Shoot early in the day or before dusk.** Shadows and color from the sun are accentuated just after sunrise and just before sundown. The most dramatic landscapes you'll see were probably shot at these times. You'll see colors emerge that you'll never see during the midday hours, such as colors in the sky shown in the sunset in Figure 19.2.
- **Wait for the magic light.** Outdoor photographers refer to magic light as the dramatic lighting that appears just before sunrise or just after sunset. The window of opportunity can be as short as a few minutes. I am always aware of the time sunrise and sunset appear. It's at those times when the most saturated colors of the day appear. Figure 19.3 shows the color that magic light can provide in this sunrise over Lake Huron.
- **Rainy and misty days may be the best times to photograph waterfalls or foliage!** Clouds overhead provide the best soft box lighting you can get. Wet trees are darker and provide great contrast, and the colors of the leaves are brilliant. Using a circular polarizer helps reduce the glare

reflecting off the trees, but will result in a loss of a few stops of exposure. The reduction of a few stops will also result in slower shutter speeds. Use a tripod, and then you can use slower shutter speeds.

Figure 19.4 shows you how colors on a rainy day jump right out at you. In some cases, you may have to tone down the color saturation after you get the image in Photoshop Elements!

19.3 © *2005 Kevin L. Moss*

NATURAL LIGHTING

My favorite lighting to use when taking portraits is natural lighting. No matter how many flash units, soft boxes, and umbrellas I add to my arsenal, sometimes the best light to use is still the light that comes through the window. Using and controlling natural light for your subjects can greatly improve the quality and diversity of your photographs. If you're taking photos of people in your home studio, take everyone outside and take some shots. Sometimes all you have to do is place your subject in front of some foliage and you have an instant dynamic background for the portrait. Figure 19.5 shows a portrait I made for a friend of mine who needed images for a political campaign brochure. When I arrived on location for the shoot, I decided to take him outside to take advantage of the diffused natural light of the late-day, partly cloudy sky.

> **TIP**
>
> If your schedule doesn't allow you to shoot early in the morning or late in the afternoon, attach a circular polarizer over the lens and keep shooting. You can still possibly get great shots regardless of where the sun is located in the sky. Photograph subjects in the shadows; midday is a great time to get those forest photos with the sun streaming through the trees. Look for backlit subjects to capture some of those interesting silhouettes. Use the midday hours to scout potential scenes to photograph later that day or the next morning.

19.4 © *2005 Kevin L. Moss*

19.5 © *2005 Kevin L. Moss*

TAKING PHOTOS IN DIFFERENT ORIENTATIONS

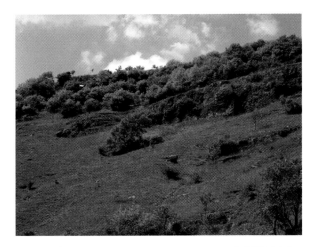

20.1 *Landscape orientation* © 2005 Kevin L. Moss

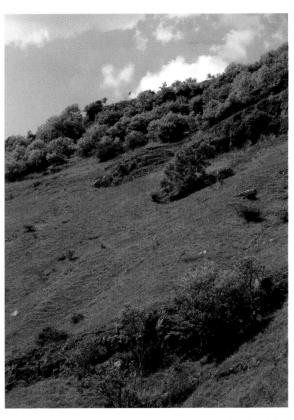

20.2 *Portrait orientation* © 2005 Kevin L. Moss

ABOUT THE IMAGE

"Cheddar Gorge" Nikon Coolpix 7900, mounted on a tripod in both portrait and landscape orientations, f/5.9@1/230.

I would say that 95 percent of all snapshots are taken one way, horizontally. If you leaf through photos taken by relatives and friends, you'll notice that probably almost all were taken in the landscape orientation. The reason is plain — most people concentrate on getting their subjects to smile and just want to take a picture; they are not planning the shot.

However, photographers like us think differently when taking photos. We ask ourselves how we can frame a picture to properly illustrate how the scene should be displayed. Should we zoom in or zoom out? Is there

anything in the scene we can use to frame the photo better? Another question we should be asking is whether the photo would be better in the vertical portrait orientation or the horizontal landscape orientation.

The image in Figure 20.1 was shot in the *landscape* orientation. I liked using landscape for this shot because it allowed for a better balance and drew attention to the geese hanging around. As a habit, I also turned my camera 90 degrees on the tripod and took the same shot in the vertical *portrait* orientation shown in Figure 20.2. I liked that one as well.

Professionals make it a habit of shooting their subjects on both portrait and landscape orientations, because various opportunities may arise in the future. For example, a photo that looks great in landscape may not translate well if it's intended for the cover or even an inside page of a magazine. (All magazine covers are in portrait mode, whether the photo is of a person, landscape, or object in a still life.)

Whether you're shooting as a professional, artist, or enthusiast, make it a habit of shooting all your shots in both orientations. The photo shown in Figure 20.3 was first shot in landscape orientation, but even though I was rushed to get the shot before the rainbow disappeared, I also made sure that I recomposed the scene and shot in the vertical portrait orientation shown in Figure 20.4. For this image, I think the only one that works for me is the image in the portrait orientation.

> **TIP**
>
> If you shoot using a tripod, make sure the model tripod head you're using has the ability to allow you to easily flip your camera to the vertical position. All advanced model tripods and tripod heads have this capability.

20.3 © 2005 Kevin L. Moss

If you are a "horizontal" shooter, give yourself the opportunity to improve the quality and interest in your photographs by giving yourself more options to choose from when taking photos.

20.4

STEP 1: EVALUATE THE SCENE

■ Set up your tripod and mount your camera. Before looking through the viewfinder or at the image preview displayed on your LCD, take a good look at the scene and determine how many different ways you can take this photo.

■ **Does the scene look better in portrait or landscape orientation?** For some scenes, an orientation will jump out at you. Go with your instincts for your first shot. If you're not worried about file space left on your memory cards, shoot both orientations.

TIP

You can get the same effect of a horizontal portrait by cropping a vertical version of an image. A drawback, however, to cropping is loss of image data, which can result in a loss of image quality. As a best practice, try doing your cropping in-camera instead of on your computer.

- **Would the scene look better zoomed in or zoomed out?** Take the photos both ways and in both orientations. Zoom in, shoot it vertically, and then shoot it horizontally. Zoom out, shoot it vertically, and then shoot it horizontally. For each scene, you'll have four images to choose from when you view them on your computer.

- **Would a portrait in landscape mode look good?** When you're shooting portraits, it's easy to get in the habit of shooting individuals in portrait orientation. I would say most of my portraits are shot in portrait mode. For a change of pace, break the rules and try shooting portraits of individuals in horizontal mode. Try not to center the person in the middle of the frame: Move him over to the right or to the left. You'll wind up with a different perspective and maybe even a really neat portrait like the one shown in Figure 20.5.

20.5 © 2005 Kevin L. Moss

STEP 2: BE CREATIVE

- How would a shot look if you tilted the camera 45 degrees to the left or to the right? You can get some dynamic images by breaking the horizontal/vertical rule by going halfway. There is nothing written in the photo encyclopedia that says your photographs have to be level. Experiment and don't be afraid to do something different! The photo in Figure 20.6 shows just how much a little tilt can add dramatic effect to your scene. For added effect, the photo was taken at a slow shutter speed. I slowly turned the zoom ring on my lens as I pressed the shutter, giving me the zoom effect in the photo.

20.6 © 2005 Kevin L. Moss

CHAPTER 5

TAKING PICTURES OF PEOPLE AND PETS

A very high percentage of all photos taken are people photos. In this chapter you find seven techniques that can help you to take better people photos. In Technique 21, you learn how to choose photographic lights for taking portraits. Technique 22 explores the advantages of using natural lighting in your photos. Technique 23 reveals how to take candid photos of people at home, at the office, or anywhere you find them! Techniques 24 and 25 show you how to take great family portraits and have fun taking pictures of kids. Technique 26 shows you how to shoot a favorite subject for portraits, pets. Technique 27 covers the topic of getting sports action photos. If you like to shoot people pictures, you'll enjoy this chapter.

CHOOSING PHOTOGRAPHIC LIGHTS

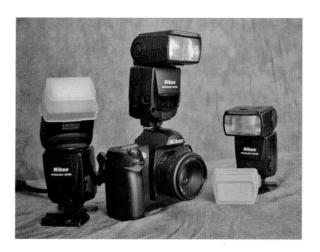

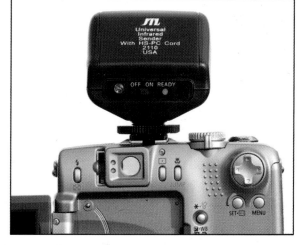

21.1 © 2005 Kevin L. Moss 21.2

Without the right quality of light, taking a good portrait is hard. Although you can have too much light, the most common problems are that you have too little light, the wrong quality of light, or light you don't have complete control over. In each of these cases, you need to choose some kind of photographic lights and light modifiers to get the portraits you want. If you routinely use a digital camera to shoot photos of people, a little extra equipment can help, such as the flashes shown in Figure 21.1. If you want to shoot better portraits in a controlled-light environment, this technique can help you get started using photographic lights. Figure 21.2 shows a Canon PowerShot with a Morris Universal Infrared Sender attached, which fires external photographic lights wirelessly.

DIFFERENT TYPES OF PHOTOGRAPHIC LIGHTS

Before looking at why you would want to choose one type of light over another, first take a quick look at a few different types of photographic lights:

■ **Built-in camera flash:** Many compact digital cameras have a built-in flash. Although built-in flashes are simple to use and convenient, they rarely produce light that flatters the subject. Built-in flashes are mostly used for snapshot photos. This type of flash provides harsh, flat light that can wash out your subjects, produce strong black shadows behind your subjects, and cause red-eye if you photograph people.

■ **Hot shoe-mounted camera flash:** Some compact digital cameras have a *hot shoe,* a place for mounting an accessory flash unit made by the camera vendor or a third-party vendor such as Vivitar, Sunpak, or Metz. Figure 21.3 shows a Canon Speedlite 550EX mounted on the hot shoe of a Canon PowerShot. These larger flash units not only produce more light with more control, but you often can also direct them at a ceiling to create a softer, *bounced* light. Another benefit is they don't drain your camera's batteries, because they have their own source of battery power.

■ **Hot shoe camera flash located off camera on a light stand:** If you have a hot shoe flash like one of the Canon Speedlites, you can either mount it on the camera's hot shoe, or you can mount it on a stand off the camera. To fire an off-camera flash, you need to use a connector cord called a *sync cord.* Alternatively, you can fire the flash wirelessly via a control unit attached to the camera, which helps to prevent anyone from tripping over a wire. Taking the flash unit off the camera entirely gives you the chance to use even more effective light modifiers such as umbrellas, which spread soft directional light across your subject.

Sticking with the same vendor for your digital camera and flash is usually best (and more expensive). Both Canon and Nikon offer a wide range of flash equipment for their respective cameras. The best part of using either of these vendor's products is that they also work with many of their film cameras and their newer digital SLR cameras, so your investment is protected if you later move up to a digital SLR (same brand) or want to use the flash on a film camera (same brand), too.

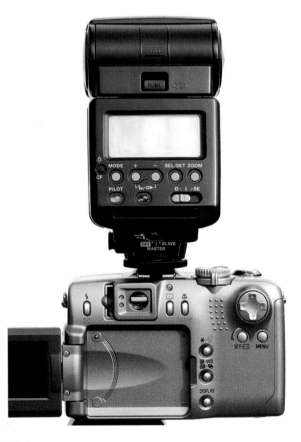

21.3

■ **Off-camera slave flash triggered by flash:**
Besides hot shoe–style flash units, you can find
some very fun and exceedingly useful flash units,
like those made by the Morris Company. The
Morris Mini Slave Flash Plus, shown at the right in
Figure 21.4, is a small compact flash that contains
its own batteries and can be fired either by your
camera's hot shoe or remotely by its sensing the
light from another flash. Figure 21.4 also shows
the Maxi Slave Flash (on the left), which has more
power and two power levels as well as a detachable
wide-angle adapter. Figure 21.5 shows the Morris
Universal Infrared Sender mounted on a Canon
PowerShot. This infrared unit can also be used to
trigger the Mini and Maxi Slave Flash. These inex-
pensive Morris lights are wonderful supplemental
lights to use for adding light to places not covered
by other lights. They are especially useful for light-
ing up the side or back of a subject. I find these
Morris lights to be wonderfully fun and easy-to-
use lights to get creative shots not normally possi-
ble with many of the other more expensive types
of photographic lights.

■ **Studio strobe (flash):** If you need more light
and control than you are getting from flash units
that have been designed to be mounted on a cam-
era's hot shoe, you need a studio strobe. These
lights are not only more powerful lights, but they
also usually have modeling lights and advanced
controls. A *modeling light* shines on your subject
so you can see how the flash will light your subject
when the flash fires. Modeling lights also make
using your camera's autofocus easy for you
because they stay on except during the exact
moment of exposure.

Many companies make studio flash kits. However,
not many companies make them with the power and
features at the prices that are offered by AlienBees
(www.alienbees.com). The entire AlienBees
line of studio strobes is affordable, and they're excel-
lent lights. You can purchase single lights or complete
kits with stands and umbrellas. Considering that
some of the top-of-the-line camera flash units
offered by the major camera vendors can cost more
than $350, the price of an AlienBees B400 studio flash

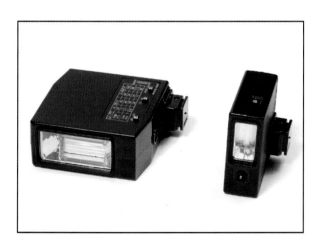

21.4

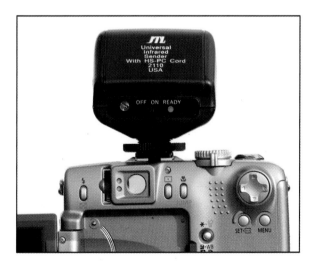

21.5

unit, a general-purpose 10-foot stand, and a 32-inch brolly box, shown in Figure 21.6, is an exceedingly good value at just under $300. Figure 21.7 shows the control panel on the back of the AlienBees B400 studio flash.

If you need two studio strobes, you can buy two B400 studio flash units, two LS3050 general-purpose 10-foot stands, one U48TWB 48-inch shoot-thru umbrella, one U48SB 48-inch silver/white umbrella, and a carrying bag for $600 direct from AlienBees.

■ **Hot lights:** Hot lights are unlike strobes in that they are hot to work under because they don't flash; rather, they are continuous lights that remain on until you turn them off. Many of the powerful tungsten lights are rated at 500–600 watts. They

are simple to use but they consume lots of power while putting out lots of heat. Smith Victor lighting kits, such as the Q60-SGL, are available for about $250.

■ **Other nonphotographic lights you can use:** The previously listed types of lights are all specifically designed for use as photographic lights. However, you can use lights designed for other purposes as photographic lights, too! Some of the most useful lights for shooting small items like jewelry are swing-arm halogen desk lights. You can illuminate larger subjects with the quartz lights designed for construction work, which you can find at most building supply stores. The light from these lights is not as even as the light from true photographic lights, but by bouncing the light off walls and ceilings, a strong even light can be had for very little cost.

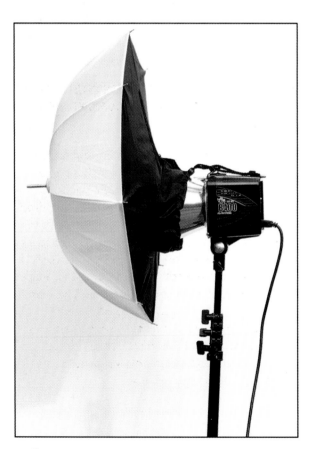

21.6

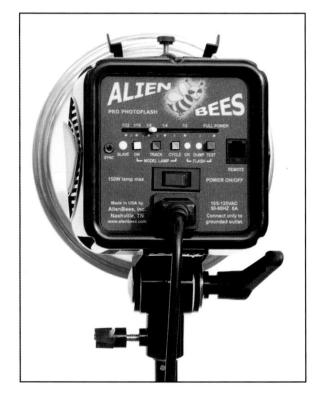

21.7

WHY CHOOSE A STUDIO STROBE OVER A FLASH UNIT (OR VICE VERSA)?

Studio units have modeling lights, which are a decided advantage when you want to preview the light or you want to avoid turning lights on and off while you work. Modeling lights automatically turn off when the actual strobe fires, so they will not affect your photograph. This makes setting up and adjusting your lights before you take your first shot much easier. Without modeling lights you would have to shoot multiple tests and review them on your LCD monitor before you would know what to expect from your flash units. Some studio units also put out much more light than standard camera flash units, and they use regular household current, not expensive batteries as a power supply.

ARE FLASH UNITS OR HOT LIGHTS BEST?

First, let's compare flash units with hot lights (continuous lights). Flash units put out light that has a color balance that is very close to daylight. This means that colors, especially blues, are captured in a more accurate way than under incandescent lights. Second, they send a very short burst of light, so you don't have to worry about subject or camera motion the way you do with hot lights. Finally, they are much cooler to work under; your subjects don't feel like they are in a sauna while you shoot. The cool light also means you can use more kinds of light modifiers, such as umbrellas or soft boxes, without worrying about setting the house on fire.

Hot lights have advantages, as well. First, they are generally less expensive than comparable studio strobes. This can be a big factor if you're on a budget. Second, they work with any digital camera, even those without a hot shoe or sync cord features, because no special synchronization is needed. This alone can be the deciding factor, unless you're planning to buy a new camera soon! Finally, if you shoot any video, you can easily use your hot lights to light up your movie scenes, something that flash units can't do.

So which type of light is best for you? Read on to decide for yourself.

STEP 1: THINK ABOUT YOUR SUBJECTS

- If you primarily take people pictures, strobes are the best way to go. Not only are they more comfortable to work under, but their quick bursts of light prevent any blurring if your subjects move while you shoot. If you shoot still life or product shots, either incandescent lights or strobes can do a good job. If color is critical, studio flash units will yield truer colors.

STEP 2: CHECK TO SEE WHETHER YOUR CAMERA CAN WORK WITH EXTERNAL STROBES

- This step is critical, because some digital cameras just can't be used with external flash units. Sometimes a workaround exists, like using the on-camera flash to trigger slave units, but other times there just is no practical way to make it work. Read your camera manual to learn more about any flash synch features your camera may have. If your camera has a hot shoe, you can use an adaptor to connect it to a studio flash unit. The Wein Safe Sync (www.saundersphoto.com/html/wein.htm) is an adaptor that both connects a flash to your camera, and protects your camera from potential damage from the flash unit's trigger voltage.

STEP 3: CONSIDER YOUR BUDGET

■ Not too many years ago, a good set of studio strobes would have been prohibitively expensive. Now, the same advances that are driving down costs and making digital cameras better and cheaper are also bringing down the costs of high-quality studio flash units. One-piece strobe lights, like the AlienBees units (also called mono lights), have the power supply and flash tube in the same package and are remarkably affordable. They are available as part of an inexpensive kit, with quality light stands and umbrellas. Of course, inexpensive is a relative term. Professional units with separate power packs and flash heads cost many thousands of dollars. You can purchase a starter kit of two AlienBees flash units, umbrellas, and stands for under $600.

Traditional tungsten halogen lighting kits like the Smith Victor Q60-SGL are available for about $250. These consist of a pair of 600-watt lights with barn doors and light stands. Umbrellas, soft boxes, and other light-control devices are extra.

STEP 4: DECIDE BETWEEN STROBE OR HOT LIGHTS

■ If your evaluation of your digital camera in Step 2 showed it to be incapable of synchronizing with external flash units, your decision is an easy one. Incandescent lights will work with your camera, whereas external flash units won't. Of course, if you have been thinking of buying a new digital camera, this could be an additional motivating factor to get one sooner rather than later. But

assuming you're happy with the quality of the images you're getting from your digital camera, it's time to go shopping for hot lights.

If your camera can synchronize with strobes, you can choose from several options. Of course, hot lights are still a possibility. They are simpler to work with, and can cost less than studio strobes. You also can work with a pair of hot shoe flash units, mounting them on light stands and pointing them into umbrellas. This option is attractive if you already have one or more hot shoe flash units or you plan on buying them for other purposes. The primary downside to these flash units is the lack of modeling lights, which will make it difficult to see the effect of the lighting without shooting test shots. If you're really serious about shooting indoor pictures, and you have the budget, buy some studio strobes like those offered by AlienBees.

STEP 5: SHOP FOR LIGHTS AND ACCESSORIES

■ When you've decided what to buy, you should visit a local pro camera store if one is nearby. Otherwise, you can get good advice and reasonable prices from a large mail-order dealer like B&H Photo Video in New York (`www.bhphotovideo.com`) or Calumet Photographic (`www.calumetphoto.com`) in Chicago.

You need at least two lights for most studio-type pictures. A third light gives you added flexibility, but you can start with two and add more lights later if budget is a consideration. In addition to the lights themselves, you need light stands and light modifiers such as umbrellas. If you are buying strobes, you also need

synch cables and an adaptor to match them up with your camera. Some flash units come with cables; others do not. Check when you order, and ask about the connectors on the cables. You may also need an adaptor for your camera so that you can connect it to the synch cables. If you don't have these important parts, you can't use your lights when they are delivered.

Studio strobes, like those from AlienBees, have a built-in *slave* sensor, which fires the flash when any other flash unit is triggered. This means you only have to connect one light to your camera; the others automatically trip when the connected one fires. If you're working with a pair of regular flash units, you have to connect them all together. For example, Nikon Coolpix cameras without a hot shoe use Nikon SC-18 and SC-19 flash cables, and they connect directly to the Nikon flash units. But they need the Nikon AS-10 hot shoe adaptor to mount the flash on a light stand or tripod. Nikon Coolpix cameras that do have a hot shoe use the Nikon SC-17 cord to connect to a Nikon flash unit off-camera.

WARNING

Cameras trigger flash units by momentarily completing an electric circuit. Check to see what the limit of this trigger voltage should be before connecting any external flash units. Exceeding the rated voltage could damage your camera's internal circuits. If you are not sure or if your flash units exceed the camera's rating, you can use a safe synch-type module such as the Wein Safe Sync to keep the higher voltage from hurting your equipment.

USING A BACKDROP CLOTH

One last accessory you likely want to consider purchasing is a black drape. You can use black drapes to block light coming from a window or doorway, or use them as a background for your subjects. Although purchasing a variety of black cloth from a local fabric store is possible, some companies offer select materials specifically for use as blackout cloth or as backdrops. One such company is Backdrop Outlet (`www.backdropoutlet.com`) in Chicago. This company offers an 8×16 foot economy black cloth for around $70. It also has a very good 10×21 foot blackout cloth and a soft black cloth for around $170 and $140, respectively. The more expensive blackout cloth is a richer black and is a good choice if your budget allows the extra expense. You also need to buy some wide tape to remove lint and pet fur if a pet is nearby because these cloths are lint and hair magnets!

Good studio lighting techniques take time to learn. Fortunately, your digital camera will allow you to quickly experiment with very little cost other than your time. Review your photos constantly, and you soon will get a feel for the way each light affects your subject. Because you will be in complete control of your subject and the light that falls upon it, you will learn a lot quickly! When you get results you like, take notes so you can reproduce the quality of light when you need to shoot a similar subject. Make a little sketch of light placements, including distance measurements.

Granted, this is a fast overview of photographic lights, but it is sufficient to help you get started, and you will quickly learn whatever else you need to know as you go. In the next technique, you find out how to take people pictures without photographic lights.

USING NATURAL LIGHT
FOR PORTRAITS

22.1 © 2005 Kevin L. Moss

22.2 © 2005 Kevin L. Moss

You can shoot portraits of people with two types of light sources — studio lighting or natural lighting. Both types of lighting provide excellent sources for photos of people; however, natural lighting lends itself to creative possibilities that can't easily be duplicated in the studio. To take great portraits of people using natural lighting, you need to understand the different types of natural lighting that can be used and when they are available to you. Nature provides the best light available for photographs; however, predicting what light is going to be available and when is nearly impossible. The best way to prepare for taking portraits with natural light is to be ready for whatever lighting nature provides, as in the portraits shown in Figures 22.1 and 22.2.

STEP 1: SET UP A BACKGROUND

■ If you are shooting your portraits indoors and you don't own seamless paper, cloth, or a muslin backdrop and a backdrop stand, use a large sheet of cloth and tape it to a wall opposite the source of the natural light. A window that is adjacent to the wall in which you set up your backdrop works well for angled or side lighting. Unfortunately for photographers, homes and offices aren't designed for natural light portraits in mind. You may be forced to set up your backdrop 45 degrees from the window light source. Make the best of the situation and be creative. If you want to shoot outdoors, look for a background that doesn't interfere with the portrait by taking attention away from the person. Brick walls, tall bushes, and leafy trees work well. Make sure your subject is standing sufficiently in front of the background so that the use of shallow depth of field causes the background to become softly blurred, as in the photo shown in Figure 22.3.

STEP 2: PLAN FOR THE OPTIMUM LIGHT

■ If your light source comes from the east, a good time to shoot your portraits is mid-morning. If your window faces west, afternoon is a better time to set up for your portrait session. If it's cloudy out, open the blinds. Cloudy skies provide an excellent soft light that acts as a natural diffuser. If bright sun is streaming in, try diffusing the light by dropping the horizontal blinds or closing the vertical blinds (if you have them). Leave the blinds in an open position and adjust them to control the amount of light that is falling on your portrait subject. As stated previously, experiment with what you have available.

TIP

Position your portrait subjects 8 to 10 feet in front of the backdrop for the best effect. Cloth backdrops tend to have creases and wrinkles, so the further your portrait subject is from the backdrop, the more blurred the backdrop appears in your portrait. Blurred backgrounds are best when you want the person to be the center of attention, not the backdrop.

22.3 © 2005 Kevin L. Moss

■ If you are photographing your portraits outdoors and you want to avoid back-lit photos, have them face the light. If the sun is strong overhead, try moving the person you are photographing to a more shaded area.

STEP 3: SET UP THE CAMERA ON A TRIPOD

■ Because you're working with only available light, set your camera up on a tripod. Using a tripod for portraits helps you take sharp photos.

STEP 4: DECIDE WHAT TYPE OF PORTRAITS YOU WANT TO TAKE

■ If you're taking the portraits for your own purpose, plan out how you want your subjects to be posed. Sitting, standing, looking at the camera, or looking away from the camera are only a few of the ideas with which you can experiment. If you're photographing your portrait subject for her purposes, such as a portrait to be used for print advertising or a newsletter, ask the person you're photographing what she wants. Write down the list of different photos you want to take ahead of time, and make sure you check the list before you wrap it up.

STEP 5: SET UP THE CAMERA AND CHOOSE SETTINGS

■ Set up your camera ahead of time before you begin shooting your portraits. I usually shoot my natural-light portraits in aperture mode. If I have only one subject, I choose an aperture of around f/5.6 on my digital SLR. I set my compact digital camera that does not have aperture or shutter priority modes to portrait mode. Portrait mode helps ensure my aperture is set to a lower number, thus opening up the lens and keeping the subject focused while blurring the background. Additionally, I make sure my flash is turned off. Make sure that you are shooting at the lowest ISO possible to obtain the shutter speeds you want, such as a minimum of 1/60 of a second, and that you have set the image quality correctly to the highest setting, such as JPEG Fine or Raw.

STEP 6: POSE THE SUBJECTS AND BEGIN TAKING PHOTOS

■ Make sure the subject is comfortable, positioned away from the backdrop, and posed for the first position on your posing list. Take a few test shots and review the exposure in your histogram. Check for correct white balance, make any corrections, and take a few more shots. After you have made sure your digital camera is adjusted correctly, shoot away! Remember to be creative and capture as many poses as you can. Don't forget to photograph your subject in both portrait *and* horizontal orientations.

TIP

Whenever you shoot portraits, always inspect the entire frame to make sure nothing is out of place. Check the person's hair — are any strands hanging awkwardly or across his face? Look at the person's clothes and make sure no fibers or fuzzy things appear where they shouldn't. Lastly, look at the background and make sure you have cropped the edges of the backdrop out of the frame.

STEP 7: REVIEW THE PHOTOS

■ Take a minute after the first shots are complete and review the results on the LCD. Check to make sure the focus is correct and that the subject looks relaxed and not too posed. Look at the depth of field to make sure the background is blurred. I always spot-focus my portrait subjects on their eyes. You know what they say — the eyes are the windows to the soul! Focused eyes always make for a great portrait, but make sure the rest of the person's face is well focused too!

SHOOTING CANDIDS

23.1 © 2005 Kevin L. Moss

23.2 © 2005 Kevin L. Moss

I carry a digital camera with me at all times. I don't lug around one of my digital SLRs and lenses every time I go to the grocery store or wherever my trip takes me, but I do carry one of my compact digital cameras. I want something small I can fit in my pocket that I can easily take out and shoot a photo of anything or anybody interesting I come across during the day. The photos shown in Figures 23.1 and 23.2 are a result of just that. I spotted a window washer outside an office window doing his job and took the picture *through* the blinds. It was a sunny day and that allowed me to have just enough exposure to get the

137

shot. I made sure my flash was turned off, though; I didn't want to ruin the shot with reflections off the window *and* freak out the window washer at the same time! As it turned out, the window washer never knew I was there, making for a perfect candid shot.

Candid portraits have always made for some of the best photos of people. Capturing a person or persons doing their work, going about their day, or in a non-posed position always makes for interesting photos. Shooting candid portraits is a subject most photographers don't really think about or ever plan for. Plan on shooting candids whenever you can; you'll be surprised how your portfolio will grow with interesting photos of people.

STEP 1: BE PREPARED

■ The best way to be prepared for candid photos is to have a digital camera ready. If you're using a compact digital camera, keep it set on automatic mode so that your camera is set up for general photos with no specific aperture or shutter speeds. Technique 46 talks about the advantages of carrying a camera wherever you go; candid photos are a great example of why. Even when I'm out taking photos for a client, I'm always on the lookout for unusual people shots around me. If you don't have a camera near, you miss opportunities to shoot some interesting shots like the ones I photographed of the window washers hanging from the roof. The moral of the story: Be prepared so you can take advantage of candid shot opportunities.

STEP 2: SET UP THE CAMERA

■ If the situation allows you the time to properly set up your camera, check your settings. Make sure you've selected the proper shooting mode for

the shot. For example, if your subjects are walking, you may want to set the camera to shutter priority mode and use a fast shutter speed such as 1/300 or higher to "freeze" the action. Decide whether to use a flash. Remember, flashes draw attention to what you are doing and you may not want to alarm the subject of your candid. Is your ISO set properly? Have you set your white balance? Try using auto white balance if you're in a hurry.

STEP 3: BLEND IN

■ When taking candids, try not to stand out in the crowd. Use your zoom lens and take photos from a distance. The best candid photos are the ones where the subject does not even know you are there.

WARNING

Candid photos are great, but people sometimes don't like having their picture taken without permission, especially adults with children. If you can get away with shooting a few photos without being noticed, use your best judgment before clicking away. If you are with people you know and intend to take candid photos of them, let them know ahead of time to keep doing what they are doing and tell them "don't mind me." Try to avoid situations with potential conflict, for obvious reasons!

STEP 4: PICK A SPOT AND WAIT FOR THE OPPORTUNITY TO COME TO YOU

■ The most important part of taking candid photos is to be patient. Stay in your spot for a while and look around for potential opportunities. For good candid photos, patience is your best friend. If you wait long enough, the opportunity will come to you. If you are taking photos of crowds, hold your ground. Wait for the crowd dynamic to change and take photos from different angles and orientations.

STEP 5: REVIEW YOUR SHOTS

■ After taking a series of photos, review the shots you have taken on the LCD. Make any necessary adjustments to aperture, shutter speed, white balance, and focus before taking more photos.

TIP

If your subjects are moving, take advantage of the situation and photograph their movement. Pan the camera with their movement to get a horizontal blurred background. Secure your digital camera on a tripod, chair, or railing and use a slow shutter speed to blur the subject's movements for another effect. Sometimes a little blur can be a good thing!

EXPECT THE UNEXPECTED

After a recent portrait session, and having already packed my equipment in the van, I spotted one of my portrait subjects peering through the glass looking outside. I quickly grabbed my compact digital camera, turned it on, and quickly put it in automatic mode to get the shot shown here. Because people, especially children, are so spontaneous, you may have only a split second to capture a magical moment, so be prepared to act quickly because the moment may soon be gone!

© 2005 Kevin L. Moss

SHOOTING A GREAT FAMILY PORTRAIT

24.1 © 2005 Kevin L. Moss

24.2 © 2005 Kevin L. Moss

One of the greatest joys of digital photography is the ability to capture a family in a moment of time and then show them the results immediately. The family often gets dressed up and looks forward to having their picture taken. It is a big deal for the family and I don't like to disappoint them. Every family I photograph has the goal of mounting and framing the family portrait on the living room wall of their home. For that reason, doing it right the first time is important; second chances are hard to come by when taking portraits. Taking family portraits puts extra pressure on the photographer to perform, but proper technique and practice will set you up for success. The photos in Figures 24.1 and 24.2 show a family portrait taken onsite in their home with a portable studio setup — a neutral-color, seamless paper background, and key, fill, and background lights mounted on stands with umbrellas.

STEP 1: ASK THE PORTRAIT SUBJECTS WHAT THEY WANT

■ Different photographers have different styles when working with people. Many portrait studios offer their customers a "menu" with a limited number of sets, backgrounds, and props. Some photographers wing-it, letting each portrait opportunity be unique. As for me, I like to ask the people I'm about to photograph what they have in mind. Don't be afraid to ask; they may not feel comfortable asking themselves. Ask them about what type of portraits they have in mind. Are they looking for the traditional studio look? Candid portraits? Only portraits together as a family, or individual portraits, or both?

Getting the family involved in the decision may make your job easier because their input helps you plan how you're going to set up for the session. Get their input on the backdrop for the portraits. Do they want the photos taken outdoors as well as indoors? Keep in mind that the type of equipment you have may have to determine the types of portraits you can take. If you don't have studio lights, strobes, and backgrounds, plan on taking the best indoor available-light photos you can. Plan on taking the family outside and use nature's light to illuminate your portraits. Make the best of the situation and plan to use what is available to you.

STEP 2: PREPARE AHEAD OF TIME FOR PORTRAITS

■ The key to a successful family portrait is preparation. The last thing you want to do while taking family portraits is spend time figuring out how to set up your flash. Work out all those details ahead of time. Often, the family you're taking photos of will have small children, which gives you more reason to be prepared and work at a good pace. Kids get tired and cranky (really!), and the

window of opportunity may be small for that reason. Having all your batteries, flashes, backgrounds, stands, and tripods ready allows you to concentrate on the people you're photographing. You want to pay attention to your subjects and ensure they're posed properly.

STEP 3: SET UP YOUR EQUIPMENT

■ Whether you are photographing your family at home or another family in their home, allow yourself time to set up your equipment. I often pack a few cloth backgrounds in addition to seamless rolls of paper that fit my background stand. If you are shooting portraits in a person's home, you may not know ahead of time what type of flooring is in the space in which you have to set up. If the room you are taking photos in has a carpeted floor, you may not be able to use seamless paper (paper rips when walked on over carpet). If the room is carpeted, use your cloth backgrounds.

STEP 4: TAKE TEST SHOTS

■ Ask one of the subjects to volunteer for a few shots so you can adjust your camera, strobes, and flashes for the conditions you have. Make sure your digital camera's shooting mode, aperture, white balance, and image size are all set appropriately. If you carefully make all your adjustments ahead of time with a test subject, such as I did with the dad in Figure 24.3, taking the rest of the portraits is easier.

STEP 5: POSE AND THEN SHOOT

■ After you're all set up, gather the people you're going to photograph and take the time to pose them. Avoid having your subjects face the camera

head on. Ask them to move their bodies toward the main light source if you're using flashes, strobes, or window light. If you're photographing a large group, avoid having them stand side by side; have the group on the left half turn their bodies toward the right and have the people on the right turn their bodies toward the left. Try to arrange them in a horseshoe arrangement. Make sure families of three or four members are huddled close enough to fit in the frame, as in the portrait shown in Figure 24.4. Don't be afraid to move around yourself to make sure you have a good angle. Use your zoom to crop in the camera as opposed to doing it later in Photoshop.

TIP

After taking the test photos, carefully review them on your digital camera's LCD. Check to see whether the exposure, white balance, and depth of field need adjustments. Make the necessary changes and take a few more test shots until the photos look good and your digital camera is ready to shoot.

24.3 © 2005 Kevin L. Moss

24.4 © 2005 Kevin L. Moss

If children are part of your portraits and the parents would like photos of the kids individually, getting those poses done first is a good idea. Children are often more attentive and less tired at the beginning of the shoot as opposed to later in the day. As the day wears on and you have been taking portraits for a while, don't forget to let everyone take a break! This break is a good time for you to review the photos you've taken to make sure exposure and posing are consistently good. Zoom in on the images on your LCD to see whether the camera is properly focused. Make any necessary adjustments and then get the family back together for more photos.

STEP 6: REVIEW THE PORTRAITS WITH THE FAMILY

■ One of the advantages of using a digital camera is the ability to review photos on the spot and make any corrections while you are still set up to take photos. Review what you have done so far with the family you are photographing. Ask whether they are happy with what you have captured so far and whether there are any more photos they would like to have taken. Be sure to ask the parents whether they would like just a photo of them without the kids, like the photo shown in Figure 24.5. There will be plenty of opportunities to take photos of the kids as shown next in Technique 25.

24.5 © 2005 Kevin L. Moss

TAKING GREAT PHOTOS OF KIDS

25.1 © 2005 Kevin L. Moss

25.2 © 2005 Kevin L. Moss

One of the most fun and rewarding types of photography is taking photos of kids. Whether you're taking photos of your own children, or neighbors', friends', or your relatives' kids, you know that you've gotten some great shots when everyone wants prints, such as the portraits shown in Figures 25.1 and 25.2. Taking great photos of kids can be rewarding, but it can also be challenging.

Unlike adults, kids can't stand still for long periods of time. They want to move about, explore, and interact with the other kids who may be around. The younger the kids, the harder it is to have them sit still and pose. The best you can do is to first prepare and then go with the flow.

From personal experience, I have found that the best photos I've taken of children came out of the less restrictive environments. Let's face it — getting children to pose the way their parents want them to is hard. The best strategy is to capture them at the moment they're doing what they do best — playing!

STEP 1: SCHEDULE PHOTOS AT THE BEST TIME FOR THE KIDS

■ If you are going to be shooting photos of small children and you can choose the time, try to schedule your session a few hours before the kids' naptime. Although photos of cranky kids can be cute sometimes, for most portraits you'll want to catch the kids at a time they aren't tired. If the kids are yours, you'll know what times to avoid; if the children are someone else's, ask the parents what the best time is to take photos. The last thing you want to do is arrive and have the kids ready for their nap!

STEP 2: PLAN FOR THE TYPE OF PHOTOS YOU WANT

■ Sit down with the parents of the kids (or your spouse if you are photographing your own kids) and discuss what type of photos you want to take. Decide whether you want to use any special props, such as athletic equipment or musical instruments, in the photos. Does the child have a special stuffed animal or chair that should be part of the photographs? Be creative and ask whether the parents (if other than yourself) would like anything

special done while you're shooting the photos. They'll be grateful you asked and the information can help you in your effort to do a great job!

STEP 3: SET UP FOR PHOTOS BEFORE THE KIDS ARE READY

■ If you are going to be taking photos of kids with a studio setup, you'll want to make sure the kids don't have to sit, watch, and wait until your backgrounds, lights, stands, and digital camera are all set up. Don't bring them in until you are absolutely ready. Go through your camera setup ahead of time, making sure the proper mode, aperture, flash, white balance, and focus are set. Double-check the file size and ISO settings, as well.

STEP 4: TAKE TEST SHOTS

■ Ask one of the older kids (if there are any) or an adult to volunteer for some test shots so you can make sure all the settings are correct and the camera is ready to go. Review the test shots on the LCD and histogram. Check to make sure the focus, white balance, and exposure are correct.

STEP 5: POSE THE KIDS AND TAKE PHOTOS

■ Keeping in mind the poses you've planned to take, start with the most desired photo you've agreed upon. Keep Mom as a resource to help with the posing, but keep in mind that even she may distract the children. If that approach isn't working, see whether the kids will listen to your instructions. Make sure other family members aren't in back of you; they can distract the kids you are photographing and you can wind up with photos where the kids are all looking in different directions.

STEP 6: REVIEW THE PHOTOS

■ After taking all the photos you had planned for and a bunch of shots you didn't plan for, review the photos on the digital camera's LCD, with the parents if the children aren't your own. Check for any poses that didn't work out and try to shoot those again. Review exposure, lighting, white balance, and focus to make sure you are getting the best from your digital camera. If necessary, make any adjustments and take some more photos, if the kids are up to it.

■ Try to work quickly, but review the images on the LCD to make sure you're getting what you want. Make sure you're focusing on the children's eyes and that you have cropped properly with your zoom lens.

■ If the kids become distracted and lose interest after you take some photos, take a break. Forcing them to do anything they don't want to at the moment doesn't make sense; it just ruins the fun! Take the opportunity to let the kids recharge for five minutes while you review some of the photos on the LCD. See what worked so you can plan for more photos. Ask the kids if they're ready to take some more photos before getting back to work. Make them feel like they're part of the process and the fun.

■ Expect the unexpected. After all, kids will be kids; take advantage of the situation. Let the kids be themselves and let them jump up and down and have fun, all while you take photos: You'll get some great shots like the photo shown in Figure 25.3.

25.3

PHOTOGRAPHING PETS

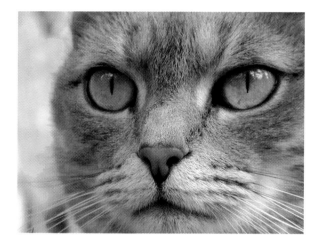

26.1

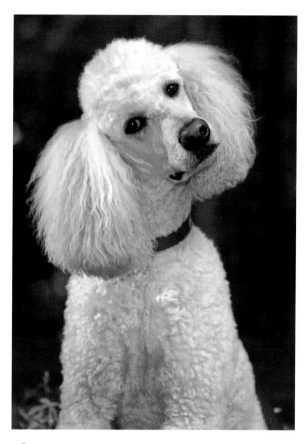

26.2

ABOUT THE IMAGE (26.1)

"Yellow Cat Eyes" Nikon Coolpix, hand-held, zoom set to 111mm (35mm equivalent), f/4.0@1/99, ISO 80.

Many people are so attached to their pets that they consider them to be members of the family, so even though pets are animals of one kind or another, this technique is in the people chapter rather than the nature chapter. In many ways, taking a pet portrait is rather like taking a people portrait. You can shoot tightly and just show part of your pet, like the face of the cat shown in the photo in Figure 26.1. Or you can shoot it doing something that it enjoys, like sleeping, chasing a ball, or perching on a bird stand (if it's a bird). You can also work to bring out a facial expression that is just so *them,* as in Figure 26.2. In this technique, you learn how to get a good pet portrait that you will enjoy taking and viewing.

STEP 1: DECIDE WHERE TO SHOOT

■ The first step to getting a good pet portrait is deciding where to shoot. Sure, you can put the pet on a chair or table in front of a black drape and shoot the subject with strobes just as you would a people portrait. However, you can get much more interesting photos of pets if you shoot them in their natural surroundings doing things they enjoy doing. If your pet is a cat, try catching it napping in the sunlight in front of a favorite window. Or, you can shoot pets outdoors playing with a ball or chasing children.

Once again, you should be aware of how important it is to have good light. An attempt at shooting a black Labrador in dark shade will be challenging. Likewise, when shooting a white poodle in bright sun, getting a well-exposed photo will also be hard. Yet, if you place the same white dog in an area of your yard where overhead trees soften the bright sun, you can easily shoot against a shady background to get a photo like the one shown in Figure 26.2. The quality of light makes or breaks a photo — so choose a day, time, and place where you have good light.

If you have a small pet like a bird, mouse, or snake, having someone hold the pet in his hands or on a comfortable perch held near a window can provide both a good source of light and a way of controlling the pet's movement. Think about ways to involve your pet that result in some good facial expressions. A meow sound made the poodle in Figure 26.2 turn his head and look curiously at the owner, who was standing directly behind the photographer. With a cat, a string or a bit of twine can work wonders. For a horse, it might be a carrot or a lump of sugar, or maybe you can get a good photo just by shooting it in the stall, like the horse shown in Figure 26.3. Be creative, and experiment!

Remember, a great pet shot doesn't have to be a formal shot. Next time your pet is fast asleep, with legs up in the air, and has a silly expression on its face, quietly grab your camera and take a few shots. Many of the best photographic opportunities just happen — they aren't created.

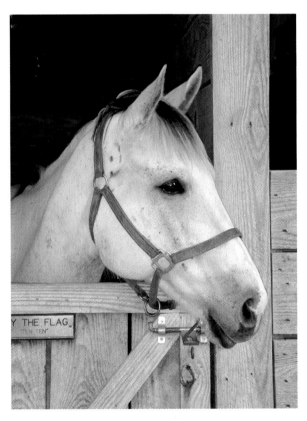

26.3

STEP 2: CHOOSE FOCAL LENGTH

■ Depending on the length of the zoom lens on your camera, you may want to use the maximum focal length of your lens when taking a pet portrait. Using maximum focal lengths allows you to be farther away from your subject, which can be helpful if your pet is uncomfortable with too much attention. A little extra distance can also be helpful if your pet is a real attention hog, as you can reduce your pet's activity by being a bit more distant and aloof.

STEP 3: CHOOSE CAMERA SETTINGS

■ If you are planning to shoot outdoors, select aperture priority mode and open your lens to its maximum f-stop. Depending on the amount of available light, the maximum f-stop setting will ensure that you are getting the fastest shutter speed you can, which helps stop any movement and helps keep your pet sharply focused. Try to use at least 1/250 of a second as the shutter speed if your pet is moving quickly. Next, consider using your flash. Using your flash outdoors provides the right amount of extra light to allow you to capture detail in shadows, and is especially helpful if your pet has dark or black fur.

■ If you plan to shoot indoors, you have to evaluate the amount of available light to decide whether or not to use flash. If you have a cat that likes to sit on a window ledge, your primary concern is getting a good exposure by metering for the cat, not the bright window. Use your camera's exposure compensation feature, or spot metering with exposure lock to ensure that your subject is properly exposed. Shooting in a darker part of the room may work for sleeping pets (which can actually make some very good pictures), but if you have an active animal, you need to use supplemental lights. See Technique 21 for help on choosing lights.

STEP 4: GET YOUR PETS READY

■ Because shooting a pet can be more or less challenging depending on whose pet it is, what kind of pet it is, and how manageable it is, decide who ought to be working with the pet and who ought to be behind the camera taking photographs. Some of the most manageable pets, such as a well-trained dog (you cannot really train a cat, can you?), can still be challenging unless you can get them to mind and to look like you want them to look.

■ Getting your pet's attention, getting the right composition, and taking pictures all by yourself is sometimes tough, so, if possible, have an assistant who can either engage your pet or take pictures. If you plan to use an assistant, choose someone who has a good relationship with the pet and knows how to control it. A family member or a close friend who knows the pet would be a good choice.

■ In addition to your camera gear, make sure you have a plentiful supply of the pet's favorite treat. Food is a good motivator and reward, and it helps to get the pet to do what you want. Other useful tools for getting attention are noise makers, such as squeakers and clickers. For animals who are fascinated by movement, like cats, a string or bit of yarn can be useful to attract their attention. If your pet has a favorite toy, use it to keep the pet posed for good photographs.

STEP 5: COMPOSE AND TAKE PHOTOS

■ Look critically at the light, and choose your angle based on its direction. While the obvious orientation is to have the sun shine toward the subject, you should also try some shots with the sun behind your subject, and fill the shaded face with light from your flash. If your camera has an automated fill flash mode, try it first. If not, you may need to move closer or farther away to achieve the correct balance between flash and existing light. You can't shoot from too far away, because built-in flash units are only effective at close range. Getting the exposure correct may take a few tries, but backlit and sidelit shots can do wonderful things for subjects with fur. Be sure to review the results on your LCD monitor as you shoot to ensure that you are getting the right exposure, and that you are not picking up any red-eye from the flash. If your pet has dark fur, you may need to shoot with the sun behind you to get the detail you need.

■ When you are composing a picture of a pet, be sure to get the eyes in focus. If the eyes are in focus, your mind fills in the rest of the detail, and overall, it makes for a more pleasant portrait. The same technique applies for photographing people. A *catch light* (a reflection of the light source) in the eyes gives your portrait more life — try to shoot to get one.

■ Try shooting close to the ground so you're shooting level to the pet, as that perspective is much better than one where you are looking down at it. To a small kitten, grass may be like a jungle, and you can shoot through the blades of grass to capture a unique perspective. Turn off your flash if it lights up too much of the foreground. Be aware of the background, and try to keep it simple. Indoors, choosing an angle that allows the background to go dark is relatively easy; when you are shooting outdoors, try to keep the background plain or out of focus.

STEP 6: EVALUATE SHOTS AND CHANGE SETTINGS IF NEEDED

■ After you've taken a few pictures, take time to carefully evaluate the results to see that they are well-composed, that they are in focus, and that they are properly exposed. Use your LCD monitor to look at the overall composition, and if your camera review has a zoom feature, use it to zoom in on the subject's face to see whether the eyes and face are in focus. Likewise, if your camera has a histogram, take a quick look to evaluate exposure.

■ Although obviously some differences exist between photographing different kinds of pets, great pictures of any kind of pet share a surprising number of similarities. First, the animal's attention is focused. When a horse's attention is focused, its ears are pricked forward, both pointing in the same direction. With a snake, it could be indicated with a fixed stare of one eye, and a flick of the tongue. No matter what size the pet is, its eyes should be alive and bright, and the pet should be shown in a setting that is free of distracting elements.

TIP

Shoot many pictures because expressions on pets come and go quickly. Try to capture a moment of focused attention; it can be a great way to show the personality of your pet. Getting this shot may be difficult with some pets, but not impossible. With most animals, cocked ears, a focused gaze, and an alert body posture are the signals of a happy pet. Happy pets make great photos!

TAKING SPORTS ACTION PHOTOS

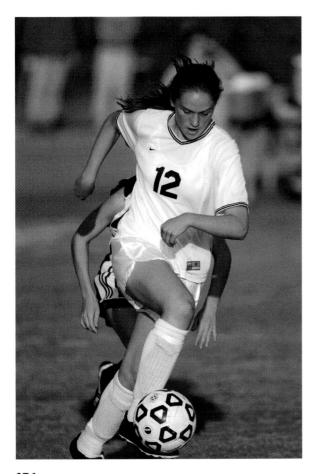

27.1

27.2

ABOUT THE IMAGE (27.1)

"Sterling Heading Toward the Goal" Canon EOS 1D, mounted on monopod, Canon EF 300mm F/2.8L IS with 1.4× teleconverter (546mm effective focal length), f/4.0@1/600, ISO 200.

Getting a good sports action photo is exciting for everyone — the players in the picture, the friends and family of the players, and the photographer! Of all the different types of photography, sports action photography involves more skill and luck than just about any other kind of photography. In this technique, you learn some tips and techniques to help improve your chances of getting lucky and getting great sports action photos like the ones shown in Figures 27.1 and 27.2.

Two of the most frequently asked questions on many of the online photography forums are "Can you shoot sports photos with a compact digital camera?" and "What kind of digital camera is best for photographing sports action?" With the growing popularity of digital cameras and of photographers being involved in sports as players or spectators, these seemed like good questions to answer in this book, which was primarily written for those using compact digital cameras.

WHAT KIND OF DIGITAL CAMERA IS BEST FOR PHOTOGRAPHING SPORTS ACTION?

You can get lucky (after taking lots and lots of photos) and get a reasonable sports action photo, but if you want to get lots of good sports action photos, you need a digital SLR camera. Two categories of digital SLR cameras can be used for sports action photos. First are the low-end *prosumer* digital SLR models like the Canon Digital Rebel XT and the Nikon D50. For the ultimate sports action photos, you need to spend more money and get a Canon EOS 1DS Mark II or Nikon D2X — both specifically designed for photojournalists and sports photographers. These pricey but excellent cameras take wonderful sports action photos!

WHAT LENS SHOULD YOU HAVE?

The ultimate lens for shooting sports action photos depends on the sport you are shooting and the kinds of shots you want. Many pro sports photographers use two or more different lenses during a game — one for when the action is close and one or more for shooting when the action is farther away.

If you want to shoot games on playing fields like soccer, lacrosse, and football, a 300mm, 400mm, or even 500mm lens is excellent. However, it is not just the focal length that is important. Having a fast-focusing lens and one with a large, maximum aperture is also important. The large aperture lenses (for example, f/2.8) allow more light in, which makes it easier to use faster shutter speeds to get photos when little light is available, as you will find in night or evening games. The large aperture also makes shooting photos of players who are perfectly focused against a soft blurred background possible.

STEP 1: DECIDE WHAT KIND OF PHOTOS YOU WANT

■ Once again, you must decide what kind of photos you want before choosing a lens, camera settings, and where you will stand to shoot. Are you looking for full-frame photos of players for large prints? Do you want team photos, or photos showing five or more players at the same time? Or do you just need a few good photos for a Web page?

■ After you decide what kinds of photos you want, you also need to decide how realistic you are about getting them. Important things to consider have to do with the amount of available light, the focal length of your lens, and the camera you are using.

When shooting sports events, remember that it is an event — not just a game between competitors. Look for good shots of spectators, cheerleaders, happy or sad fans, coaches, and players celebrating on and off the playing field. Figure 27.2 shows two players celebrating after one of them got an important goal. This photo is much more exciting than the photo in Figure 27.1 of the player kicking the ball in the goal.

STEP 2: SET UP CAMERA AND MONOPOD

■ Depending on the weight of your camera and lens, the focal length of your lens, and your strength, decide whether you want to shoot with a monopod or hand-hold your camera and lens. In most cases, when you use a lens with an effective focal length over 200mm, you ought to be shooting with some kind of support.

STEP 3: CHOOSE CAMERA SETTINGS

■ Choose your camera settings based on the following variables: the sport you are shooting, available light, camera, lens, distance to action, jersey color, and so on. Choosing camera settings to shoot sports action is a major topic of debate among sports photographers. There are two basic approaches. You can use an automatic exposure setting — either aperture priority so that depth of field is set, or shutter speed priority to stop action. Or you can use the manual shooting mode and set both the shutter speed and aperture. The manual approach works effectively when you're shooting players with bright white jerseys playing against a team with dark jerseys. To determine a good exposure when using the manual mode, you can either use a hand-held light meter, or you can shoot a few players and use the camera's histogram to decide how much to adjust the setting.

STEP 4: DECIDE WHERE TO SHOOT

■ Deciding where to stand to shoot is one of the most important decisions you can make after you've chosen your camera settings. Being in the right place at the right time to get the shots you want is what sports photography is all about. There are lots of photographers who shoot sports; however, there are far fewer good sports photographers. The difference between the two is knowing where and when to shoot, and how to choose the optimal camera settings for the light and the intended results. The only way to become a good sports photographer is to know how to read the game you shoot and to practice. The more you study the game and the more you shoot, the better you will become.

■ Where should you stand? Once again, it depends on the game. Assuming you are shooting a field sport such as soccer, lacrosse, or football, you want to shoot where the play occurs, where you can shoot the faces of the players, and where you have a good background behind the players as often as possible. And you should avoid shooting when possible when the sun is behind the players. Otherwise, you will be shooting into the sun, the player's face will be covered in shadow, and you will risk lens flare from light striking the front of the lens.

■ When the game has been underway for a few minutes, you can get a better idea which part of the field the game will be played on. If you have permission and are allowed to move around the field during the game, you want to keep moving depending on where the players are and the state of the game (that is, one is whipping the other team, or it is a tightly fought game that occurs in the middle of the field).

STEP 5: COMPOSE AND SHOOT

■ When the players are in range of your lens, watch their eyes, the ball, and the defending players. In soccer, you can get excellent shots when the players jump up to head the ball after a goal kick, as shown in Figure 27.3. Often you can sense which player will get the ball by watching the eyes and facial expression as the player braces himself to get a ball or take a bump from another player. Another good soccer play to watch is a corner kick. Keep your camera on the players in front of the goal and wait for the ball to get to them.

27.3

In lacrosse, you can get some awesome shots as a player runs around the back of the goal and comes toward you in line with the goal. The offensive player will usually be facing you while being tightly guarded by one or more defensive players. If you're in luck, you can get a shot of this action with the goalie showing behind the action with his stick extended, ready to stop a shot. Each sport is different. Getting good shots takes time and experience.

STEP 6: EVALUATE RESULTS

■ Use the camera's histogram to make sure you're getting a good exposure and that you're capturing the action you want. This is the best part of using a digital camera — you can look at what you just shot, make adjustments, and continue shooting.

SHOOTING NIGHT AND INDOOR GAMES

Shooting night and indoor games is very challenging to both the photographer and to the equipment. If you are not shooting with a lens with an aperture of f/2.8, you're not likely to be able to shoot even if you can set the ISO setting to 3200! If you are using a lens with an aperture of f/2.8, you will be just able to stop action at 1/250 using ISO 1600.

WHY MOVE UP TO A DIGITAL SLR FOR SPORTS?

If you're intent on shooting sports action, there are four driving reasons to move to a digital SLR: focus speed, minimal or no shutter lag, three to eight frames per second shooting speed, and choice of fast lenses. If you want more information on shooting sports action, consider becoming a member of Sports Shooter at www.sportsshooter.com. This active Web site has all the information any sport shooter would want on cameras, playing fields, and techniques.

CHAPTER 6

PHOTOGRAPHING NATURE

Photographing nature is one of the most popular and rewarding forms of photography that exists. One of the benefits of shooting landscapes and wildlife photos is being in the natural environment and enjoying everything nature has to offer. If you like photographing nature, you'll enjoy these techniques. Technique 28 shows you how to get great photos of fall colors. If you're faced with bad weather when you want to shoot nature photos, check out Technique 29 for tips on taking advantage of adverse weather conditions by shooting the weather itself! Technique 30 shows you how to take great close-up photos of flowers. In Technique 31, you learn how to shoot waterfalls. Technique 32 shows you how to take photos of the largest natural wonder we have, the sky. Using these techniques, you can successfully capture digital photos of the most spectacular subject of all, nature itself.

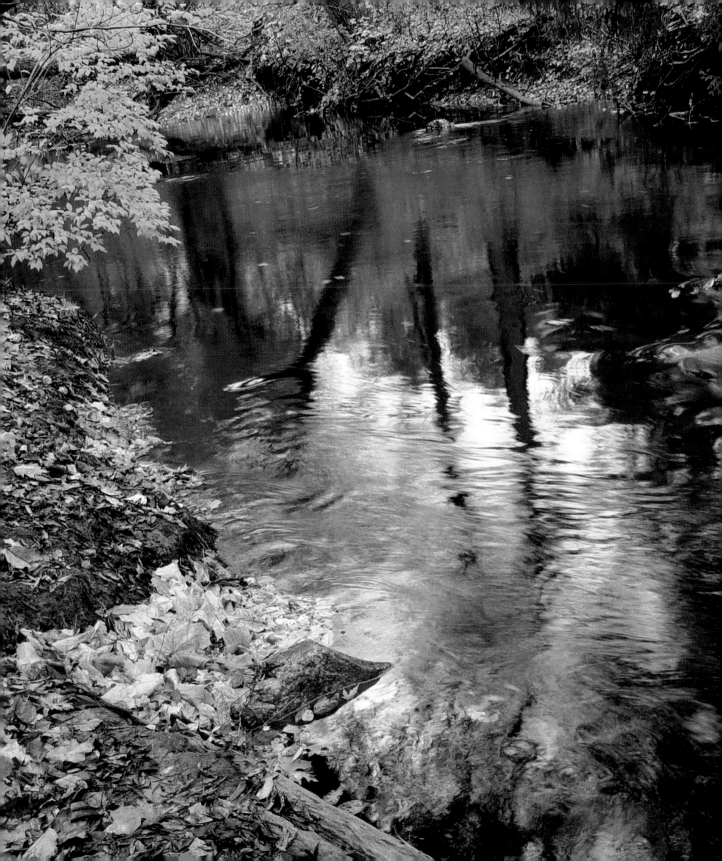

SHOOTING FALL COLORS

28.1 © 2005 Kevin L. Moss

28.2 © 2005 Kevin L. Moss

One of the greatest times of the year for nature photographers is autumn. Trees begin to change color as early as late August in some northern latitudes and continue to change until late October or early November further south. Many photographers like myself take yearly trips out of the city to areas where fall color is at its best with one purpose — to capture blazing fall color. The window of opportunity in various regions is usually a few weeks, beginning from when colors start to change and lasting until they are at full color, also known as *peak* color.

Photographs of fall foliage are a staple in many nature photographers' portfolios. If you love shooting color, the autumn season provides you with unlimited digital photography possibilities. No other time of year offers you the reds, yellows, purples, greens, and browns that fall colors provide. This coming fall, schedule some time to take a few color tours with your digital camera and tripod so you can get some shots like the ones shown in Figures 28.1 and 28.2.

STEP 1: SCHEDULE YOUR FALL COLOR SHOOTING

■ Depending on what part of the world you live in, fall colors emerge at different times. For example, the peak fall color in northern Michigan occurs around the second week of October, but in New England and parts of Canada the peak occurs in late September. You can catch great fall color in the Smokey Mountains as well as in parts of Minnesota in late October. Organizations such as the AAA Motor Club or even the Weather Channel provide daily fall color updates on their Web sites, `www.aaa.com` and `www.weather.com`, respectively.

STEP 2: SCOPE OUT LOCATIONS

■ If you are traveling away from home for your fall color shooting or shooting in areas near your home, take time to scope out locations to shoot fall color. If any wooded areas, state parks, or even municipal parks are nearby, check them out ahead of time and put your favorite sites on your "to-photograph" list. Some of the best fall color I've ever photographed came from areas in my own neighborhood, such as the photo shown in Figure 28.3, which was taken in a nature preserve within walking distance of my home. Sometimes you

don't need to travel far to find opportunities to photograph nature; opportunities may be as close as your own backyard!

STEP 3: PLAN FOR THE WEATHER

■ Take advantage of the so-called adverse weather that's common in the fall season to get some great photos. You can expect rain, wind, and thick cloud cover when the seasons are changing. The photo in Figure 28.4 shows the result of being patient and waiting for the wind to die down. If you enjoy shooting colorful leaves, sometimes the best time to photograph is just after it rains. Trees are saturated with water, giving you more contrast resulting from the darker wet wood. If it is still cloudy out, you have the best diffused light source available, providing saturated and bright colors. The combination of dark trees and brilliant color makes for the best fall foliage conditions you can have. The photo in Figure 28.5 shows how the saturated colors and wet trees show more contrast on rainy days, providing the best conditions for fall color shooting. You can find more information on taking advantage of adverse weather in Technique 29, "Shooting the Weather."

28.3 © 2005 Kevin L. Moss

Shorter days, darker skies, and limited light in the forest almost always eliminate your ability to photograph fall color by hand-holding your digital camera. Make sure you use a tripod for all of your fall color shooting. For many of your photos, you want to use an f-stop that provides you with a deep depth of field to make sure the foregrounds and backgrounds of your photos are in focus. Using f-stops in the smaller range (f/6, f/7, f/8, f/9, and so on) on a compact digital camera produces a sharper depth of field but results in slow shutter speeds, typically below 1/30 of a second. Slower shutter speeds require the use of a tripod, but you can consider increasing the ISO setting slightly to enable you to use faster shutter speeds, which also helps reduce blur from wind-blown leaves.

STEP 4: SET UP YOUR CAMERA

■ Before even getting out of the car or setting your digital camera on a tripod, choose all your settings ahead of time. Choose the lowest ISO setting you can on your digital camera to ensure you get the highest quality images with the least amount of noise. Consider shooting in aperture priority mode so you can set your apertures to settings that give you the greatest depth of field, such as f/7 on a compact digital camera or f/16 on a digital SLR. If your digital camera does not have aperture or shutter priority modes, choose the landscape mode.

28.4 © 2005 Kevin L. Moss

28.5 © 2005 Kevin L. Moss

Make sure your camera is set to the best image size setting available, either JPEG Fine or Raw if Raw format is available on your digital camera. When you arrive at the site where you'll be taking photos, manually set your white balance to the lighting conditions you are in, such as cloudy, shady, or sunny. Consider setting the white balance setting to automatic if your manual white balance setting is not producing the results you want.

STEP 5: TAKE FALL COLOR PHOTOS

■ After you've scoped the location and chosen your camera settings, you're ready to get out and take some photos. Landscape photographers have no excuse for not using a tripod; make sure you use one as much as possible, especially in low light conditions when you shoot fall foliage. Your photos will come out much sharper. When I'm hiking and taking photos, I try to be aware of my 360-degree surroundings; I'm always on the lookout for a wide-angle vista or a close-up of leaves on the forest floor, like the photo in Figure 28.6. Shoot your photos in both portrait and landscape orientations. Zoom in on the scene or zoom out, looking at

different perspectives. One thing I'm always on the prowl for is water. Fall colors look great reflecting off of lakes, ponds or rivers, such as in the photo shown in Figure 28.7. Look for opportunities to take some panoramic photos, too. For more information on taking panoramas, refer to Technique 36.

Don't overlook all of your creative possibilities and don't be reluctant to fill up your memory cards with images; the more photos you take, the better the chance you'll capture that perfect fall color photo.

28.6 © 2005 Kevin L. Moss

28.7 © 2005 Kevin L. Moss

> **TIP**
>
> When shooting in rainy or misty conditions, try using a circular polarizer if you have one. Using a circular polarizer reduces glare off foliage and helps saturate colors. Experiment using a polarizer; rotate the filter clockwise or counterclockwise while viewing the effect on your LCD or through your viewfinder. (As a general rule, rotate the filter until you can just start seeing the glare reduced off the leaves.) Keep in mind that too much polarization can make the photo look unrealistic. Experiment until you get the effect you want.

SHOOTING THE WEATHER

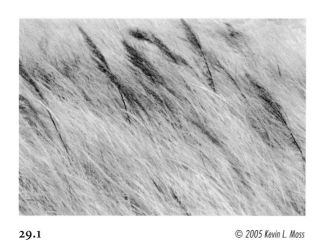

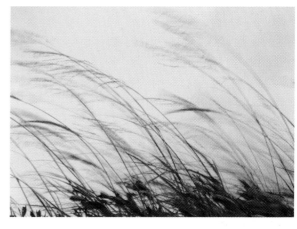

29.1 © 2005 Kevin L. Moss 29.2 © 2005 Kevin L. Moss

ABOUT THE IMAGE (29.1)

"Blowing Grasses" Nikon D70, mounted on a tripod, zoom set to 95mm, f/16@1/15, ISO 200.

As a photographer who has taken many landscape photo trips over the years, I've had my share of bad weather. I've dealt with week-long thunderstorms, sustained 50-mile-per-hour winds for two days straight, and blinding snowstorms, all in the month of October! Instead of staying in the hotel room, camper, or travel trailer, I take advantage of the weather and get out and shoot (but I also take precautions to protect my safety). The photos in Figures 29.1 and 29.2 never would have been taken if I had stayed at my campground during a storm that was producing 40- and 50-mile-per-hour winds. The day wasn't perfect for shooting fall foliage, but it *was* perfect for shooting the weather.

STEP 1: PLAN FOR BAD WEATHER

■ If you're setting aside a morning or afternoon for some nature photography, plan ahead for good weather *and* bad weather. Be ready for both situations and make the best of the time you have to take nature photos. You can get great shots when it's warm and sunny, cold and snowy, or just on a boring gray day. If you are planning a nature hike to take some photos in a wooded area, make sure you take a poncho or other rain-related gear. Protect your camera equipment with large sealable plastic bags and go out anyway. If it's raining hard, you can still take shots under cover of structures or even out of the window of your automobile.

> **WARNING**
>
> Taking photos in adverse weather conditions can be very hazardous to your health and well-being. When shooting photos in adverse weather conditions, make sure to use common sense; running out into an open field during a lightning storm while holding a digital camera attached to a metal tripod is just inviting lightning to visit your location. Remember, being outside during a thunderstorm does mean that there is an increased risk of being struck by lightning. Take extra precautions to protect yourself and others around you. Keep yourself informed by listening to the radio for weather reports and warnings. During a severe weather warning, adhere to the stated precautions. No photo is worth risking injury due to adverse weather.

■ Some of the most dramatic nature photos can be captured before, during, or after thunderstorms. Spring and early summer are the best times of the year for thunderstorms. Skies can be dramatic at these times, and if you're lucky, you may be able to capture some lightning while you're at it. The photo in Figure 29.3 shows a sky photo taken during a break in a line of thunderstorms traveling east over Lake Huron. It was late in the day and the sun was starting to set at the same time there was a break in the storm clouds, allowing just enough magic light to peek through. Where there are thunderstorms, there is bound to be a rainbow after the storm passes by, especially in late afternoon when sunlight is shining in a more level direction parallel to the horizon. Be ready to look in the direction the sun is shining for rainbows like the one shown in Figure 29.4.

29.3 *© 2005 Kevin L. Moss*

29.4 © 2005 Kevin L. Moss

STEP 2: SET UP THE TRIPOD AND CAMERA

■ If possible, make sure you set up your camera on a tripod. In many bad weather situations, you're faced with lighting situations where you may be forced to use a higher ISO setting (to allow for faster shutter speeds) to reduce blur from subjects that are showing movement such as leaves blown in the wind. Alternatively, you may want to intentionally show movement, and in that case you want to use the lower ISO setting. Using a tripod helps reduce shake and improves the sharpness of your photos.

STEP 3: CHOOSE THE CAMERA SETTINGS

■ Bad weather means that you need to have your digital camera ready and waiting for the right opportunity. During storms, I keep my digital camera mounted on a tripod ready for action. If you plan to take photos of scenes that are a great distance away, set your aperture to the lens *sweet spot,* a few stops above the maximum aperture. On a compact digital camera with an available aperture priority mode, this means setting your aperture from f/4 to f/5.6. If you are using a digital SLR, set your aperture to around f/8. Chances are good that you will be shooting the scene at infinity (past the focusing distance of the lens), so shooting at your lens' prime setting will not affect depth of field. Check to make sure you have the proper white balance; in other words, your ISO is set to the lowest setting to ensure the maximum image quality. To be safe, check that the image size is set correctly to the best image-quality setting.

STEP 4: COMPOSE AND SHOOT PHOTOS

■ In bad weather, you may be tempted to rush. Try to take the time and plan your shots. Does the scene look better in portrait or landscape mode? Try different orientations and zoom in and out of the subject to gain different perspectives. The photo in Figure 29.5 was taken just after a snow-storm at the point when the snow had subsided. Thick cloud cover made for a moody shot in low-light conditions. Using a tripod and the self-timer on the digital camera helped reduce vibration from pressing the shutter when shot at a slow shutter speed.

STEP 5: REVIEW YOUR PHOTOS

■ After taking some photos, review what you have captured using the LCD on your digital camera. Use the image review zoom feature on your digital camera (if you camera has that feature). Zoom in to make sure the photos are in focus. Check to make sure the white balance is set correctly; usually a cloudy setting works best in bad weather conditions. Consider switching to auto white balance if your manual white balance settings are not giving you the results you want. Check to make sure the photo looks properly exposed; use the histogram to check exposure (if your digital camera has that feature). Make any necessary corrections and then plan more photos.

> **TIP**
>
> To get an artistic blurred effect in bad weather such as rain, wind, or snowstorms, try setting your shutter speed to a slower setting, such as 1/20 of a second or slower. Make sure your camera is mounted on a tripod. If you're shooting in aperture priority mode, set your aperture to the third or second highest setting such as f/7 to f/8 on a compact digital camera or f/16 on a digital SLR; this maximizes your depth of field while slowing down the shutter speed. The slow shutter speeds and small apertures I've described allow you to capture rain, snow, or wind-blown grasses with a blurred effect while maintaining depth of field, if that is your goal. If you want a more shallow (or more blurred background) depth of field, consider attaching a neutral density filter to your camera lens. A neutral density filter of a rating ND2 reduces the amount of light by one stop. A neutral density filter of a rating of ND4 reduces the amount of light by two stops.

29.5 © 2005 Kevin L. Moss

TAKING CLOSE-UP PHOTOS OF FLOWERS

30.1

30.2

© 2005 Kevin L. Moss

Taking flower photos can be as rewarding as it can be challenging if you shoot them in their natural environment. When you shoot flowers outdoors, you usually face two challenges — how to minimize movement caused by wind, and how to shoot in good light. In this technique, you learn how to take a close-up photo of a flower, like the pink water lily shown in Figure 30.1, or the saucer magnolia shown in Figure 30.2.

STEP 1: CHOOSE THE DAY AND TIME TO SHOOT

■ Choose a day and time to shoot when the conditions are excellent. You have heard this advice several times before in this book, but what if you don't have a choice of which day and time you can shoot, which is frequently the case? What if the shooting conditions for a specific flower you want to shoot are never good?

The pink water lily, found in Hawaii, was in the shade most of the day, and the trade winds that always blow on the Hawaiian Islands kept it continuously moving. If you want to take a photo in these or similar conditions, you must learn to adjust your camera settings and use flash, if needed, to get the best shot you can. To do so, you must learn to balance the trade-offs between low ISO setting and digital noise, aperture opening and depth of field, and shutter speed and image blur caused by subject movement.

STEP 2: DECIDE HOW YOU WANT THE PHOTO TO LOOK

■ Deciding how you want a photo to look before taking a photo is always an important step. Because the water lily was in the middle of a pond, shooting it was not possible without getting into the pond. In the pond, I could shoot straight down on the lily, and I decided to get a photo that showed the whole flower surrounded by the lily pads and to have everything in the photo be sharply focused.

STEP 3: SET YOUR CAMERA ON A TRIPOD

■ Set up your tripod and attach the camera to the tripod. While the available light allowed shooting at f/8.0 and 1/200 of a second, I still used a tripod to reduce camera shake and to get more precise control over composition.

STEP 4: SELECT CAMERA SETTINGS

■ Start with the camera settings that give you the best image quality with the most depth of field. Choose the lowest ISO setting your camera offers (for example, 50 or 100 ISO) to minimize digital noise. Use an evaluative or matrix metering mode to meter the entire composition. Select automatic focusing and choose a focus point centered on the flower. Select the aperture priority mode, choose the maximum aperture (for example, f/8.0), and let the camera select the shutter speed.

STEP 5: COMPOSE AND TAKE PHOTOS

■ With the appropriate camera settings chosen, you can now compose and take one or more photos. Align the camera so that it is directly over the flower and make sure the face of the lens is parallel to the surface of the water or to the flower to keep as much of the flower in focus as possible. Take a few photos while slightly varying the exposure by using exposure compensation.

STEP 6: EVALUATE PHOTOS AND SHOOT AGAIN

■ After you've taken a few photos, look at the images on the LCD monitor and check the histogram, if your camera has one. (See Technique 11 for more about using the histogram.) After evaluating the photos, make any additional changes to your camera settings that you want and shoot a few more photos to get the ones you want.

If there is no way to control for the wind, and you do not want to use a higher ISO setting, but need to use a faster shutter speed, you can use a built-in flash or a macro ring light flash like the Canon Macro Ring Lite MR-14EX, shown mounted on a Canon PowerShot in Figure 30.3, or other external flash to help stop the movement.

If you have used a 35mm camera with a macro lens to shoot subjects like flowers, you may be aware how depth of field is severely limited. This is usually not the case with compact digital cameras due to the small size of their image sensors and the interrelated mathematics of optics and sensor size. This means that using the smallest aperture to get maximum depth of field may not be as important as you think. Figures 30.4 and 30.5 are photos of the same water lily shown in Figure 30.1, except the settings are ISO 50, a maximum aperture of f/8.0@1/50, and ISO 50, a minimum aperture of f/2.2@1/500, respectively.

TIP

If you're not sure whether you have a sharply focused subject, use your camera's image review zoom feature to zoom in on the image using the LCD monitor. You may need to check the documentation that came with your camera to see whether your camera has such a feature.

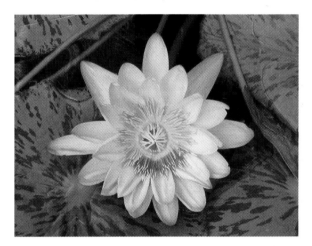

30.4

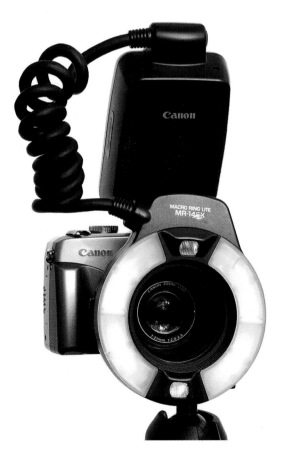

30.3

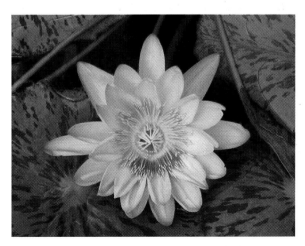

30.5

SHOOTING WATERFALLS

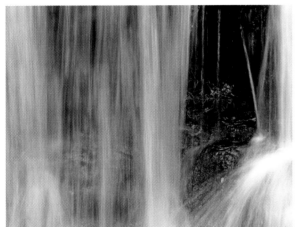

31.1 © 2005 Kevin L. Moss

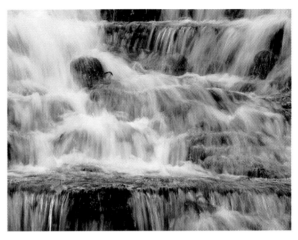

31.2 © 2005 Kevin L. Moss

Waterfalls are one of the most breathtaking and beautiful subjects nature provides for any photographer to photograph. If you are fortunate to live close to an area where waterfalls are in abundance, take advantage of the easy access to them and plan a day of shooting. Many photographers have to travel to reach areas where you can find waterfalls, but that can be half the fun! I had to drive six hours to Michigan's Upper Peninsula to capture the shots shown in Figures 31.1 and 31.2, but it was worth the trip.

STEP 1: RESEARCH LOCATIONS

■ Unless you live in an area where you know the locations of the waterfalls, you have to do some up-front planning. Pick an area where you know waterfalls are located and research how to get to them. Many waterfalls are in state or national parks and close to major highways, but some are in more distant locations. Consult travel guides such as Frommer's (`www.frommers.com`) for waterfall locations in the area you are traveling to.

STEP 2: PLAN FOR THE WEATHER AND LIGHTING CONDITIONS

■ As in any nature photography trip or day excursion, plan for the weather. Check ahead of time if rain or snow is a possibility and dress accordingly.

WARNING

When planning for your trip to shoot waterfalls, make sure your research includes how you can get to the waterfalls safely. Many waterfalls are located in an area where you may have to hike a few miles to get to them. Check to see whether you have to climb hills or rocky areas. Extra caution must be taken around waterfalls — they often feature slippery, moss-covered rock surfaces that can increase your chance of injury. If the waterfall is hard to get to or too dangerous to walk around, consider taking a pass on the opportunity in favor of a safer location.

Don't let rain or cloudy days stop you; waterfalls are best photographed in conditions where sunlight is diffused, such as during times with thick cloud cover. Unlike other types of nature photography, you can get great shots of waterfalls in low light conditions where you can slow down the shutter speed to less than 1/10 of a second in order to get a smooth, silky, falling water look. Rainy or cloudy days are perfect when you want to set your shutter speed to a slow setting and still get a good exposure. On bright, sunny days, you can also get good results by shooting at a fast shutter speed to freeze the splashing action of the waterfall as it rushes toward you. Special care must be given in this situation because it can be difficult to obtain an accurate exposure in bright and "contrast-y" conditions where the water is reflecting sunlight and you're including dark rocky surfaces in your photo. The photos in Figures 31.3 and 31.4 were shot on a cloudy, rainy day in the middle of the afternoon. I was able to use a slow shutter speed to achieve a smooth look to the water as it was falling in both of these waterfalls.

STEP 3: PLACE YOUR DIGITAL CAMERA ON A TRIPOD

■ Shooting waterfalls with slow shutter speeds dictates that you must mount your digital camera on a tripod. If your digital camera has a self-timer or a remote shutter release, use it when shooting waterfalls. Even when your camera is mounted on a tripod, your camera can still suffer from vibration when you press the shutter; using a remote or self-timer helps further reduce vibration at slower shutter speeds.

STEP 4: SELECT CAMERA SETTINGS

■ To get that smooth blurred effect of falling water, select a shutter speed setting of 1/2 of a second or slower. If your digital camera has shutter priority mode, it automatically selects an aperture setting after you set your shutter speed. Set your white balance according to the conditions in which you are shooting. Make sure your digital camera is set to the lowest ISO setting to ensure the best image quality (and slower shutter speeds). Check to see whether your camera is set to the maximum image size.

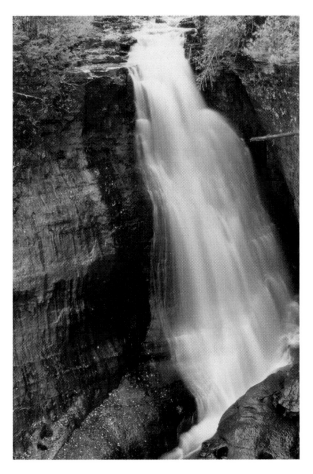

31.3

© 2005 Kevin L. Moss

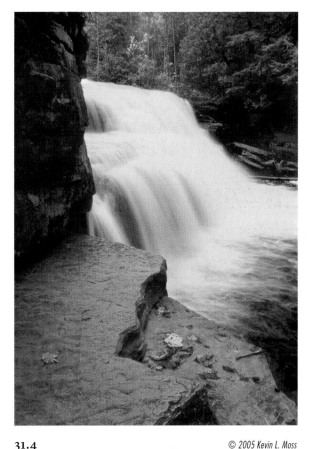

31.4

© 2005 Kevin L. Moss

STEP 5: COMPOSE THE WATERFALL AND TAKE PHOTOS

- Take time to view the scene you are about to shoot. Determine whether the shot will be better in portrait or landscape mode, but don't be afraid to shoot in both orientations. Zoom in your digital camera lens on the waterfall to isolate small portions of the scene to get photos you normally wouldn't think of, like the waterfall shown in Figure 31.5. I captured a number of different photos of this waterfall, but the zoomed-in image was the best of the bunch.

TIP

If you are shooting waterfalls in bright sunlight and you find you cannot achieve slower shutter speeds, consider using a neutral density filter. A neutral density filter acts as a light-blocker, making a difference of a few f-stops depending on the type of neutral density filter you use. Neutral density filters are available in different ratings. For example, a Tiffen neutral density filter rated at .3 reduces light by a factor of one stop, whereas a rating of .6 reduces light by a factor of two stops. Different filter manufacturers rate their filters differently from another, so make sure you purchase the correct strength of filter according to the particular manufacturer's rating system. Note that some compact digital cameras may need an adapter for you to attach filters.

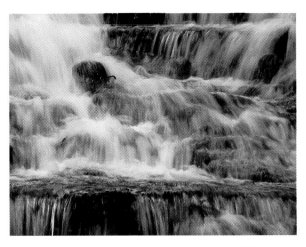

31.5 © 2005 Kevin L. Moss

STEP 6: REVIEW YOUR SHOTS AND TAKE MORE PHOTOS

■ After taking your photos, make sure to take time to review what you have shot on your digital camera's LCD. Review exposure and white balance for accuracy. Make necessary adjustments and take more photos from different angles. While shooting Wagner Falls in Michigan's Upper Peninsula, I shot this small waterfall in Figure 31.6 that was running off a creek just on the other side of the path where I was set up.

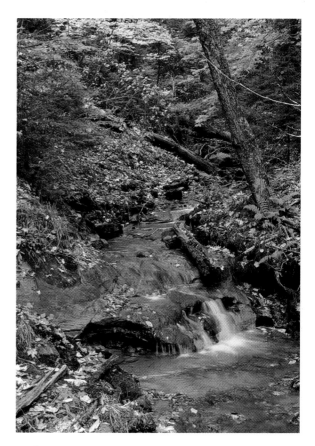

31.6 © 2005 Kevin L. Moss

TIP

Take advantage of all the photographic opportunities you have by carefully viewing the entire area. Don't forget to take a 360-degree view around you to see whether you can find other interesting scenes to photograph.

SHOOTING THE STARS

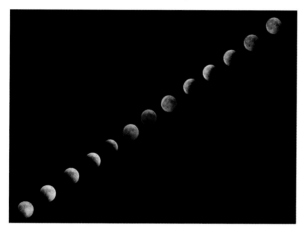

32.1

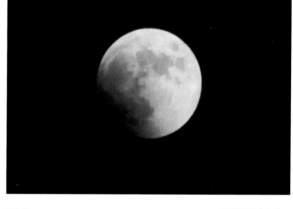

32.2

ABOUT THE IMAGE (32.1)

"Lunar Eclipse" Nikon D70, mounted on a tripod. A composite of a series of 13 timed photos with changing lighting conditions throughout the eclipse.

Many nature photographers concentrate on photographic subjects that are in front of them. To give yourself more opportunities to shoot dramatic photos, be aware of the total environment around you, including looking up at the sky. Taking photos of the stars and planets requires a different approach than photographing normal skyscapes does. Long exposures, movement of the planet as Earth rotates, and image noise are only some of the challenges an *astrophotographer* (photographer of stars, planets, nebula, and other space objects) faces when shooting the night sky.

The photo in Figure 32.1 is actually a composite of 13 photos taken of the moon during the total lunar eclipse on October 27, 2004. I had many challenges that evening. The eclipse lasted approximately four hours, but for the first hour I had to deal with partly cloudy skies. Due to the nature of an eclipse when the moon is shadowed from the sun by the Earth, I had to keep

changing the exposure to accommodate the changing lighting conditions of the moon. I took multiple shots of the moon every 15 minutes throughout the entire eclipse, manually varying exposure to make sure I captured each phase of the eclipse. Exposures varied a great deal, starting at f/5.6@1/500, ISO 200 and going to 1/250 at ISO 800. The photo shown in Figure 32.2 was shot at f/5.6@1/400 of a second at ISO 800. During the hour where the moon was in the *totality* phase (when the moon is completely shadowed from the sun's light but emitting a reddish glow), I had to double my exposure to properly capture that phase. By taking multiple shots at varying exposures of each phase, I was able to produce this composite of the eclipse using Photoshop Elements 3.

STEP 1: RESEARCH CELESTIAL EVENTS

■ Unknown to most of us, a variety of celestial events occurs on a regular basis. Many times during the year we experience meteor showers as the Earth's orbit around the sun takes the planet into the ancient paths of asteroids, thus giving us yearly meteor showers. Comets appear regularly, some even visible to the naked eye. One celestial event that occurs regularly in northern latitudes is an aurora, also known as the northern lights.

TIP

Auroras are a luminous glow that is caused by energetic particles that enter the Earth's atmosphere. These particles are emitted by the Sun when solar flares occur. Auroras can be predicted by scientists who measure solar flares and calculate when the Earth's orbit takes the planet into the streams of energetic particles. For daily reports on auroras and other celestial events, visit www.spaceweather.com.

Figure 32.3 shows an example of auroras that appeared in the sky one evening while I was taking photos of the planet Mars.

STEP 2: PLACE YOUR CAMERA ON A TRIPOD

■ Shooting long exposure photos of the stars and planets requires you to set up your camera on a tripod to reduce camera shake for low light conditions where your camera is set to slower shutter speeds. Setting your digital camera on a tripod allows you to reduce vibration while giving you more control composing sky photos. You can also hang small sandbags or your camera bag from the center post of your tripod to achieve even greater stability.

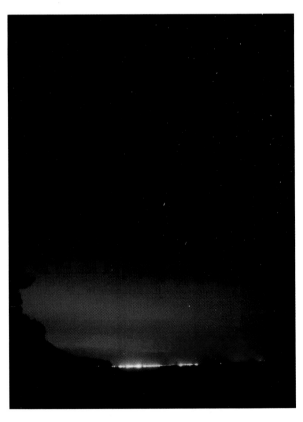

32.3

STEP 3: SELECT CAMERA SETTINGS AND TAKE TEST SHOTS

■ When taking photos of the night sky, you first have to set your digital camera in manual mode. Your camera's internal light meter cannot measure the exposure for dark skies correctly, so you have to take test shots to judge the exposures yourself by viewing the test shots on your digital camera's LCD screen. Set your aperture a few stops above the maximum aperture, such as a setting of f/2 to f/3 on a compact digital camera (f/4 or f/5.6 on a digital SLR). Setting a few stops above the maximum setting helps ensure sharper photos; lenses are usually not at their sharpest at the extreme settings. Because you're focused to infinity, all of your subject is in focus, allowing you to set your aperture to a more open setting without sacrificing depth of field. Setting your aperture to a large

aperture setting allows your digital camera's sensor to collect more light in a shorter period of time, reducing image noise in the process without having to increase your ISO setting (which would increase the change of noise in your image). If you're using a digital SLR, the optimum aperture setting for night sky photos is from f/2 to f/5.6.

Set your shutter speed to 1 second and take a test shot. Review the test shot on your LCD, and use the zoom feature while reviewing your photos to check focus of stars or other space objects. Take more test shots with slower shutter speeds up to 1 minute until you have reached an acceptable exposure for your night sky photos. The photo of the planet Mars (the brightest object in the sky) in Figure 32.4 was taken at f/2.4 at 30 seconds with a Sony Cyber-shot 707 digital camera when Mars was at its closest position to Earth in the summer of 2003. Thirty-second exposures may

TIP

If your digital camera doesn't have an aperture priority mode, check your camera's user manual for information on how to shoot photos in night mode. Setting your camera in night mode automatically adjusts your shutter speed and aperture to the optimum settings for shooting photos at night. The downside to using these modes are loss of control over your camera's ISO setting. Night mode usually automatically sets the ISO to a higher setting. If your digital camera doesn't have a night mode feature, experiment with exposures to see how high of an ISO setting you can use for long exposures to a limit where image noise doesn't degrade the quality of the image. By experimenting with different apertures, shutter speeds, and ISO settings, you can determine the "quality" limits of your particular model of digital camera.

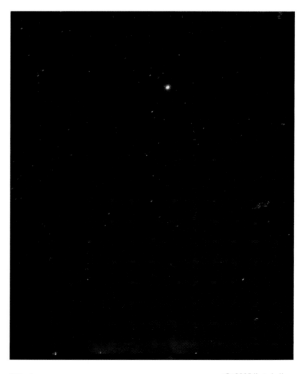

32.4

be the limit for photos of stars; you start to see *star trails,* the actual rotation of the Earth, in your photos as the example in Figure 32.5 shows.

STEP 4: COMPOSE AND TAKE CELESTIAL PHOTOS

■ Tripods with both pan and tilt and ball heads allow you to easily pan and tilt your camera so that you can take different perspectives of the night sky. See Technique 16 for more information on selecting and using a tripod.

■ Take the time to view the night sky with your own eyes and decide how you are going to compose your sky photos. Your digital camera's LCD isn't going to be sensitive enough to display the night sky scene, so you have to experiment with composing your sky scenes. If your digital camera has manual focus, set your camera's focus to infinity. Consider taking wide-angle photos of the sky, because using your lens to zoom in on stars and planets may not produce desirable results.

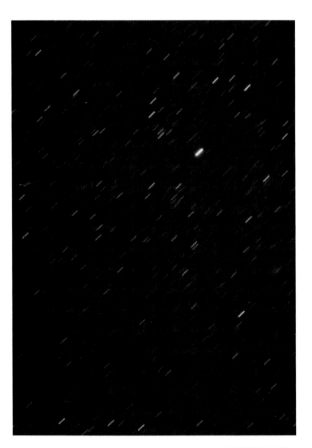

32.5 © 2005 Kevin L. Moss

TIP

There are many new technology trends enabling digital photographers to attach their digital cameras to automated "go-to" telescopes. Go-to telescopes contain onboard computers that allow you to choose celestial objects from a hand-held controller, and then automatically point the telescope to your chosen celestial object and track these objects accurately as the Earth rotates on its axis. Manufacturers such as ScopeTronix (www.scopetronix.com) make custom adapters that attach to your digital camera lens, allowing you to attach your digital camera directly to the telescope's eyepiece. By attaching your digital camera to a motorized go-to telescope that compensates for the Earth's rotation, you can take long exposures over 30 seconds while keeping the object in focus. For more information on astrophotography using your digital camera and telescope, visit Sky and Telescope Magazine's Web site at www.skyandtelescope.com/howto/imaging.

STEP 5: REVIEW YOUR CELESTIAL PHO-TOS AND TAKE MORE SHOTS

■ Taking photos of the night sky requires patience, and a lot of trial and error. After you have set up your digital camera on a tripod and have made your initial settings, take a few test shots and then review the photos you've taken on your digital camera's LCD. While taking astrophotos, you constantly need to review your photos to check for proper exposure. If you are taking photos of the moon and it appears overexposed, consider increasing the ISO or shutter speed. If the object appears too dark, consider decreasing the ISO setting or shutter speed to allow for more exposure. If you're taking wide-angle photos of the night sky, but you can't see any stars when you review the image on your LCD, decrease your shutter speed, review the result, and then decrease the shutter speed again until you view what appears to be a properly exposed night sky image.

7

"SCAPE" PHOTOGRAPHY

This chapter covers the topic of shooting "scapes." First, you'll find out how to photograph cityscapes in Technique 33. Technique 34 shows you how to capture dramatic skyscapes in all colors. Photographing country landscapes with barns and farmhouses is the topic of Technique 35. If you have always wanted to capture a beautiful panoramic view that exceeds your camera's widest angle view, see Technique 36, which shows you how to shoot multiple overlapping photos in a series that can later be digitally stitched to make a panoramic photo. Technique 37 gives you insight on taking photos of abandoned structures. Taking scape photographs is great fun because there can be so much variety in each scene as the sun moves across the sky and as weather conditions change.

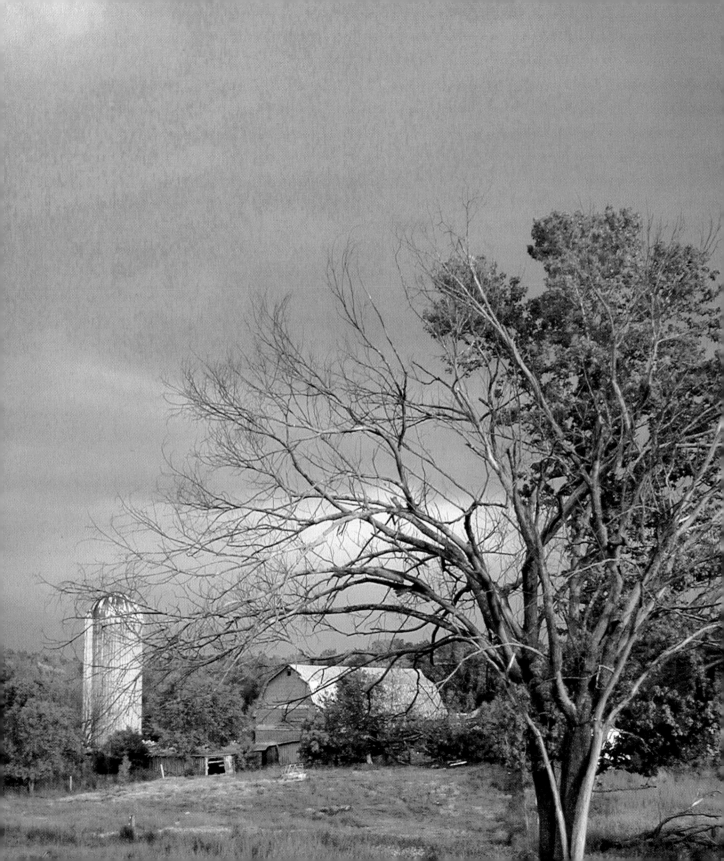

PHOTOGRAPHING URBAN LANDSCAPES

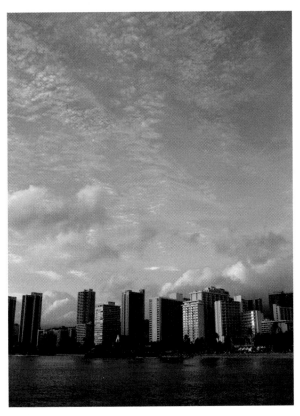

33.1

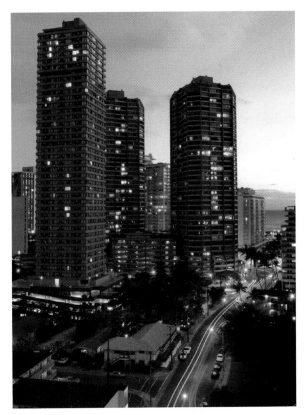

33.2

ABOUT THE IMAGE (33.1)

"Waikiki Beach" Nikon Coolpix, mounted on tripod, zoom set to 111mm (35mm equivalent), f/4.0@1/7, ISO 80.

Cityscapes are constantly changing subjects that can be photographed at all times of the day and night. In early morning and late evening light, you can often get a photo of a city that glows due to the sun reflecting off the glass in the buildings, like the photo shown in Figure 33.1. During the day, you can shoot cityscapes filled with the bustle of traffic and people. Late at night, you can shoot with a slow shutter speed and record the bright trails of automobile lights as they move on the roads, as shown in the photo of Honolulu in Figure 33.2. Some cities, like Las Vegas, have so

185

much colorful light that when you shoot them at night, you get spectacular night colors like the rich reflected colors shown in the water in the photo shown in Figure 33.3. In this technique, you learn how to decide when to shoot cityscapes and how to get good photos of them.

STEP 1: CHOOSE THE DAY AND TIME TO SHOOT

- Depending on the city you choose to photograph, quite likely you can get successful photos no matter what time of day or night you shoot. Generally, you'll find that midday sun offers the least attractive light. As with all subjects, you want to consider carefully when the sun provides the best light from your chosen vantage point. Some of the best views of a city may be seen from one direction only. If the sun sets behind a city (from your chosen vantage point), you may find that the best time to shoot that city is in the morning when the sun is shining on the city — not when the sun is shining from behind the city, which would cause the buildings to be covered in shadows. Because many cities are often covered in haze (a nice word for pollution), you may get some excellent photos if you shoot right after a rain because rain clears the air and possibly provides a rich blue sky, too.

> **TIP**
>
> Sometimes a photograph taken with the sun behind the skyline can make a great silhouette, especially if the skyline is distinctive enough to be recognizable.

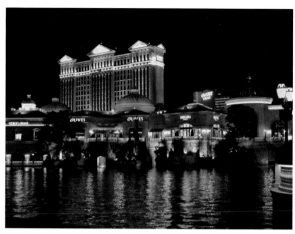

33.3

STEP 2: SET UP THE TRIPOD AND CAMERA

- Choose a good place to set up your camera and tripod. When you've determined the city you want to shoot, decide what vantage point you want. Consider shooting from a balcony in a high-rise building, or from a bridge. A different vantage point from the more obvious vantage points results in a more unusual photo.

STEP 3: CHOOSE THE CAMERA SETTINGS

- Select the slowest ISO speed your camera offers (possibly ISO 80 or ISO 100). Choose the aperture priority mode and set the aperture to its smallest setting (for example, f/8.0) to provide the greatest depth of field. Use automatic focus and try using a matrix or evaluative metering mode to meter the entire image.

STEP 4: CHOOSE THE FOCAL LENGTH

■ Generally, you want to use the widest-angle setting your camera offers when shooting cityscapes. However, you can take many successful cityscapes with a telephoto lens as well. If you are some distance back from the city you want to shoot, you can select one small portion of the city to shoot with a telephoto lens.

STEP 5: COMPOSE AND TAKE PHOTOS

■ Use the composition tips offered in Technique 7 and look for creative ways to compose your photos in new ways. A beautiful city, perfect light, and the right camera equipment can all result in a not-so-good photo if your composition is not good. Figure 33.4 shows a photo of a tall hotel in Las Vegas. To fill the frame, the camera was tilted to get the entire hotel in the frame. Experimentation is good.

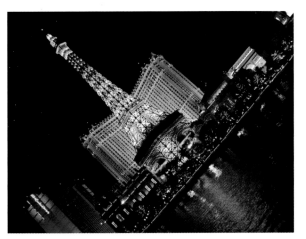

33.4

STEP 6: EVALUATE THE RESULTS AND MAKE SETTING CHANGES

■ As you shoot with a digital camera, take advantage of your camera's histogram (if your camera has one). Use the histogram in addition to the image on the LCD monitor to see whether your images are properly exposed. Varying the settings slightly, especially by bracketing exposure (three exposures of the same shot), gives you a choice between images when you download the photos to your computer and view the images on a computer monitor.

SHOOTING DRAMATIC SKYSCAPES

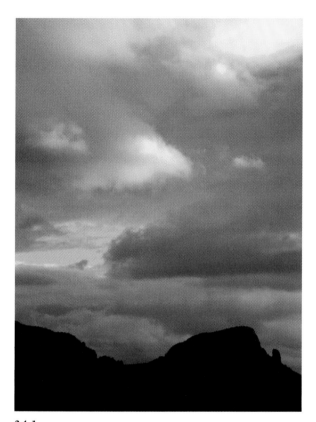

34.1

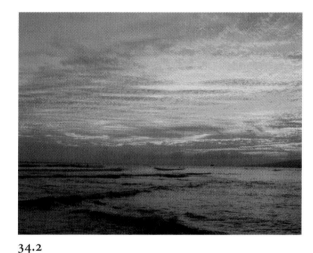

34.2

ABOUT THE IMAGE (34.1)

"Arizona Sunset" Nikon Coolpix, hand-held, zoom set to 103mm (35mm equivalent), f/6.6@1/69, ISO 820.

Many poets have watched sunrises and sunsets and have been inspired to write award-winning poetry about what they witnessed. For centuries, great painters have painted with the rich colors of early morning and late evening sky. Now you can capture all the brilliant colors that are found in dramatic skyscapes. You simply have to press the shutter button on your digital camera to take a photo of a sky with rich blue colors, like the one shown in Figure 34.1, or one with pinks and blues, like the photo shown in Figure 34.2. In this technique, you learn how to

189

photograph dramatic sunrises and sunsets to get photos that will make excellent prints.

STEP 1: CHOOSE THE DAY AND TIME TO SHOOT

■ Keep in mind that many factors contribute to, or take away from, the beauty of a sunrise or sunset. Clouds are often the key to having a beautiful skyscape because they can reflect the glow from the sun in very stunning ways. Clouds can be so deep and low on the horizon that they can completely block a sunrise or sunset. The best time to shoot a sunrise can vary from twenty minutes before sunrise to an hour or two after sunrise. Likewise, some of the best sunsets occur in the range between an hour or two before sunset to twenty or thirty minutes after sunset.

As you gain experience in watching sunrises and sunsets, you'll learn that you must have time and patience. More often than not, photographers leave a sunset scene just as the sun dips below the horizon — what a mistake that can be! You can get some of the most beautiful sunset photographs by capturing the afterglow that can occur up to twenty or thirty minutes after sunset, like the one shown in Figure 34.3, where the sun had long before dipped below the horizon line in Maine. The tide was out, and the wet muddy bottom of the water reflected the brilliant colors of the sun, adding even more color to an already colorful photo.

If you're going to an unfamiliar place or will be in an area where seeing the sunset is hard due to trees or other visual barriers, you may want to purchase a compass to help you find a good place to shoot the sunrise and sunset. Trying to find where the sun will set can be surprisingly difficult when you're driving around in the middle of the day. If you have a compass, you can know well in advance of sunset exactly where the sun will drop, and you can be in the right place at the right time.

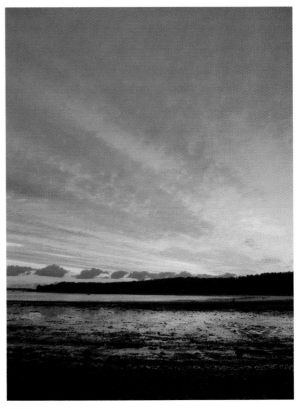

34.3

TIP

If you want dramatic sunrise photos, you must get up early. Be ready to shoot the sunrise twenty minutes before it is scheduled to come up, shoot often, and have patience. Depending on where you plan on shooting, good sunrises or sunsets may be rare or common. When you travel to shoot sunrises or sunsets, visit a Web site like www.weather.com to get a forecast and sunrise and sunset times. You'll then know when to set your alarm so that you don't miss the sunrise, and you'll know the exact time for when you ought to be in position to take photos of the sunset.

STEP 2: SET UP THE TRIPOD AND CAMERA

■ A sturdy tripod is required to shoot sunrises and sunsets. When you've decided when and where to shoot, set up your tripod and camera early so you're ready to shoot when the sky gets painted in rich colors.

STEP 3: CHOOSE THE CAMERA SETTINGS

■ Select the slowest ISO setting (for example, 80 or 100 ISO) your camera offers. Use autofocus and select auto white balance. Select the aperture priority, set the aperture to the smallest aperture (for example, f/8.0), and allow the camera to choose the shutter speed. If you don't normally use an image review feature (see Technique 4), you should turn it on when shooting sunrises and sunsets because doing so enables you to monitor how well you've exposed each shot.

STEP 4: COMPOSE AND TAKE PHOTOS

■ Use the tips you learned in Technique 7 to compose your sunset photos. Consider shooting both horizontally and vertically, as covered in Technique 20. Figure 34.4 shows the same sunset shot in horizontal mode that was shot in vertical mode in Figure 34.3.

■ Consider shooting to capture foreground items as a silhouette, as shown in Figure 34.5. To get the best silhouettes, you may have to experiment with the exposure by using exposure compensation. Figure 34.6 shows the same trees and sunset shot in horizontal mode. Notice how much the sun lights the clouds from below in this picture. What was strange is that the sun had dropped

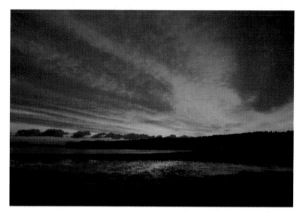

34.4

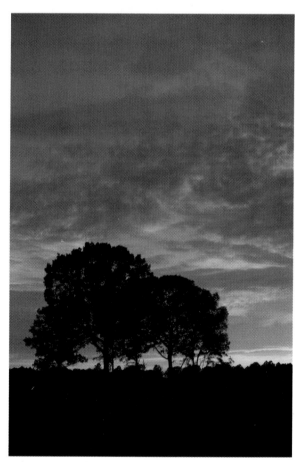

34.5

below the horizon ten or fifteen minutes before this strong under-lighting of the clouds occurred. If I had left when the sunset dropped below the horizon, this shot would have been missed.

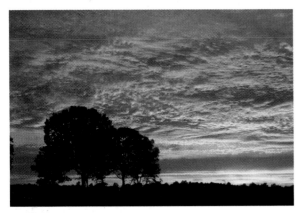

34.6

STEP 5: EVALUATE THE RESULTS AND MAKE SETTING CHANGES

■ Because sunrises and sunsets can often mislead the automatic metering systems found on digital cameras, which can result in a poor exposure, make sure that you check exposure when you shoot by looking at the images on the LCD monitor or by using the histogram. In those cases where you need to make an adjustment, use exposure compensation. You can learn more about exposure compensation in Technique 12. Slightly underexposing can make the colors of a sunrise or sunset richer than if they were overexposed.

WARNING

The most beautiful part of a sunrise or sunset may only last for less than a minute or even just a few seconds. Be careful not to be caught short of space on your digital photo storage media when you're shooting a quickly changing sunrise or sunset, or you may miss the best part.

TIP

If you take a photo every sixty seconds or so without moving your camera or changing composition, you can create an animation for a Web page that shows an entire sunset or sunrise by using layers in ImageReady, which is part of Photoshop.

TIP

Metering the sky at sunrise or sunset can be difficult. A good starting place is to meter the sky near, but not including, the sun. Use that reading as a starting point for bracketing (exposure variations). If your camera has an auto bracket feature, this would be a great time to experiment with it.

PHOTOGRAPHING COUNTRY LANDSCAPES

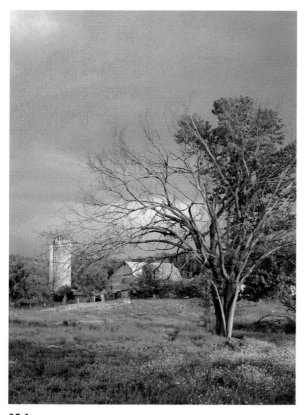

35.1

35.2

Barns, grain silos, rolling hills, plowed fields, tractors, and grassy fields make excellent subjects for photos. When you have a few hours, take a drive out to the countryside to take a few photos. If you're there at the right time, you may be able to shoot in the golden glow that is frequently found out in the country around sunset, as shown in the photo in Figure 35.1. Not only will you have a pleasant drive, but chances are also good that you'll get some good photos. In this technique, you discover how to take photos of the countryside that you'll be proud to share with others.

STEP 1: CHOOSE THE DAY AND TIME TO SHOOT

■ More often than not, you can get the best photos of the countryside a few hours before sunset to twenty minutes or so after sunset. Sunlight coming in from a low angle often casts a wonderful warm golden glow to the surrounding area. Besides shooting toward the sunset, remember to turn around and shoot behind you, too, because that is where the warm light will be shining.

■ Part of the challenge in getting a good countryside photo is knowing where you ought to be and what you should shoot — and being there when the best light occurs. When you find a good place to shoot, set up your tripod and camera, and wait for the light. You can easily find yourself driving all around and not being near a good place to shoot when the light gets good. When possible, make your trip to the countryside when the weather is changing or when there are rich blue skies and many white clouds.

■ The days where you're likely to get fewer good landscape photos are days when the sun is bright or when you have bright but hazy white skies. Unless you're able to shoot without including the bright sky in the photo, you're better off to wait and shoot on a day where you have blue sky or blue sky and white clouds, as shown in the photo in Figure 35.2.

STEP 2: SET UP THE TRIPOD AND CAMERA

■ After you determine what you want to shoot, decide where to set up the tripod and camera. If you just pulled your car off to the side of the road, where it was safe and convenient to park, you may not be in the best place to take photographs. Grab the camera gear you need and walk if a better place to shoot is nearby, like I did for the photo shown in Figure 35.2. Many amateur photographers take photos within a hundred feet of the roadside where they parked their car, and they miss getting a better photo because they were too eager to shoot or too lazy to walk to a better place.

■ Consider setting up your tripod and camera where you can include some foreground in the photo; notice how the tree in the foreground shown in Figure 35.1 helps to frame the image. Without this tree, the photo would be much less interesting. If a tree isn't nearby, consider shooting tall weeds or part of a wooden fence to give your photo some depth and scale.

STEP 3: CHOOSE THE CAMERA SETTINGS

■ When shooting landscapes of any kind, you usually want to use the slowest ISO setting your camera offers. Use autofocus and matrix or evaluative metering. Choose auto white balance unless the sky is full of dark clouds; in that case, choose a white balance for shooting under cloud cover. Choose the aperture priority, set the aperture to the smallest setting (for example, f/8.0), and allow the camera to choose the shutter speed.

■ After the camera has chosen the shutter speed, decide whether you can shoot without a tripod. If you're shooting in bright sun and the camera has chosen a shutter speed that is faster than 1/200, you can maybe get by without setting up a tripod. Although after you get used to using a tripod for your landscape shots, and the more sharply focused and better composed shots that result, you'll probably use the tripod.

STEP 4: CHOOSE THE FOCAL LENGTH

■ When you're out in the country and looking at a wide expanse of land and trees and sky, the

natural tendency is to shoot with your camera lens set to the widest angle. However, you can also get good landscape photos with focal lengths that are longer than the minimum focal length that your camera offers. If you have a reasonably long tele-photo lens, try selecting a small portion of the landscape to shoot. Be creative and experiment.

STEP 5: COMPOSE AND TAKE PHOTOS

■ As you compose your photo, visualize the effect of all of its elements. Consider the foreground, midground, and background. Note how objects such as trees, barns, and fences relate to each other. Composition is extremely important, and poor composition can ruin an otherwise beautiful scene. To learn more about composition, read Technique 7. Should you shoot vertically or horizontally (see Technique 20)? Should you zoom in or should you use maximum wide angle? These questions are just a couple that you'll need to answer as you compose and take photos. Figures 35.3, 35.4, and 35.5 show three variations of the same dairy farm shown in Figure 35.1. Which one do you like best?

35.4

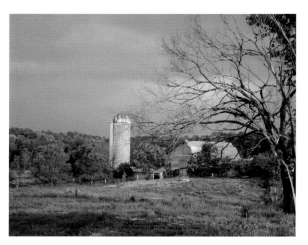

35.3

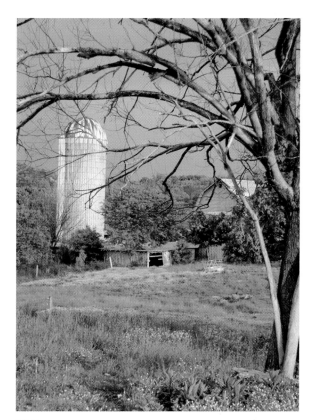

35.5

TIP

Traveling to a good location to shoot photos takes time and money. Because it does not cost anything to shoot many photos when you are using a digital camera, shoot as many as you need when you are there. Many amateur photographers think they have one or two good photos and they leave the site only to find out later that they really didn't get the photos they wanted. Try composing in many different ways and vary the exposure settings to ensure that you'll have a choice of photos and improve your chances of having a perfect one.

STEP 6: EVALUATE THE RESULTS AND MAKE SETTING CHANGES

■ After you've taken a few photos, look carefully at the images on your camera's LCD monitor and review the histogram if your camera has one to make sure you're getting a good exposure. If you need to alter the settings and are using an automatic exposure setting like aperture priority, try making the needed adjustments using the exposure compensation feature. To learn more about using exposure compensation, see Technique 12.

TAKING PHOTOS TO MAKE PANORAMIC LANDSCAPES

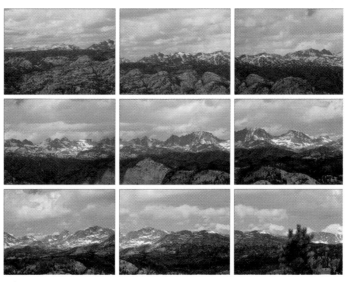

36.1

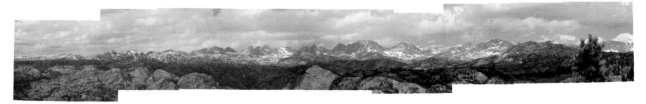

36.2

"Wind River Mountains" Nikon Coolpix, hand-held, zoom set to 111mm (35mm equivalent), f/111.4@1/176, ISO 80.

One of the most exciting things about working with digital images is that you can digitally stitch them together using special "stitching" software to create vertical or horizontal panoramic photos. The nine photos shown in Figure 36.1 were taken with a Nikon Coolpix digital camera and then digitally stitched to make the photo shown in Figure 36.2. The resulting image is 9,520×1,499 pixels in size and it makes a wonderful 40×6.24 inch print at 240dpi — way beyond what you could get shooting with a 35mm film camera or a wide-angle lens. If you haven't made a panorama yet, try making one soon — it is great fun!

STEP 1: SET UP THE CAMERA AND TRIPOD

■ When you've decided where you want to shoot, set up your tripod and mount your camera. When shooting panoramas, having a tripod head that allows you to pan the camera without the possibility of moving in the other two axes is nice. If you have a pan-tilt head, and you plan to shoot many panoramic photos, you may want to consider getting a panoramic base for your head. Alternatively, you can purchase a ball head that has a separate panning control, like the Manfrotto 488RC2 Midi Ball Head, shown in Figure 36.3. The lever on the right locks the panning motion.

■ Getting your camera level to shoot a series of images for a digitally stitched panoramic photo can be challenging. To make the process of leveling the camera easier, consider purchasing the Hama camera spirit level shown in Figure 36.4. While it is a costly product, it takes the hassle out of leveling the camera — just insert it into your camera's flash shoe (if your camera has one) and use the two bubbles to level the camera.

STEP 2: CHOOSE THE CAMERA SETTINGS

■ When using a camera that has a zoom lens, you can set it to any focal length that you desire to get the composition that you want. However, when using a lens that has some distortion, choose a focal length that is not distorted, for example a midrange focal length. Avoid using extremely wide-angle focal lengths and fisheye lenses.

Depending on your camera, you may be able to take either of two different approaches when shooting

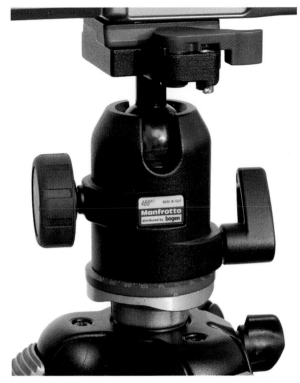

36.3

36.4

photos for panoramas. If your camera has a panorama mode, you can select it, and the camera chooses the rest of the settings for you. Many cameras that have a panorama mode allow you to see how much you're overlapping images by showing the previous photo on the LCD monitor next to the one you're currently composing. Such a feature makes shooting a series of overlapping images easy. For example, the Canon PowerShot has a Stitch Assist mode that not only helps you overlap images, but also has different settings for taking photos horizontally in either direction, or vertically in either direction, as well as clockwise if you want to overlap photos in a 2×2 square.

The other approach is to choose the manual shooting mode so that each photo has the same exposure. This approach is more challenging, but it can yield excellent results.

> **NOTE**
>
> Although it's much easier to make a panorama from images shot on a tripod, you can still get good results without one if you use the right camera settings, take care to hold the camera carefully, and shoot from the same position. A tripod was not used to take the nine photos shown in Figure 36.1 because one was not available. Great care was taken to shoot the camera from the same place and to hold it steady to avoid blurring the image. One disadvantage to handholding a camera is that it is likely that the image will have to be cropped to make it rectangular, which can considerably reduce the size of the image.

■ After choosing the lowest ISO setting (to avoid digital noise), set the aperture to the smallest setting to maximize depth of field. Now look across the area that you will shoot and determine which area has an average exposure. For example, in Figure 36.2, the middle portion of the image is the average exposure. The right side is slightly darker than the extreme left side. After you find an area with a good average exposure, compose a photo on that area and adjust the shutter speed until you get the exposure you want. Because you're shooting in manual mode, this exposure setting will be used for the entire set of photos.

If you don't use manual mode or a mode that has been created especially for taking panoramas, and there is variance in light levels across all the images, stitching software may not be able to blend the photos — one image may be noticeably darker than the image next to it. This is also the reason you want to find an average exposure and lock it in before shooting the series. Otherwise, you may start by underexposing the first part of the panorama and end up with an overexposed part as you get to the opposite end.

STEP 3: COMPOSE AND TAKE PHOTOS

■ After your camera is set up and you're ready to shoot, begin by composing your first shot from the left. If you start from the left, your image files will be numbered in the order that you shot, which makes picking out the images that you took for a panorama easier.

■ When shooting, overlap each image by a third so that the stitching software has sufficient image to use to align one image with the next image. If the images overlap by more than a third, the

blends may not be as good as they would be if there were less overlap. You also should compose the photos (when possible) so that the overlapping areas have distinctive items in them, such as a tree or a rock. These items make matching the images easier for the software. After you have taken one photo, do not change the focal length by zooming. If you do, the images cannot be stitched.

STEP 4: EVALUATE THE RESULTS AND MAKE SETTING CHANGES

■ After you have taken all the photos in a series that you want, take some time to look back over them to see whether they are properly exposed and that they overlap as they should. If you have enough empty space on your digital photo storage media, you may want to vary the exposure setting slightly and shoot the series again. Shooting again won't take much time compared to the amount of time you took to set up.

WARNING

When shooting photos to be digitally stitched together, be mindful of the fact that if parts of the scene are moving, the movement may make combining the images difficult for the stitching software, or the movement may result in less-than-perfect images. Fast-moving clouds or waves on a seascape can make stitching images together difficult or impossible for stitching software.

STEP 5: USE A DIGITAL STITCHING APPLICATION TO CREATE A PANORAMA

■ After you have taken a series of photos and have downloaded them to your computer, you're ready to stitch them together to create a panoramic photo. Quite a few software applications exist for digitally stitching images. Photoshop Elements has a feature called Photomerge, which can stitch images together all the way up to a full 360 degrees. Figure 36.5 shows the Photomerge window with three images of a sunset stitched together.

TIP

If you want to learn more about creating panoramas, James Riggs has created an excellent Web site dedicated to "photographers interested in panoramic photography achieved by manipulating a sequence of pictures taken with a conventional (non-rotating) camera." It includes lots of useful tips, software reviews, and galleries. You can visit his site at www.panoguide.com.

TIP

If you want larger digital photos, you may not have to buy a camera with more pixels. Consider taking several photos and digitally stitching them into one image.

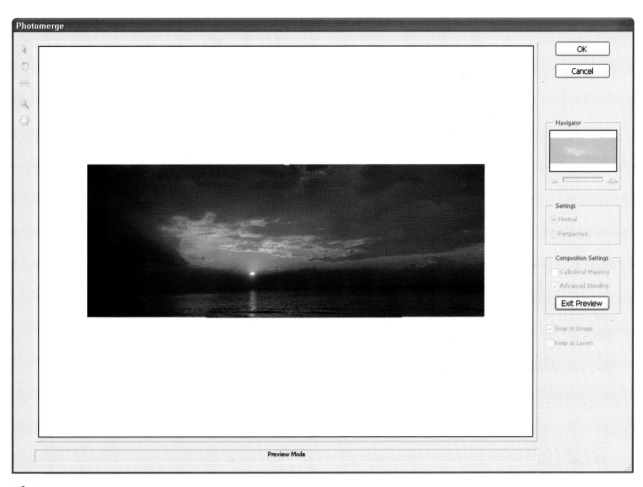

36.5

SHOOTING ABANDONED STRUCTURES

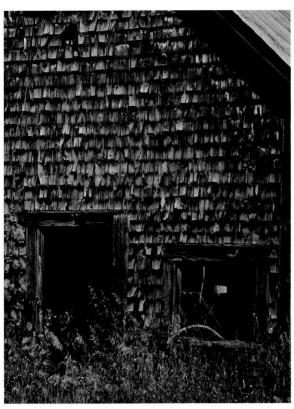

37.1 © 2005 Kevin L. Moss

37.2 © 2005 Kevin L. Moss

A while back I got in the habit of carrying around a digital camera with me at all times. In my everyday travels, I always look for something interesting to photograph. If I'm on a landscape assignment, I try not to limit myself to shooting just landscapes; I also like to shoot old abandoned farms and buildings like the ones shown in Figures 37.1 and 37.2.

I do a lot of travel in urban areas, and I always look for abandoned homes, burned-out buildings, and other abandoned structures. In my hometown, there is an abundance of these structures. I don't shoot these buildings to

203

communicate any societal commentary; I just find these structures interesting. The photographs of these abandoned structures illustrate a sense of history. Given enough time, they become part of the landscape as decay, plants, trees, and vines start to take them over, making some interesting photos.

FIGURING OUT WHAT EQUIPMENT YOU NEED

My shooting gear and preparation for shooting abandoned structures is not any different than how I prepare for shooting landscapes. Start off with your digital camera and enough formatted memory cards to get you through the day. Some photographers shoot tens or hundreds of photos of the same subject; some like to shoot less. Let your past experience be your guide, and make sure you take all the memory cards you have; you never know what interesting subjects you'll come across in your travels!

The next piece of equipment I recommend packing is a tripod. Even if it's sunny out and you can shoot at high shutter speeds, practice shooting your subjects with your digital camera attached to a sturdy tripod. (See Technique 16 for more tripod information.) By using a tripod in most shooting situations, you can improve the quality of your photographs.

Make sure your digital camera battery and spare battery are all charged up. There's nothing more disappointing than having to end a shoot early due to running out of power for your equipment. The good news is that newer digital camera batteries can give you enough juice to shoot all day long.

If you have one, bring a circular polarizing filter. A circular polarizer is a great tool to attach to your lens on days when the sun is bright and overhead. The filter reduces glare from the sun on foliage and on the structures you're shooting. Blue skies are darkened

and colors become more saturated. The photo shown in Figure 37.2 was shot on a tripod with a circular polarizer attached to the lens. The filter greatly reduced the sun's glare off the metal roof and the leaves in the scene, allowing for a very usable image that normally would have been unusable due to the bright sunlight and glare.

STEP 1: CHOOSE A PRIMARY SUBJECT

- Plan ahead for the locations you definitely want to shoot. Set a goal to photograph a particular area or structure that you've seen in the past. If you see something interesting along the way, by all means pull over! Don't waste any good shooting opportunities; sometimes the best shots taken are the ones you didn't plan for. After you reach your destination, walk or drive around the structure to visualize how you want to approach photographing the structure.

STEP 2: SET UP THE CAMERA

- Before you start to set up your tripod and shoot, take your digital camera out of the bag. Turn on your camera and go through your preparation checklist of reviewing all your settings to make sure they are correct for the lighting conditions you have that day. Make sure your camera is in the correct shooting mode, preferably aperture priority in order to control the depth of field. Set the white balance to the auto setting or to the particular conditions: shade, sunny, or cloudy. A little preparation can help you avoid shooting a whole memory card in the wrong mode or white balance!

STEP 3: SET UP THE SHOT

■ Mount your digital camera on the tripod and set up your first shot. I usually start composing wide-angle shots of the structure, like the one shown in Figure 37.3. After taking various angles of the structure, in both landscape and portrait modes, I'll then crop in to specific details that I find unique, like those in the photograph in Figure 37.4.

STEP 4: REVIEW THE FIRST IMAGES

■ Before moving your camera to another position, take a minute and review the shots you've already taken. Does the image show an accurate white balance setting? Does it contain any noticeable color casts? Are the foreground and background in focus? Try zooming in and out of specific areas of the photos to check for sharpness. Are there any blown-out highlights? Look at the histogram to ensure you have achieved the correct exposure.

STEP 5: RECOMPOSE AND SHOOT MORE PHOTOS

■ Walk around the structure and look for new opportunities and areas you have not seen yet. Get in close and check for lighting through windows and doorways, like in the photo shown in Figure 37.5. If you are already there, set up with a tripod, take your time, and look around. Become aware of your surroundings by taking a 360-degree tour of where you're standing; you may even find another subject to photograph!

37·3 © 2005 Kevin L. Moss

37·4 © 2005 Kevin L. Moss

TIP

Look for patterns in the subjects you photograph. In nature or man-made structures, a series of windows, rows of barrels, or any other pattern makes for interesting photos and abstracts.

© 2005 Kevin L. Moss

STEP 6: LOOK FOR COLOR

■ Although abandoned structures can often look dull and worn out, look for color in these structures, whether natural or manmade, such as the urban art in the photo shown in Figure 37.6. This abandoned building located in downtown Detroit was "redecorated" window by window by local urban artists. Figure 37.7 shows how each window was painted using colorful paint, making the building much more interesting as a subject for a photograph.

WARNING

Keep safety in mind when venturing out and photographing old structures. Be careful not to disturb the landscape and try not to venture in past the doorway: You never know what's on the other side or what's ready to collapse! Watch where you walk: You don't want to fall in any holes or trip on broken glass, pipes, bricks, or empty bottles that may be lying around. Carry a cellphone with you at all times and make sure someone knows where you are.

37.6

37.7

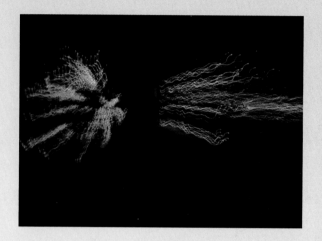

CHAPTER 8

CREATIVE AND ALTERNATIVE PHOTOGRAPHY

Being able to shoot photos with a digital camera and use a computer to manipulate photos in image-editing programs such as Photoshop and Photoshop Elements gives all of us the capability to create true works of art. Many digital photos could be considered art even if you don't manipulate them in Photoshop or Photoshop Elements, but these powerful photo-editing tools create artistic opportunities for the photographer that are limited only by one's imagination. If you enjoy creating artistic images from digital photos, this chapter has a lot to offer you. Technique 38 shows you the possibilities of shooting abstract subjects. You'll see how to shoot photos to manipulate later in Photoshop Elements 3 in Technique 39. Technique 40 shows you how to use a desktop scanner as a digital camera, and you'll find out how to take amazing close-up shots in Technique 41.

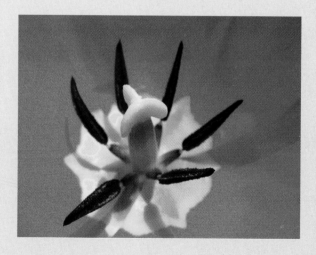

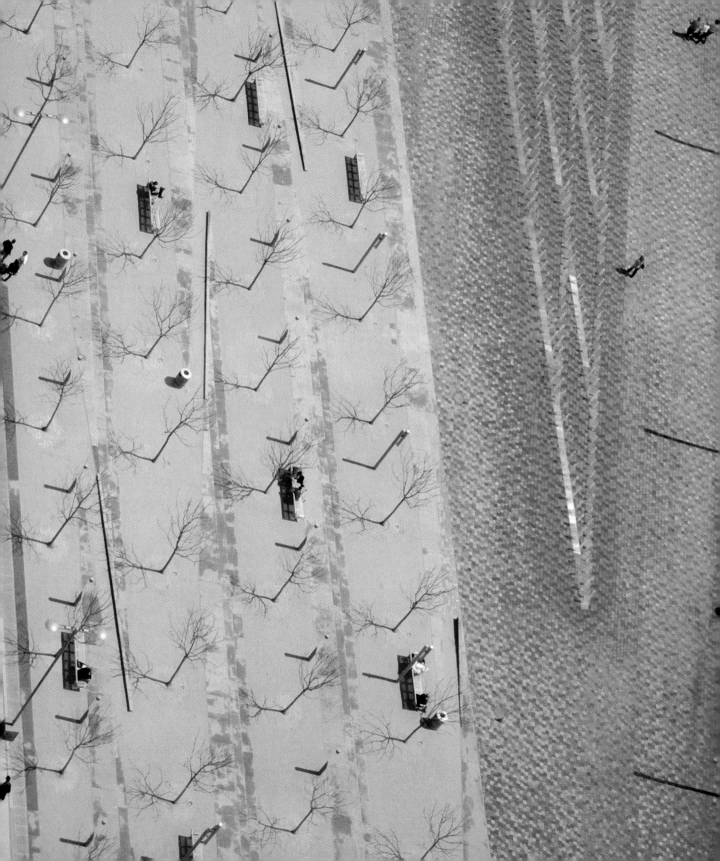

SHOOTING ABSTRACTS

38.1

38.2

ABOUT THE IMAGE (38.1)

"Holiday" Nikon D70, hand-held, f/5.6@.8, ISO 200.

ABOUT THE IMAGE (OPPOSITE)

"City Park" Nikon Coolpix 7900, hand-held, f/8.2@1/90, ISO 50.

One of the most integral parts of my portfolio of fine-art prints is the abstract collection. Abstract photos are nonrepresentational images that cause people viewing them to think twice about what they're looking at. An abstract can be a close-up of a flower where only a small portion of the image was used after cropping, a pattern on a building or in nature, a subject photographed from an odd angle, or any other subject that the photographer judges as interesting and thought-provoking. The photos in Figures 38.1 and 38.2 make many people wonder what the photos actually are; I have to tell them that they are colored lights shot while the camera was in movement.

STEP 1: FIND A SUBJECT
TO PHOTOGRAPH

■ Abstract subjects are all around us. I usually
don't plan to photograph abstract subjects; they
come to me when I'm out shooting other subjects.
I may shoot an aerial photo of a park area as an
abstract, like the full-page photo shown in the
beginning of this chapter. The abstract shot could
also be a close-up of a puddle I come across while
taking a walk. The best way to find an abstract
subject to photograph is to be aware of your sur-
roundings at all times and to *train* yourself to look
at subjects as potential abstract photos. One of my
favorite subjects is flowers, which I shoot
extremely close up with my digital camera. I then
crop out a portion of the image in Photoshop
Elements, like in the photo shown in Figure 38.3.
The result from cropping in Photoshop Elements
is a portion of the subject that normally wouldn't
be visible to the naked eye. Be careful not to crop
too much; eliminating too much data can affect
the quality of your image. The photo is considered
an abstract because most people viewing it really
don't know what the subject actually is. It looks
strange and foreign, but it's actually only the cen-
ter of a flower.

38.3 © 2005 Kevin L. Moss

STEP 2: MOUNT YOUR DIGITAL CAMERA
ON A TRIPOD OR CAREFULLY HOLD IT

■ Depending on the subject, you may not want to
mount your digital camera on a tripod. For exam-
ple, when I shoot colored lights at night, such as in
the photo shown in Figure 38.4, I intentionally set
my camera to a slow shutter speed to get a move-
ment effect caused by panning my digital camera
from left to right or in slow, curved movements
while the camera's shutter is open. For other sub-
jects I shoot as close-ups, I mount my camera on a

38.4 © 2005 Kevin L. Moss

tripod in order to provide a stable platform to reduce vibration. Using a tripod is especially handy when shooting flowers outdoors where wind causes movement of your subject, or when you're shooting stationary subjects at night with long exposures, like the photo shown in Figure 38.5. The subject in the photo was stationary, but the sense of movement in the lights was achieved by zooming out of the subject while the shutter was open during an .8-second exposure.

38.5 © 2005 Kevin L. Moss

STEP 3: SELECT CAMERA SETTINGS

■ Depending on the subject you are shooting, make the appropriate camera settings before you start taking photos. Abstracts can come from any subject of the imagination, so there really isn't any rule to follow on setting up your camera. For photos where I want to capture motion by the subject, I'll slow down the shutter speed. Make sure your white balance is correct by taking some test shots and viewing the results on your LCD; check the histogram if your digital camera has that feature. Your ISO should be set to the lowest possible setting to ensure the best image quality.

> **TIP**
>
> Not every photo needs to have the subject centered exactly in the middle of the frame. Try moving your subject to the right or left, and to the top or bottom of the frame. Different compositions of your subject may give you a totally new feel to the photograph. When shooting abstracts, experiment with various positions of your subject to get different versions of the same photo.

STEP 4: COMPOSE AND TAKE PHOTOS OF ABSTRACTS

■ Take photos in both landscape and portrait orientations. Zoom in on the subject and take photos as well as zoom out to get wide-angle photos of the same scene. Shooting abstracts gives the photographer more choices for composing subjects than when shooting traditional shots. Don't be afraid to tilt your digital camera; there is no rule that says you need to take abstract photos in a perfectly horizontal manner!

STEP 5: REVIEW PHOTOS

■ After taking abstract photos, review them on the LCD. Make sure the exposure, white balance, and focus were set properly. Make any necessary adjustments to the settings, recompose the subjects, and take more photos. Don't forget to try as many compositions of your subjects as you can; you'll have more photos to choose from when you work with the images in Photoshop or Photoshop Elements 3.

TAKING PHOTOS FOR DIGITAL MANIPULATION

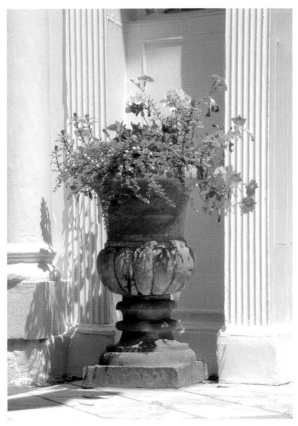

39.1 *Original image*

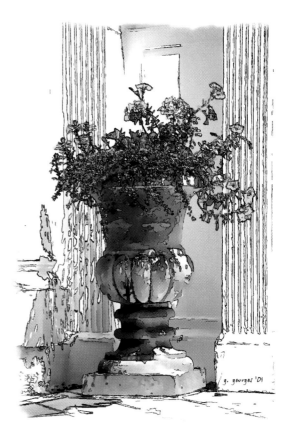

39.2 *Edited image*

"Flowering Urn in Charleston, South Carolina" Nikon Coolpix, zoom set to 90mm (35mm equivalent), f/10@1/114, ISO 80.

The moment you open up a digital photo in an image editor such as Photoshop or Photoshop Elements, you open yourself up to a whole new world of creative possibilities. Understanding what you can do with an image editor before you take photos helps you to see everything differently. You can take a fantastic blue sky with puffy white clouds from one photo and put it in another photo that has a less interesting sky. You can insert and

215

remove people in a group portrait. Adding the texture or color from one photo to another is also possible, as are an infinite number of other possibilities. After you understand what is possible, you can begin taking photos specifically to be manipulated digitally.

In this technique, you learn how to take the digital photo of the urn shown in Figure 39.1 and transform it into the watercolored pen-and-ink sketch shown in Figure 39.2. The point of this technique is that a photo is no longer just a photo; rather, you can use it as a starting point or as just a piece of an entirely new creative process, way beyond what was possible in the traditional darkroom.

In the next six steps, you make an image look like a watercolor painting, and then turn a second copy into a pen-and-ink sketch. In the end, you combine these two images into a watercolored pen-and-ink sketch. Although the technique was done using Photoshop Elements 3, you can easily complete it with any of the other Photoshop products, too.

STEP 1: OPEN A FILE

■ After launching Photoshop Elements, choose **File ➤ Browse Folders** to display the File Browser. Alternatively, you can press **Ctrl+Shift+O**.
■ Choose a file to manipulate and double-click the thumbnail to open it. I've chosen an image named **urn-before**.

STEP 2: MAKE A COPY OF THE IMAGE TO BE USED FOR THE WATERCOLOR PAINTING

■ Because this technique uses both watercolor and pen-and-ink effects, duplicate the image by choosing **Image ➤ Image Duplicate**.
■ When the **Duplicate Image** dialog box appears, type **pen-ink** to name the image, as shown in Figure 39.3, and then click **OK**.

STEP 3: TRANSFORM THE FIRST IMAGE INTO A WATERCOLOR PAINTING

Photoshop Elements does have a watercolor filter, but in most cases, I find that it makes the images too dark with too many odd-looking brush strokes. Therefore, let's try another approach.

39.3

■ Click the **urn-before** image to make it the active image.

■ Choose **Filter** ➢ **Artistic** ➢ **Dry Brush** to get the **Dry Brush** dialog box. Click the preview window and drag the image around until you can see the area of the image you want to work on. Begin experimenting with the settings for **Brush Size**, **Brush Detail**, and **Texture**. I used **2**, **8**, and **1**, as shown in Figure 39.4. Click **OK** to apply the settings.

To soften the brush strokes and make them look more like a watercolor wash, try using a blur filter:

■ Choose **Filter** ➢ **Blur** ➢ **Smart Blur** to open the **Smart Blur** dialog box. Try using a **Radius** of **10** and a **Threshold** of **50,** as shown in Figure 39.5. Make sure you have **Quality** set to **High**, and **Mode** set to **Normal**, before clicking **OK** to apply the settings.

39.4

39.5

For this particular image, these few steps produce a realistic-looking watercolor. After using many images and trying many different techniques to create watercolor paintings, I've concluded there are many variables and settings for each of many different techniques; what works on one image may work poorly on another. In general, these steps work well on images that are about 1,600×1,200 pixels in size and have been taken with a digital camera.

On larger files, and when photographs have been scanned with a flat-bed scanner or negatives or slides have been scanned with a film scanner, the same techniques work well if you first apply a light Gaussian Blur to the image. The larger the files, the better this technique seems to work, provided that the image is a good-quality image with minimal grain. Sometimes, you may also find that you can make an image look more like a watercolor painting if you apply some of these filters more than once. Experimentation is the key to getting what you want.

STEP 4: TRANSFORM THE SECOND IMAGE INTO A PEN-AND-INK SKETCH

The next step is to turn the second image into a pen-and-ink sketch. Although many digital imagers use and recommend the Find Edges filter to make line drawings, I find I get much better results with a hidden option in the Smart Blur filter. The results, as you'll see, can be quite outstanding.

- Click the second image, named **pen-ink** in Step 2, to make it the active image.
- Choose **Enhance ➢ Adjust Color ➢ Remove Color** to remove all color. Alternatively, use the **Ctrl+Shift+U** keyboard shortcut.

■ Choose **Filter** ➤ **Blur** ➤ **Smart Blur** to open the **Smart Blur** dialog box shown in Figure 39.6. I set **Quality** to **High**, and **Mode** to **Edge Only**.

Finding settings that show the vertical lines on the columns while not adding too many lines around the flowers is important. To do this, click in the preview window inside the **Smart Blur** dialog box and drag the preview image until you see the area of the image you want to work on, as shown in Figure 39.6.

■ Try setting **Radius** to **25** and **Threshold** to **35**. Click **OK** to apply the settings.

■ You may be surprised to see what now looks like white lines on a black ink scratchboard, as shown in Figure 39.7, but this is okay. Choose **Image** ➤ **Adjustments** ➤ **Invert,** and you see black lines on a white background sketch. Alternatively, you can press **Ctrl+I**.

39.6

39.7

STEP 5: COMBINE THE IMAGES

At this point, you have learned two techniques and you have two entirely different images made from the same digital photo — a watercolor-like image and a pen-and-ink sketch. Now you can combine these two images:

■ Click the **urn-before** image to make it active, choose **Select** ➣ **All** (**Ctrl+A**), and then choose **Edit** ➣ **Copy** (**Ctrl+C**) to copy the image into memory.

■ Click the **pen-ink** image to make it active, and choose **Edit** ➣ **Paste** (**Ctrl+V**) to paste the image as a new layer.

■ Looking at the **Layers** palette in Figure 39.8, you can see two layers. Click the **Layer 1** thumbnail once in the **Layers** palette to make sure it is the active layer, and, still in the **Layers** palette, set the **Blend Mode** to **Multiply** and **Opacity** to **100** percent.

39.8

STEP 6: MAKE THE FINAL COLOR ADJUSTMENTS AND ADD YOUR SIGNATURE

■ Choose **Layer** ➣ **Flatten Image** to flatten the layers into one layer.

You have lots of adjustments for changing color, such as Levels, Color Cast, and Hue/Saturation.

■ To lighten the image, choose **Enhance** ➣ **Adjust Lighting** ➣ **Brightness/Contrast** ➣ **Levels** (**Ctrl+L**) to open the **Levels** dialog box. I set **Input Levels** to **0**, **.75**, and **160**, as shown in Figure 39.9.

■ Click **OK** to apply the settings.

The final step is to adjust the colors as you like them. Because I have both Photoshop Elements and an artistic license to create, I decided to make the image turquoise, purple, and green with yellow flowers, as shown earlier in Figure 39.2.

39.9

■ Choose **Enhance** ➢ **Adjust Color** ➢ **Hue/Saturation** (**Ctrl+U**) to open the **Hue/Saturation** dialog box. I set **Hue**, **Saturation**, and **Lightness** to **100**, **20**, and **0**, respectively, as shown in Figure 39.10.

If you don't like turquoise, purple, and green, use Hue/Saturation or Color Variations to get the colors you want. Creating something out of the ordinary is great fun, and if you like it, do it! If not, make adjustments to suit your taste. Additionally, don't forget to add your signature — it adds a nice touch to your painting. If I wanted, I could also hand-paint more of the flowers yellow. Some of them seem to be lacking a bit of color on the left side of the image. A good tool for painting the flowers is the **Brush** tool. If you want to put a soft edge on your image, you can use a soft eraser. Save your file, and it is ready to be printed.

Although this image looks reasonably good on a computer screen, it really does look exceptional when printed on a fine-art watercolor paper with a photo-quality inkjet printer. I used an Epson 1280 printer and Waterford DI Extra White CP watercolor paper distributed by Legion Paper Corporation (www.legionpaper.com). Printing on quality fine-art paper is essential to getting a print that you'll be proud to frame.

This is just one example of how you can digitally edit photos and make something entirely different than what you started with. The point of this technique is that you can begin to shoot with an entirely new view of what you want to get!

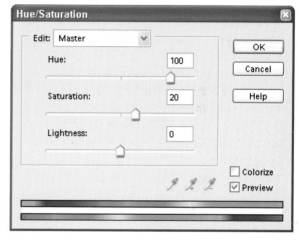

39.10

USING YOUR DESKTOP SCANNER AS A DIGITAL CAMERA

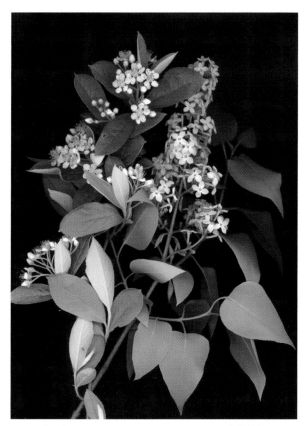

40.1 *Original image* © 2005 Kevin L. Moss

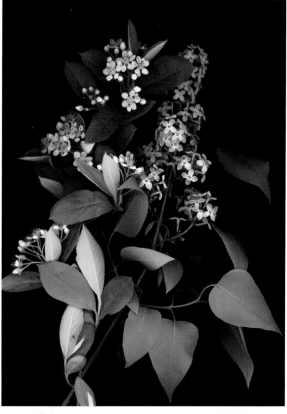

40.2 *Edited image* © 2005 Kevin L. Moss

Now that using digital cameras is the primary way to capture digital images, photographer's flatbed scanners are not used as much. It used to be that the primary way photographers got their film-based images into Photoshop was to scan either a print or preferably a negative using a flatbed or dedicated film scanner. Some still do. I've been 100 percent digital the past few years now, but I still maintain a huge film library that I am *still* in the process of digitizing using a high-end flatbed scanner to get all of my old images from 35mm transparencies to digital files.

223

I now use my flatbed scanners for another purpose, a little trick I've come across, which is using the flatbed scanner to capture beautiful images of plants, flowers, and anything else I can think of to scan. The photo in Figure 40.1 was captured using an Epson Perfection Photo 3170 flatbed scanner. I simply placed my subjects — lilac and chokeberry blossoms — right on the glass and scanned the image directly to Photoshop. I then adjusted Levels, Brightness/Contrast, and Saturation, and then removed dust particles in Photoshop Elements. The photo in Figure 40.2 shows the processed image.

STEP 1: CHOOSE A SUBJECT

■ I've always found that flowers, dead or alive, make for my best scanning subjects, but what you can scan is only limited by your imagination. Most flatbed scanners provide an area of around 8½×11 inches. I try to pick subjects that take up as much of that space as possible, giving me a full *frame,* or area, of an 8½×11 image at 300 ppi.

STEP 2: SET UP YOUR FLATBED SCANNER

■ The most important part of the flatbed scanner to keep clean is the glass on which you place your prints and negatives to be scanned. The glass needs to be kept as clean and dust-free as possible, because the scanner captures an image of the reflective surface that is placed *directly* on the glass. Any dust particle, smudge, or fingerprint that is on the glass when you scan an object becomes part of the digital image. To avoid having to touch up your scanned images in Photoshop or Photoshop Elements, make sure the glass is clean and dust-free.

TIP

Be careful how you take care of your scanner's glass surface. The glass should be treated just as gently as a digital camera lens. Clean your scanner's glass with glass cleaning solution and a soft cloth. I find that sterile gauze works best. Flowers and plant life leave pollen and other small products on the glass. Use a can of compressed air to blow off any dust particles or pollen after you remove objects and before placing new ones on the scanner glass surface.

STEP 3: COMPOSE YOUR SUBJECT ON THE SCANNER SURFACE

■ Just like when you compose a subject with your digital camera, you must compose a subject on the scanner. If you are scanning plants or flowers, make sure all of the subject is on the scanner surface and you are not chopping off any part of the object. Center or place the subject on the scanner surface to compose the photo in the same manner in which you would place the subject with your digital camera when composing a photo using your LCD or viewfinder.

STEP 4: DARKEN THE ROOM

■ To achieve black backgrounds for your scanned object, eliminate light in the room as much as possible. The scanner will capture the object that is placed on the scanner glass and anything else above the subject. Darken the room by closing the blinds and turning off the lights. If your scanner is within 6 feet of the ceiling, the scanned image may

have part of the ceiling in it if too much light is in the room. For best results, capture photos with the scanner at night when you can guarantee a properly darkened room to scan in.

STEP 5: LEAVE THE SCANNER LID IN THE UP POSITION

■ It is vital that you don't close the scanner lid. Leaving the scanner open prevents the scanner lid from showing up in the background of your image.

STEP 6: OPEN THE SCANNER DRIVER SOFTWARE

■ In Photoshop Elements, choose **File ➢ Import** and choose your scanner from the list of import devices displayed.

STEP 7: MAKE ADJUSTMENTS IN THE SCANNER DRIVER SOFTWARE

■ After choosing the **File ➢ Import** command, set up your scan in the scanner driver software window like the one shown in Figure 40.3. The scanner I used to scan the images in this technique was an Epson Perfection 3170; Figure 40.3 shows the scanner driver window for that scanner. Your scanner driver window may be different — every manufacturer has different software they provide for their brand of scanners.

Regardless of the model scanner you are using, make adjustments to indicate a scan resolution of **300** dpi (dots per inch), a **Reflective** document type (flatbed scanners can scan reflective objects, such as photos or negatives), and an image type of **24-bit Color**.

NOTE

You must have a scanner properly installed on your computer. Photoshop Elements and Photoshop automatically list the installed scanner in the File/Import list. If your scanner does not appear as an Import option, try reinstalling the scanner driver and software that was included with your scanner.

TIP

Setting the scanner to a scan resolution more than 300 or 400 dpi results in an image file that is far too large for your needs, unless you are making prints poster size or larger. Scanners are designed primarily to scan negatives and slides whose size requires much higher resolution settings, such as 4800 dpi. For scanning reflective objects such as old photos or objects such as flowers, dpi settings of 300 or 400 provide you with an image file that can be later printed as an 8×10 print, or as a print up to 16×20 inches. Any larger dpi settings just slow down the actual scanning and result in image files that take up more disk space on your computer.

40.3

The scan preview may show some of the background it picked up while scanning the object. This is normal during scanning because the scanner captures some of the background of the object it scans. You can easily remove artifacts that the scanner may pick up from the background using Photoshop Elements or other image editors.

40.4

STEP 8: PREVIEW THE SCAN

■ Click the **Preview** button to preview how your scan will look. Figure 40.4 shows the **Preview** window. Check to make sure your object is properly placed on the scanner glass by viewing the preview. If needed, make any adjustments to your composition, and then preview the scan again.

STEP 9: SCAN THE OBJECT

■ Click the **Scan** button in the scanner driver window. The higher the resolution you set, the longer the scan takes. When the scanner completes the scan, the scanner driver automatically loads the image into a Photoshop Elements document window.

STEP 10: EDIT THE IMAGE IN PHOTOSHOP ELEMENTS 3

■ Scanned images often first appear light with a lack of contrast and color saturation. Using Photoshop Elements 3, make adjustments to Levels, Brightness/Contrast, and Hue/Saturation to achieve the desired results for your scan. The tulip in Figure 40.5 was composed on the scanner just as I would have composed it using my digital camera, scanned, and then adjusted in Photoshop Elements 3.

Try different compositions for the objects you are scanning. A single flower perfectly positioned vertically doesn't create as much drama in the image as if you positioned it from lower left to upper right, like the example shown in Figure 40.6. The 400 dpi scan of the flowering chokeberry produced a beautiful image printed in large format on an Epson R1800 printer using Epson Watercolor Radiant White paper.

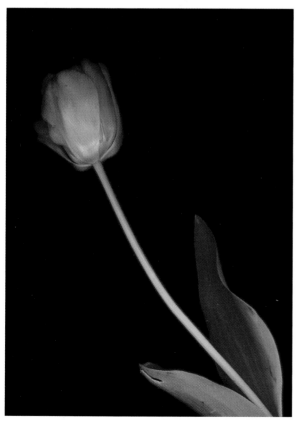

40.5 © 2005 Kevin L. Moss

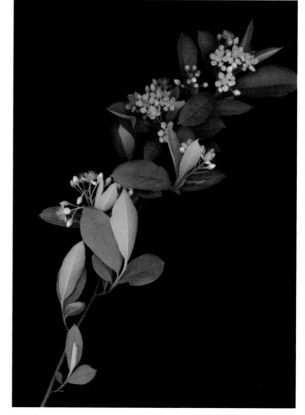

40.6 © 2005 Kevin L. Moss

USING MACRO MODE TO TAKE CLOSE-UP PHOTOS

41.1 *Original image*

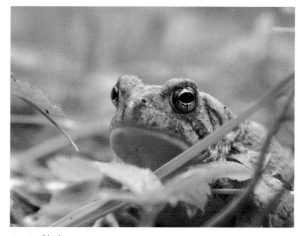

41.2 *Edited image*

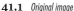

ABOUT THE IMAGE

"Looking Up at a Frog"
Nikon Coolpix, hand-held,
zoom set to 111mm (35mm
equivalent), f/4.0@1/65,
ISO 80.

The world of digital macro photography is full of opportunity and surprise. You can make small things look large. Tiny things you ordinarily never see or notice can be presented in an attention-grabbing photo; so get your camera, put it in macro mode, and look for fun subjects to shoot, like the frog shown in Figures 41.1 and 41.2. In this technique, you learn about the challenges that you'll face when shooting close-up photos, and you learn how to use macro mode to get great photos that you'll enjoy sharing with others.

First, let's cover a few terms. Many people use the terms *macro photography* and *close-up photography* interchangeably, but they shouldn't. Technically, macro photography is taking photographs that are life-size or larger. In other words, the actual image on the image sensor (or film if you are using a film camera) is 1:1 with the subject or larger. Close-up photography is merely taking photographs close to the subject — generally, between a couple of inches and a few feet — depending on the focal length

of the lens you use. However, a macro mode on compact digital cameras simply enables the lens to focus on a subject closer than if the camera were not in macro mode. Strictly speaking, using a macro mode doesn't necessarily mean that you are taking macro photos, but depending on the distance between your camera and the subject and the focal length of the lens you are using, you could be taking macro photos!

When you shoot within a few inches to a foot of your subject, depth of field is limited at these close-focusing distances. Depending on your camera and lens, depth of field can be as shallow as 1/8 inch. Notice how the right eye of the frog is clearly in focus in Figure 41.1, but the left eye is slightly out of focus.

Because of the shallow depth of field, one of the challenges of close-up photography is to get enough of your subject in focus to realize your vision of the photo you want. Quite often you will not have sufficient depth of field and you will have to focus very carefully on the most important part of your subject. The photo shown in Figure 41.2 was taken after a tiny adjustment in focus on the frog was made. Notice how the left eye is now in focus and the right eye is slightly blurred. This tiny difference made one photo good and the other unacceptable.

In Technique 10, you learned that aperture determines the amount of depth of field you get — a larger aperture number (for example, f/8.0) setting results in less depth of field than a smaller aperture number (for example, f/2.2). Because aperture size and shutter speed are tightly interrelated, a small aperture setting (that is, good depth of field) requires a slow shutter speed to get adequate exposure. Anytime you shoot with a shutter speed 1/60 of a second or less, you have to be much more concerned about camera shake and subject movement if you want to avoid getting blur in the photo.

One other challenge you'll face when taking close-up photos is getting enough light where it is needed. When you're within a foot or so of the subject, blocking light with your body or camera is possible. In addition, because many close-up subjects, like the frog, are usually found in shaded environments, the use of a slow shutter speed is almost a given. Factor in a little wind with the previously mentioned factors and you get a good idea why close-up photography is a challenge but quite rewarding when you get it right!

STEP 1: READ YOUR CAMERA MANUAL

■ As macro modes vary widely between camera models, take a few minutes now and read the documentation that came with your camera to learn all that you can about your camera's macro feature, if it has one. The macro mode on most compact digital cameras enables the lens to focus closer to a subject than it can without using macro mode, thus allowing the image to fill up more of the frame or magnifying the subject more than when the camera is not in macro mode.

■ Also look up the minimum and maximum distance that you can shoot when in macro mode. If you completed the Digital Camera Features/Specification checklist in Technique 1, you already have the information you need. For example, when using the Canon PowerShot macro mode, you can shoot close-ups of subjects in the range of 2.4 inches to 2.3 feet at maximum wide angle, and 7.9 inches to 2.3 feet at maximum telephoto. Some of the Nikon Coolpix cameras can focus to less than 1 inch when set on macro.

STEP 2: DECIDE HOW YOU WANT THE PHOTO TO LOOK

■ Visualize the photo you want before setting up to take a photo. Do you want a tight image showing just your subject, or do you want to show the subject with some of the surrounding area, too? Should the whole subject be clearly in focus, or is part of your design to blur part of the subject and all the background?

My intention taking the frog photo was to place the camera on the ground and shoot up at the frog to make the small one-inch-long frog look huge. The intent was also to make the background as blurred as possible so that the image looked more dramatic with just the big bright frog eyes being in focus.

STEP 3: SELECT CAMERA SETTINGS

■ Depending on how you want your photo to look, you can choose aperture priority mode, select an appropriate aperture setting, and let the camera select the shutter speed. Alternatively, you can choose shutter priority mode and choose the shutter speed to minimize or show subject movement; then, let the camera choose the aperture. In either case, you may find that the camera-chosen settings are outside the limits of your camera or not the settings you want to use. In that case, you can consider changing the ISO setting, add light with a flash, or reconsider how you want the photo to look.

STEP 4: COMPOSE AND TAKE PHOTOS

■ After you have selected the desired camera settings, compose and take a few photos. One of the great things about shooting with most compact digital cameras is you do not have to press your eye right against a viewfinder to compose a shot. Instead, you can place the camera where needed to get the best shot and then look at the LCD monitor. If your camera has a swivel LCD monitor like many of the Nikon Coolpix or Canon cameras, it is even easier to see what you are shooting without having to be a gymnast to get the shot you want. When pressing the shutter button, be careful to minimize camera movement, which robs sharpness from your pictures.

STEP 5: EVALUATE PHOTOS AND SHOOT AGAIN

■ When shooting close-up photos, carefully evaluate the results on your LCD monitor and with the histogram if your camera has one. You may also want to use a zoom review feature, if your camera has one, to zoom in on an image to see whether the subject is in focus as you want it. However, be aware that a small LCD monitor can mislead you into thinking you have the photo you want — when in fact, the subject is poorly focused, or there is image blur due to camera or subject movement. The best strategy is to shoot many photos so that you can choose from more than one when you download them to your computer and look at them on a large computer monitor.

TIP

When it suits your vision of the photo you want, try to keep the plane of the image sensor parallel with your subject to keep as much of the subject in the area of focus as possible.

TIP

If you want even more magnification of tiny subjects, you may want to consider purchasing a close-up filter. Close-up filters are supplemental lenses designed to allow even closer focusing than is ordinarily possible with your camera's lens, even when it is in macro mode. Close-up filters screw onto the camera's filter ring. Depending on your camera's macro capability, you may never need one of these filters, or it could allow you to get the extra close details that your camera could get no other way.

CHAPTER 9

DISPLAYING AND TAKING CARE OF YOUR DIGITAL IMAGES

T aking photos of your favorite people and places is a great way to spend any day if you're a professional photographer or an enthusiastic hobbyist. It's easy to fill up memory cards with shots to download to your computer. After a while, your portfolio begins to grow with many quality photographs worthy of printing and sharing. This book is about digital camera techniques, but a chapter on displaying and taking care of your digital images is worthwhile because the purpose of taking photos is to show them off! Technique 42 shows you how to get prints from files downloaded from your digital camera, and Technique 43 shows you how to send your digital images to Web-based companies that do the printing for you. Technique 44 shows you how to easily build a Web site to show off your photos to friends or to the rest of the world. Digital images need to be stored and backed up safely, so Technique 45 shows you the best practices for storing and archiving your digital files.

GETTING PRINTS FROM DIGITAL IMAGES

42.1 © 2005 Kevin L. Moss

42.2 © 2005 Kevin L. Moss

For many photographers, the ultimate destination for their digital photos is the final print. All the digital cameras, tripods, memory cards, filters, and other gadgets in your digital arsenal are intended for one purpose — getting great images from which to make prints. Most photos have traditionally been printed on small-sized paper — around 4×6 inches. Today's inkjet printers give all of us the capability to print from 4×6 up to 13×19 inches or larger. The photos in Figures 42.1 and 42.2 were taken while I was printing 8½×11 brochures on one of my photo-quality inkjet printers.

GETTING IMAGE FILES FROM CAMERA TO PRINTER

Photographers have a few choices on how to get the photos they take with their digital camera to prints. The first and most popular way is to download images from a memory card to your computer, edit the images in Photoshop or Photoshop Elements, and print the photos on a photo-quality inkjet printer. With this method, the photographer has absolute control over the appearance and color attributes of an image and how that image looks when printed.

The second method is to print directly from your digital camera to a printer. Kodak offers digital camera printing docks for some of its digital camera models. After shooting photos, connect the digital camera to the printing dock and make prints directly from the digital camera. Some digital camera manufacturers use PictBridge technology, allowing you to use your digital camera's USB cable to connect directly to a PictBridge-compatible photo-quality printer, such as the Epson PictureMate. Some printers are built with compact flash, memory stick, and SD card slots where you can plug a memory card into the slot and print images directly from the memory card.

A third way to get photos you take with your digital camera is to copy your digital images to a CD and take them up to the local photo lab. Most drug stores, camera stores, and photo labs have the capability to read your digital images from CD and produce prints using their printing equipment. Prices vary from store to store, so do some shopping for the best price, service, and print quality.

Direct-printing methods produce acceptable quality snapshots, but nothing beats the quality of a print resulting from first adjusting and editing images in Photoshop or Photoshop Elements 3 before printing.

STEP 1: DOWNLOAD IMAGES TO YOUR COMPUTER

■ After filling up a memory card with great photos, download the files to your computer using one of two methods. The first is to connect the USB cable that came with your digital camera to your computer. (Some digital SLR cameras use FireWire cables.) The second way is to remove your memory card from your digital camera and insert it into a card reader that is connected to your computer like the card reader shown in Figure 42.3. Downloading images using card readers is the fastest method of transferring images from your digital camera to your computer, and it's also the preferred method.

TIP

Some digital photo media readers are much faster at transferring files than other readers. The primary factor that determines data transfer speed is the interface. The two most common interfaces are USB (Universal Serial Bus) and FireWire. The USB 2.0 interface can yield data transfer rates that are up to 13 times as fast as USB 1.1. While USB 2.0 has a slight edge in data transfer speed over FireWire, differences in architecture give FireWire a slight edge when used for connecting external hard drives. It is important to note that your computer must support the interface version of your card. Attaching a USB 2.0 reader to a USB 1.1 interface only allows data to be transferred at the USB 1.1 rate. If you don't have a USB 2.0 or FireWire interface on your computer, you can purchase a relatively inexpensive card from Adaptec (www.adaptec.com). They even offer dual USB and FireWire cards for about $80.

42.3

© 2005 Kevin L. Moss

STEP 2: SELECT AND OPEN AN IMAGE TO ADJUST, EDIT, AND PRINT

■ Using Photoshop Elements 3, choose **File ➤ Browse** to select and open the file browser shown in Figure 42.4. Click the image you want to open and then choose **File ➤ Open** or double-click the image.

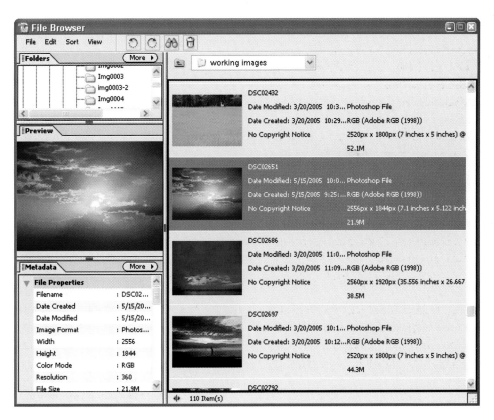

42.4

STEP 3: MAKE ADJUSTMENTS AND EDITS TO THE IMAGE

■ Make adjustments to the image (see Figure 42.5) to improve Levels, Brightness/Contrast, and finally Hue Saturation. (You can make these adjustments in any order, but get in the habit of making these adjustments in a particular order so that your adjustments to your images are consistent.) Figure 42.6 shows the **Layers** palette, showing that the background layer was duplicated, and then Levels, Brightness/Contrast, and Hue/Saturation adjustments made. Get in the habit of making image adjustments in this order.

TIP

If you shoot a lot of images with your digital camera, consider investing in a card reader. These devices connect to one of your computer's USB or FireWire ports and are the fastest method of transferring images from memory cards to a computer. Costing less than a memory card, a card reader will save you time if you shoot a lot of digital photos. Some desktop and laptop computers come with built-in card readers; when shopping for a new computer, consider purchasing one with this feature.

42.5

TIP

When editing images for printing in Photoshop Elements, make sure your color settings are appropriate for printing, not for producing images for some use, such as viewing on the Web. Choose **Edit** ➤ **Color** Settings and choose the **Full Color Management** option. Full Color Management sets your working space to Adobe RGB (1998), the preferred color space for editing images for printing. If you plan to display the image on the Web, you can always save a version of the image file with the Limited Color Management option, which uses the sRGB color space, which is optimized for images to be viewed on the Web.

42.6

STEP 4: SAVE THE EDITED FILE

■ Before proceeding to printing an adjusted and edited image, save the file in Photoshop PSD file format to preserve the layers in which you made the adjustments. By saving the adjusted and edited image as a Photoshop file, you can always go back and make changes to the individual layers you have created when making corrections to your image.

STEP 5: FLATTEN LAYERS

■ With the edited image saved and safe for later use, flatten the layers in the image by choosing **Layer** ➤ **Flatten Image**. Flattening the image greatly reduces the image's size, lessening the time needed to process and print your photo.

STEP 6: CHANGE THE IMAGE SIZE TO MATCH PRINT SIZE

■ Click the **Crop** tool in the Photoshop Elements 3 **Toolbox** and then enter the image width, height, and resolution in the **Option** bar. Set the width and height to match the size photo you want to print. If you are printing a 5×7-inch print in landscape mode, enter a width of **7** and a height of **5**. Type a value between **300** and **360** in the **Resolution** box. A resolution of **300** to **360** is the optimum resolution setting for most inkjet printers. Click and drag the crop area you want in the image window, as shown in Figure 42.7. Click the **Checkmark** button located on the right side of the **Crop** tool in the **Option** bar to accept the crop.

42.7

STEP 7: CHOOSE PAGE SETTINGS

■ Choose **File ➢ Page Setup**. Set the size in the **Size** drop-down list for the paper that is loaded in your printer. Select the **Portrait** or **Landscape** setting in the **Orientation** section, as shown in Figure 42.8. Click **OK** to save the Page Setup settings.

42.8

STEP 8: PRINT YOUR PHOTO

■ Choose **File ➢ Print**. In the **Print** window, select **Show More Options**, as shown in Figure 42.9. In the **Color Management** section, make sure the **Source Space** is set to **Adobe RGB (1998)**. This is the color space in which you adjusted and edited your photo. From the **Print Space** drop-down list, choose the printer to which you are printing or the paper profile (the type of paper you have loaded in your printer). Click **Print** to continue.

TIP

When you install printer software, the installation CD automatically installs paper profiles, which appear in the Print Space selection box. If no paper profiles are listed, choose your printer from the Print Space drop-down list in the Print Preview window.

42.9

■ In the **Print** window, click **Properties**. You can use the **Printer Properties** window, shown in Figure 42.10, to make final settings before printing. The example shown is for the Epson R1800 printer. Your **Printer Properties** window may appear different, depending on the model printer you have.

■ Choose the highest quality settings for your printer. Deselecting the **High Speed** setting improves the quality of your print, but also causes slower printing. The most important setting to make is to select the **ICM** radio button in the **Color Management** section and then select the **Off** (**No Color Adjustment**) radio button in the **ICC/ICM Profile** section. These selections ensure that Photoshop Elements performs color management, not the printer.

■ Click **OK** and watch your photo print on your printer.

42.10

USING ONLINE PHOTO PRINTING SERVICES

43.1

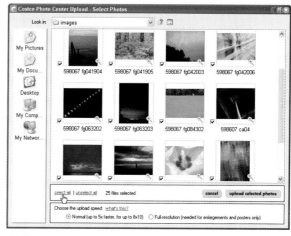

43.2

An alternative to printing your own photos is to send them out to be printed by a company that offers its services over the Internet. Many people still have their images processed just like they did when using film cameras. Instead of sending film to the lab for processing, you can send your digital images over the Web to be processed. The photo in Figure 43.1 is shown being selected for upload to the Costco Photo Center Web site in Figure 43.2.

Many companies on the Web will print your digital images. AOL, Adobe (in partnership with Kodak), Costco, and Yahoo! all offer online photo printing services. All the services allow you to choose the photos and sizes you want and then order prints right on their Web site. The easiest way to order prints online, however, is directly out of Photoshop Elements 3.

STEP 1: SELECT THE PHOTOS YOU WANT TO PRINT

■ Select the photos to be printed by clicking them in the Elements Photo Browser. Access the Photo Browser by clicking the **Photo Browser** button on the Elements **Option** bar. Choose multiple files by pressing and holding the **Ctrl** key while clicking the files.

STEP 2: SELECT ORDER PRINTS

■ Choose **File ➣ Order Prints** from the **Photo Browser** window shown in Figure 43.3. (You can also click the printer icon located on the Photo Browser menu bar and then select **Order Prints**.) Elements then connects to the Kodak Easy Share Web site and displays a new window.

43.3

STEP 3: CREATE A USERNAME AND PASSWORD FOR KODAK EASY SHARE

- Fill out the username and password information requested. This opens an account with the Kodak Easy Share printing service. Click **OK** to continue.

STEP 4: CHOOSE THE SIZE AND NUMBER OF PRINTS YOU WANT TO ORDER

- In the **Kodak Easy Share Gallery** window, shown in Figure 43.4, type the number of prints you want for each photo next to the size photo you want. (The photos you selected in the Photo Browser will be shown.) Kodak Easy Share automatically calculates the amount for each photo and the total amount for your order. Click **Next** to continue.

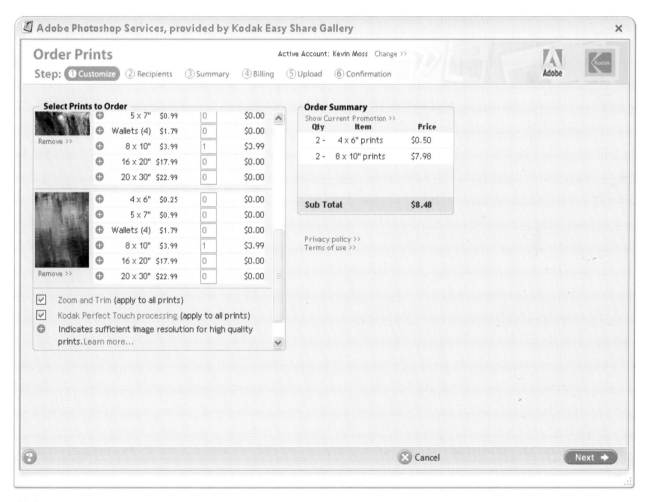

STEP 5: PROVIDE YOUR SHIPPING INFORMATION

■ Fill out your address, e-mail, and phone number in the **Edit Address** window. Kodak will ship your prints to the address you provide here. Click **Next** to continue.

STEP 6: ADD RECIPIENTS

■ In the **Recipients** window, you can add addresses for people to whom you want to send photos. You can add their names and addresses and have prints shipped directly to them. Click **Next** to continue.

STEP 7: REVIEW SUMMARY INFORMATION

■ The next page provides a review of the information you have entered so far. Click **Next** to continue or click **Back** to change information.

STEP 8: FILL OUT BILLING INFORMATION

■ Fill out the required fields to provide your credit card information and billing address. Click **Place Order** to submit your order. Kodak Easy Share uploads the images to its Web site and then provides you with a confirmation page. Your prints will then be shipped to you or to whomever you ordered prints for.

> **TIP**
>
> There are many online photo printing service Web sites available on the Internet that provide similar services to that of Kodak Easy Share. Companies such as Costco and Yahoo! offer utilities on their Web sites that allow you to upload your digital images to them and order prints. Go on the Web to visit the various online printing sites and to compare services and prices.

SHARING YOUR IMAGES ON THE WEB

44.1

44.2

TIP

Create Web sites to show off your photos using easy tools such as FrontPage or Photoshop Elements 3.

One of the easiest ways to share photos with friends, family, or even the rest of the world is to display them on the World Wide Web. The Web has become the primary showcase for photographers to display their work. My Web site, shown in Figure 44.1, goes through many iterations as I update my online portfolio with my latest images. Many Internet service providers now offer their subscribers their own Web space as part of the monthly fee, making setting up your own Web site easy and affordable. You don't even need to know how to program HTML to create Web pages; most Internet providers provide easy step-by-step templates for you to create your Web page without having to write any program code.

In addition to using templates that your Internet service provider offers, many software tools are available, such as FrontPage and Photoshop Elements 3 Web Photo Gallery, that allow you to quickly and easily set up your photo Web site. However, I find the easiest tool to use is Photoshop Elements 3 Web Photo Gallery, with which I created the Web site shown in Figure 44.2.

STEP 1: CLICK THE CREATE BUTTON

■ From the Photoshop Elements 3 **Option** bar shown in Figure 44.3, click the **Create** button to open the **Creation Setup** window shown in Figure 44.4. You can also click the **Make Photo Creation**

button from the Photoshop Elements 3 main menu page. Click **Web Photo Gallery** and then click **OK**. Photoshop Elements 3 begins to take you through a step-by-step process to create your photo Web site.

44.3

44.4

44.5

STEP 2: SELECT PHOTOS FOR YOUR WEB SITE

■ After you click **Web Photo Gallery**, the **Adobe Web Photo Gallery** window (see Figure 44.5) appears. Select the photos you want to add to your Web site. Click the **Add** button. The **Add Photos** window, shown in Figure 44.6, appears and allows you to view photos recently viewed in the Photo Browser, your entire Elements catalog, or by **Collections** or **Tags** you have created in Elements. Select the check box next to each thumbnail to select that image for your Web site. After making your selections, click **Add Selected Photos** and then click **OK**.

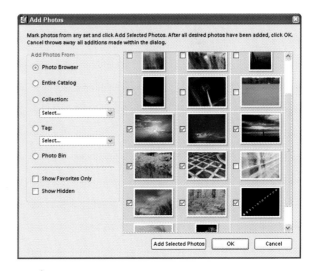

44.6

STEP 3: SELECT A GALLERY STYLE

■ From the **Gallery Style** drop-down list in the **Adobe Web Photo Gallery** window (see Figure 44.5), choose the style you want for your Web site from the more than 30 Web site styles. You can view each style by making a style selection, and then looking at the preview that appears just below the drop-down list.

STEP 4: ADD BANNER AND DESTINATION INFORMATION

■ Type the Web site title, subtitle, and your e-mail address (optional) in the **Banner** tab of the **Adobe Web Photo Gallery** window. This information will be displayed on your Web page. Choose the font and size you want for this information. In the **Destination** section, choose the path or folder on your computer where you want to save your Web pages. Type the name of the subfolder you want to use in the **Site Folder** field; doing this creates a subfolder within the path folder.

STEP 5: SELECT THUMBNAIL SIZE

■ The **Adobe Web Photo Gallery** window also lets you create thumbnails for the Web site. Click the **Thumbnails** tab and indicate the thumbnail size you want to show. If you want captions to appear for your thumbnails, choose the font, size, and type of caption you want.

STEP 6: SELECT IMAGE SIZES

■ Click the **Large Photos** tab. Make sure the **Resize Photo** check box is selected. Choose **Medium** for the size of your photos (anything larger may not appear within a browser window when viewed on the Web). If you want captions to appear under your photos, choose the font, size, and type of caption you want.

STEP 7: SELECT SITE COLORS

■ Click the **Custom Colors** tab and select colors for the various elements, such as the background and text of your Web site. Be careful to pick color combinations that are easy to view on your Web site. Avoid picking dark backgrounds with dark text, links, and banners. Click the **Save** button to create your Web site.

STEP 8: VIEW YOUR PHOTO WEB SITE

■ The **Web Photo Gallery Browser** window (see Figure 44.7) shows a finished photo Web site.

TIP

You can load, or promote, your photo Web site to one of many Web hosting sites on the Web. Check your own Internet service provider (ISP) for free Web site space that may come with your Internet account. If your ISP does not offer free Web site services to you, many free services are on the Web for you to load your Web site to so others can view your photos. One such service is www.geocities.com, where you can create your own Web site free of charge, and then transfer the Web pages you've just created from your computer to your new Web site for viewing on the Web.

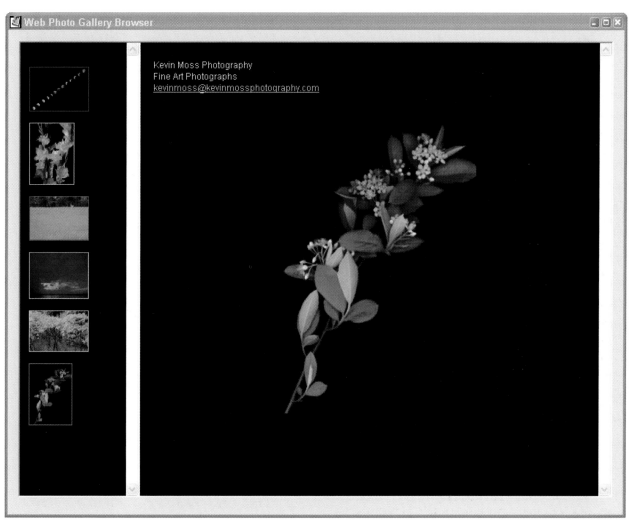

44.7

BACKING UP YOUR IMAGES
FOR SAFEKEEPING

45.1 © 2005 Kevin L. Moss

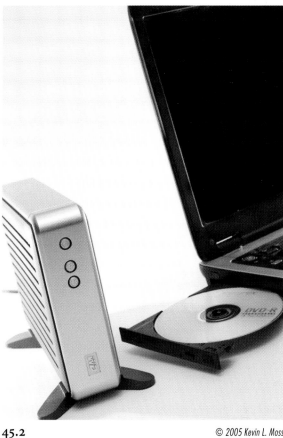

45.2 © 2005 Kevin L. Moss

Professional photographers have always made "dupes," or duplicates, of their negatives and slides for their professional work. When working with film, photographers played it safe by having a backup copy of their precious originals just in case something bad happened. Working with digital images is no different. Original digital image files needed to be duped at least a couple times in case something bad happens to your computer, like a crashed hard disk or other catastrophic failure resulting in your losing your image files forever.

255

This technique shows you a few of the best practices for protecting your digital files to ensure that your images are intact and available to you for years to come. Figure 45.1 shows the media of choice using today's technology — CD-ROMs and DVDs. Never before have we had a storage medium so inexpensive and easy to use. Almost all computers come equipped with optical drives that write, or *burn,* your image files to these discs. Standard equipment consists of either CD writers, DVD writers, or in the case of my optical drive, shown in Figure 45.2, the ability to write to both CD and DVD formats. Figure 45.2 shows an external hard disk, which you can use as a backup to your computer's hard drive as well as for auxiliary storage. In this technique, I'll show you how to back up your files to an external hard disk, one of many methods of preserving your images.

STEP 1: DEVELOP A BACKUP STRATEGY

■ Before you go out and buy a stack of CDs, DVDs, hard disks, or another computer, plan how you want to back up and archive your image files. Different photographers have different needs of archiving. I keep originals on my computer and duplicate these images to an external hard disk. Chances are good that I won't have either my current computer or external hard disk in a few years. My equipment gets used daily at least 10 hours a day and at some point is bound to fail. Hard disk drives are rated by their manufacturers as to how many hours of operation you can expect between failures; trust me, they will fail at some point. To make sure I don't lose my original files, I back up my originals to CDs and DVDs every time I download my memory cards to my computer.

Develop your backup strategy around your needs. Even if you shoot photos casually and don't accumulate thousands of images in a year, you should still make sure you make copies of your images to CD or DVD.

STEP 2: COPY YOUR IMAGES TO CD OR DVD

■ Almost all computers come equipped with a CD-RW (compact disc readable-writable) drive. Some computers come with combo optical drives that write to DVDs as well. CDs can hold about 600 megabytes of data, which is just enough to fit a full 512-megabyte memory card's worth of images on. DVDs, on the other hand, have a capacity of more than 4 gigabytes, or the equivalent of eight 512-megabyte memory cards. If your computer doesn't have a DVD writer and you shoot thousands of photos a year, consider purchasing an internal or external DVD-writable drive for your computer.

WARNING

When you choose to back up your digital photos onto CDs or DVDs, you want to buy the best ones that are available. However, it is not that easy to determine which ones are good and which are not so good. While the branding may be the same on two different boxes of CDs or DVDs, the manufacturing process or the batch may be different and therefore the reliability may be entirely different. The best approach is to buy two different brands of discs and perform your backup process twice — using two entirely different discs. This strategy decreases the chance that two discs will go bad at the same time, or that both will fail because of some manufacturing process flaw. If you decide to use CD or DVD as backup media, you should absolutely not use "rewritable" media, because it is known to suffer from more frequent problems and to last considerably less long than "write once" media. Rewriteable media includes: CD-RW, DVD+RW, DVD-RW, and DVD-RAM.

STEP 3: BACK UP YOUR COMPUTER'S HARD DISK

■ Whether you shoot dozens or thousands of photos a year, you still should back up your computer's hard disk. To make sure you don't lose valuable images, documents, spreadsheets, financial information, or any other important documents on your computer, make a duplicate copy of all files as a good practice. For years, tape drives connected either internally or externally to computers served as backup devices. Today, external hard disks, like the Western Digital 300-gigabyte model shown in Figure 45.3, can be purchased for about $100. These drives are fast, connect easily to your computer's USB port, and can be used to store image libraries as well as back up your desktop or laptop computer.

To make backing up your hard disk easy, use the backup software that is packaged with your external hard disk. To back up your computer, start your backup software and click the **Backup** button. Figure 45.4 shows Retrospect Express, a backup software program that is included with some external hard drives. You can specify what folders to back up and whether you want to back up new or modified files only or the entire contents of specified folders. If you ever need to restore files from your backup hard drive, the software has easy-to-follow utilities to make sure you can retrieve files from your previous backups.

45.3

TIP

When you copy your image files to CD or DVD, always make two copies. Keep one copy in a safe storage binder designed for CDs (some of these binders can hold more than 200 optical disks), and keep the other copy in a safety-deposit box. If you don't have a safety-deposit box, consider storing the additional CD or DVD copies in a location other than your home or office. In case of fire or other disaster, you would still have a working copy of your images. Additionally, fire safes can be considered a short-term storage medium for your CDs or DVDs.

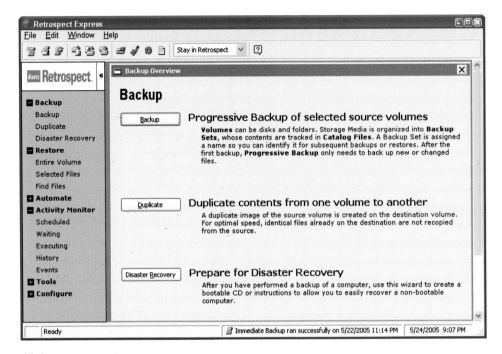

45.4

CHAPTER 10

BECOMING
A BETTER
PHOTOGRAPHER

This chapter provides you with some techniques that I've picked up over the years and started practicing. These habits have made me a better photographer, and I hope you'll find them useful, too. Technique 46 explains an important concept that will get you more photos than any other technique — carry your camera everywhere you go! Technique 47 shows you how to maintain your equipment to make sure you are always prepared to take photos at a moment's notice. You find out how to expand your portfolio in Technique 48 by taking photos of subjects in particular themes, or shooting *essays.* Technique 49 introduces you to the concept of getting both color and black-and-white photos by always shooting in color and then making black-and-white versions of the images. Technique 50 shows you the importance of organizing your ever-growing collection of digital images. Start with the techniques in this chapter that interest you, try some new techniques out too, and you're on way to becoming a better photographer.

CARRYING YOUR DIGITAL CAMERA WHEREVER YOU GO

46.1 *Original image* © 2005 Kevin L. Moss

46.2 *Edited image* © 2005 Kevin L. Moss

For years I noticed that I always came across scenes that I would shoot if I had a camera with me, but because I didn't carry a camera with me everywhere, I missed many opportunities. When I did start carrying a digital camera with me everywhere I went, I shot more photos, and with more photos, my shooting techniques improved. Shooting more photos also gave me more quality images that I wanted to print.

Today's technology has given us the ability to shoot beautiful photographs with high-quality compact digital cameras that can fit in a shirt pocket. You can now purchase digital cameras that fit in the palm of your hand, have 7-megapixel sensors or larger, and are equipped with quality lenses. With the availability of these quality compact digital cameras, there really isn't a reason why you shouldn't carry a digital camera with you everywhere you go.

I took the photo in Figure 46.1 with a Nikon Coolpix 7900 7-megapixel digital camera that I keep in my pocket at all times. On my way downtown on some business, I took a little detour off the freeway to get some shots of the old Tiger Stadium in Detroit. If I had not had the camera with me, I never would have gotten the shots. Figure 46.2 shows the same photo with unwanted portions cropped out using Photoshop Elements 3.

STEP 1: CARRY A DIGITAL CAMERA EVERYWHERE YOU GO

■ I have two camera cases full of digital camera equipment: digital SLRs, a prosumer digital camera as a backup, lenses, filters, flashes, batteries, memory cards, aspirin, a small flashlight, and a few manuals. Even though I'm a photographer, I don't lug these camera bags around with me all the time because I don't plan on shooting photos with my advanced gear every day of the week. What I do, however, is carry a smaller compact digital camera with me everywhere else.

When I started carrying a small digital camera with me, my photography improved greatly. I found myself taking photos of landscapes I came across while driving in or out of town, portraits of people I came across during the day, and other subjects that I just found interesting enough to shoot. The photo in Figure 46.3 is of Freddy, the firewood guy I met at the local farmers market one Saturday morning. I talked to him about having firewood delivered to my home, and then I asked him if I could take his picture. He gladly obliged, and I've since had Freddy deliver several cords of firewood to my home. He liked the 8×10s I gave him, which made me feel good, too.

TIP

Keep a tripod in your car in case you come across subjects to photograph while you're driving. I always keep one of my older tripods (yes, I have a lot of these) in my van just in case I need one for one of those situations where I didn't plan to shoot photos, but I happen to come across a photo-worthy subject. It's come in handy on more than one occasion.

46.3　　　　　　　　　　　　　　　　© 2005 Kevin L. Moss

STEP 2: KEEP ON THE LOOKOUT FOR PHOTO OPPORTUNITIES

■ With a digital camera at your disposal, keep on the lookout for photo opportunities. You may just be taking a drive to the mall, going to or from work, or even sitting at your desk working, but start looking for interesting subjects that you think may make a good photograph. Years ago I worked on developing a "visual" sense: I look at things throughout the day and imagine how they would look photographed. For example, I may come across a landscape photo opportunity in an area where I'm driving, but if I don't like the lighting or sky that day, I keep on driving. The next time I drive by the area, I just may pull over and take some photos if the lighting opportunities are better. Start keeping an eye out for photo opportunities everywhere you go — with a digital camera on hand, you'll get more photos!

As an example, while I was writing this technique on my computer, out of the corner of my eye I spotted a raccoon taking a stroll outside my window. Having my camera with me, I grabbed it, attached my external flash, ran outside, and followed the raccoon from a distance. Not quite trusting me, he climbed up a tree. I shot the photo in Figure 46.4 only because I had my digital camera ready to shoot at a moment's notice.

STEP 3: PLAN FOR PHOTO OPPORTUNITIES

■ In addition to keeping a lookout for photo opportunities wherever you go, plan some opportunities, too. If you're taking a trip to the mall, take your digital camera with you and take photos when you get there. Going to the zoo? Plan on taking a *lot* of photos there. If you're headed out to a concert, bring your camera and plan on taking photos during the show. You can get some great photos during the concert when the building lights are turned off in favor of the colored lights illuminating the stage. Try some hand-held shots of the lights with slow shutter speeds selected and pan your camera in different directions while the shutter remains open. Be sure to get some wide-angle shots of just the crowd.

STEP 4: CHECK SETTINGS

■ When you carry your digital camera with you, and you don't have a subject or lighting situation in mind, keep your digital camera in automatic mode. If your camera is in automatic mode, you don't have to worry about any settings if you come across a photo opportunity where you have to act fast.

46.4

The one setting you do want to make sure is set correctly at all times is the ISO. Make sure to set your digital camera's ISO to the lowest setting to ensure you get the best quality you can.

STEP 5: COMPOSE AND TAKE PHOTOS

■ As in any situation where you're shooting, carefully compose your photos on the digital camera's LCD or viewfinder. Zoom in and out with your lens to take photos with different perspectives. Shoot photos in both landscape and portrait modes.

STEP 6: REVIEW AND SHOOT MORE PHOTOS

■ After taking some photos, take the time to review them on the LCD. View the histogram and check for correct exposure. Zoom in on the photo on your LCD to make sure it's in focus. Recompose the scene or compose new ones, and take more photos!

MAINTAINING AND PROTECTING YOUR EQUIPMENT

47.1 *Original image* © *2005 Kevin L. Moss*

47.2 *Edited image* © *2005 Kevin L. Moss*

One of the keys to becoming a better photographer is to be ready at all times to capture photo opportunities. One way to make sure you're prepared is to have all your digital photo equipment in working order. Like any other type of mechanical or electronic device, digital cameras and lenses need to be maintained and protected.

Don't be caught in a situation where you have the chance to do some shooting and find out too late that your digital camera is not in top working order, such as when I took the photo shown in Figure 47.1. Unknown to me, before I went out shooting that morning, there was a spec of dust on my Nikon D70's image sensor. With a digital SLR, a chance always exists for dust particles to cling to the dust sensor when you change lenses. When you change lenses, you remove one lens and attach another, and the internal components of the camera are exposed to the outside air. Digital camera users need to check the sensors for dust from time to time to make sure dust specs do not show up in photos, like the one in the sky in Figure 47.1. I was able to remove the dust mark in the photo, as shown in Figure 47.2, using the **Spot Healing Brush** tool in Photoshop Elements 3.

KEEP BATTERIES CHARGED

■ One way to be prepared is to make sure your camera's primary and backup batteries are charged and ready for use. If you haven't used your camera for a long time and you plan on shooting in the near future, charge the battery ahead of time.

TIP

Only digital SLR users need to worry about dust particles getting on their sensors. Digital cameras with built-in lenses don't have dust problems because the insides of the cameras are sealed during production; the lenses mounted in front of the image sensor can't be removed. If you do experience the rare occurrence of dust on a digital camera sensor and the lens can't be removed, you have to send your camera to the manufacturer for service to have it cleaned.

CLEAN LENSES AND FILTERS

■ One of the most important aspects of maintaining your equipment is to keep your lenses and filters clean and dust-free. To remove dust, the best method is to use a blower brush. Use the blower brush to wipe off dust from the lens or filter; squeezing the bulb blows air onto the lens, helping to remove dust particles as you brush. If you need to clean fingerprints off the surface of the lens or filter, use a lens-cleaning cloth and gently rub the cloth on the glass until the smudge is removed.

WARNING

Only use blower brushes and lens-cleaning cloths that were made specifically for camera lenses. Don't try to clean your lens with a paper towel or tissue — these products are actually abrasive and can damage the surface of your lens if you use them. If you have spots on your lens that you think only a lens-cleaning solution can remove, contact your digital camera or lens manufacturer for suggested lens-cleaning products. Lenses have coatings applied to them during the manufacturing process, and most cleaning solutions can harm the lens coating, so make sure the lens-cleaning solution you use is recommended. If you use a can of compressed air to remove dust, make sure the particular brand you use is "safe for lenses," because some of these products also contain chemicals that can damage the surface of the lens.

HAVE YOUR DIGITAL CAMERA SERVICED BY THE MANUFACTURER ONLY

■ If your digital camera is in need of repair, make sure you send the camera to the manufacturer's repair facility only. Reputable camera dealers can send it for you, or you can check the manufacturer's Web site for instructions on where to send your camera for repair.

STORE YOUR CAMERA IN A HIGH-QUALITY CAMERA BAG

■ An important step in maintaining digital camera equipment is to store and transport your digital camera and accessories in a good-quality camera bag. Spending a few extra dollars on a camera bag that was designed for protecting camera equipment is well worth the cost. A good camera bag can last you for many years and protect your equipment from dirt, dust, and water. Camera bags include padded compartments that help protect your equipment from getting knocked around when you are traveling or on the job taking photos. Figure 47.3 shows my camera backpack that I use when hiking nature trails and traveling. My equipment is well protected, and the adjustable compartments help me organize my accessories. I even have room to store my compact tripod in the front pocket, as shown in Figure 47.4. Additionally, the model backpack I use has a rain cover that I can pull over the bag to protect my equipment from rain, which happens a lot when I'm out hiking and taking photos.

47.3 © 2005 Kevin L. Moss

47.4 © 2005 Kevin L. Moss

KEEP FIRMWARE VERSIONS UPDATED

■ Digital cameras have operating systems just like your computer does. If you have a PC, you're probably using Windows XP as your operating system. If you have a Mac, you're probably running Mac OS. Your digital camera's operating system is called *firmware*. Firmware is software that is stored in your digital camera and provides all the programming needed to operate the camera. The software is embedded in a hardware device inside your digital camera. Your camera has firmware loaded when you purchase the camera, but occasionally manufacturers update firmware to make improvements to the operation of your digital camera or to correct bugs in the current version. Unfortunately, manufacturers don't notify customers when they update their digital cameras' firmware. The best way to check whether an update is available for your camera is to check the manufacturer's Web site occasionally. Make sure

you check for instructions on how to load firmware updates from your computer to your digital camera, as well.

TIP

Don't leave your digital camera in an automobile for extended periods of time. Temperatures change drastically during day and nighttime hours, and the change of temperature can affect your digital camera batteries, weakening their ability to hold a charge. This is especially true of temperatures in the summer and cold conditions in the winter. Extreme temperatures during winter and summer seasons aren't very good for your equipment either; your digital camera's electrical components can be permanently damaged if exposed to these conditions.

SHOOTING AN ESSAY

48.1 © 2005 Kevin L. Moss

48.2 © 2005 Kevin L. Moss

Many strategies are available to help you broaden your photographic repertoire. If you mainly take photos of people, you can start taking landscape photos or architecture. Some photographers mainly shoot outdoors. These photographers may want to try shooting some still-lifes in a home studio for something different.

One strategy to use in an effort to expand your digital photography repertoire is to shoot an essay. A photo essay is a series of photos related to one

269

subject. Think of essays as photos with a *theme*. One example is an essay I worked on for a few months — urban decay in the inner-city. Over the period of a few months, I took trips into the city to shoot some of the historical districts that are now barren of people and businesses. The photo in Figure 48.1 represents part of my effort to document the decay of the old warehouse district in my city. The businesses in this district were forced to leave by the city government a few years ago, but the structures still remain, overgrown with vines and weeds, and becoming the canvas for urban artists to express their own artistic talents with a can of spray paint (see Figure 48.2).

STEP 1: PLAN AN ESSAY

■ Write down some ideas for themes that you would like to shoot a series of photos of. It can be of any subject that interests you. I decided to shoot an old warehouse district; even though it's right next door to the main business area of the city, not one window remains intact. I drive by the area on a regular basis and decided to plan some special trips just to take photos like the ones shown in this technique. Planning time to shoot your essays is essential. If you dedicate some time to taking the photographs, you have the basis for your essay.

STEP 2: REVIEW YOUR EQUIPMENT PREPARATION CHECKLIST

■ If photographing your essay assignment takes you away from home, go through your preparation checklist (see Technique 17) before you venture out. Check to make sure your digital camera is in working order, the battery is charged (and the spare if you have one), the lenses and LCD are free of dust and fingerprints, and the memory cards have been previously downloaded and then formatted in-camera.

STEP 3: CHECK CAMERA SETTINGS

■ When you arrive at your destination (unless you are shooting your essay at home), check your camera settings before you begin composing your photos. Check the ISO setting to make sure you have it set to the lowest for best quality. Set the appropriate shooting mode. If you are shooting "scapes" like the ones described in Chapter 7, use aperture-priority mode and set your aperture to a setting that gives you the depth of field you want. Set the white balance to the type of lighting conditions in which you'll be shooting.

STEP 4: COMPOSE THE SHOTS

■ Using a tripod, mount the camera and begin composing the shots. Take a good look at your subject and plan the type of photos you want to take. Take wide-angle as well as zoomed-in photos of your subject. Don't forget to shoot in both landscape and portrait modes. Shoot the photos from different perspectives to change the effect of the same subject. The photos shown in Figures 48.3 and 48.4 are of the same subject, but taken from different angles. Changing position, even slightly, can dramatically change the perspective of a photo.

STEP 5: TAKE PHOTOS

■ Take a series of photos. Review the image on your LCD and check to make sure the white balance and exposure are correct. If needed, zoom in on the image while reviewing on the LCD to make sure focus is sharp on your subject. Make any necessary adjustments, recompose, and shoot more photos.

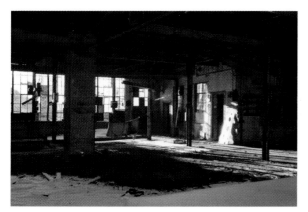

48.3 © 2005 Kevin L. Moss

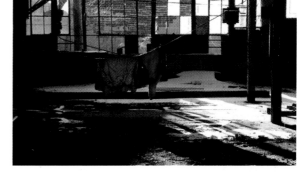

48.4 © 2005 Kevin L. Moss

CONVERTING COLOR TO BLACK-AND-WHITE

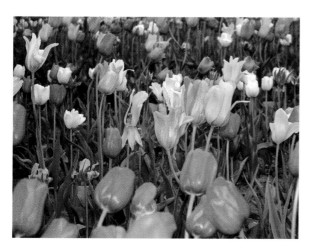

49.1 *Original image* © 2005 Kevin L. Moss

49.2 *Edited image* © 2005 Kevin L. Moss

Photographers have different opinions on the merits of black-and-white or color. Some photographers come from the old-school line of thinking that the only true fine art photography is black-and-white. Other photographers enjoy color photography and consider their photos fine art. I like both, and I create versions of my images in both color and black-and-white.

Photographers who are prefer black-and-white photography who switch to digital may even shoot their images in either the black-and-white or sepia modes their cameras offer. Shooting in color and then converting your images to black-and-white later ensures that all of your options remain open to you: You can use the images as color or select images you want to convert to black-and-white. Figure 49.1 shows a photo of tulips shot in color, but converted to black-and-white later. I added an artistic effect to the photo by converting the color to black-and-white with the exception of one tulip shown in Figure 49.2.

STEP 1: SHOOT ALL YOUR PHOTOS IN COLOR

- Many digital cameras offer you the ability to shoot photos in color, black-and-white, or sepia. Skip the black-and-white and sepia modes and stick to shooting all your photos in color. You can always convert your photos to black-and-white later using Photoshop CS2 or Photoshop Elements 3, as shown in this technique.

STEP 2: OPEN AN IMAGE IN PHOTOSHOP ELEMENTS 3

- Choose **File ➤ Browse Folders** or press **Ctrl+Shift+O** to view thumbnails of photos stored in your image folders on your computer. Choose an image that you would like to open and then convert from color to black-and-white by double-clicking the thumbnail.

STEP 3: CREATE A DUPLICATE OF THE BACKGROUND LAYER

- Choose **Layer ➤ Duplicate Layer** to create a duplicate of the image's background layer. You can view the **Layers** palette by choosing **Window ➤ Layers**.

STEP 4: DESATURATE THE IMAGE

The final step to convert a color image to black-and-white is to desaturate the image's colors to black-and-white. Photoshop Elements 3 provides a number of ways of desaturating color to create black-and-white photos. I'll show you the fastest method first.

DESATURATE THE IMAGE USING ENHANCE

- Choose **Enhance ➤ Adjust Color ➤ Remove Color** or press **Ctrl+Shift+U**. Color is removed from the photo.

After converting color images to black-and-white, I always like to make some final Levels adjustments to make sure my image contains enough contrast.

- Choose **Enhance ➤ Adjust Lighting ➤ Levels**. In the **Levels** window, move the **midpoint** slider to the right until the image's contrast is increased to a level you are happy with. Be careful not to add too much contrast: Too much contrast makes the photo look overprocessed. The photo in Figure 49.3 shows the image before I removed color from the image; Figure 49.4 shows the image after it was converted to black-and-white using Remove Color and then adjusted slightly using Levels to increase contrast.

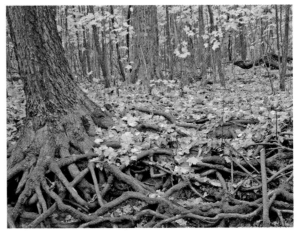

49.3 © 2005 Kevin L. Moss

DESATURATE THE IMAGE USING HUE/SATURATION

An alternative method to converting color images to black-and-white that allows you to retain some color — making your images appear *toned* — is to use the Hue/Saturation adjustment. Toning is one of the fine-art darkroom techniques in film-based photography where black-and-white prints developed in a darkroom were soaked in toner chemicals to give a slight brownish or reddish tint to black-and-white photos.

■ Repeat Step 4 using the Hue/Saturation adjustment instead of the Remove Color command by choosing **Enhance ➢ Adjust Color ➢ Adjust Hue/Saturation**.
■ In the **Hue/Saturation** window shown in Figure 49.5, click the **Edit** drop-down list and choose **Yellows** as your first color. (I intentionally skip **Reds** for now.)
■ Move the **Saturation** slider all the way to the left to remove yellows from the image.
■ Click the **Edit** drop-down list again and choose **Greens** as the next color to desaturate. Move the **Saturation** slider all the way to the left to desaturate the green colors in the image.

■ Repeat desaturating **Cyans**, **Blues**, and **Magentas** by choosing these colors in the **Edit** drop-down list and then moving the **Saturation** slider for each of these colors all the way to the left.
■ Click the **Edit** drop-down list again and choose **Reds**. Move the **Saturation** slider to the left until the amount reaches about **50**. Click **OK**.

The converted photo in Figure 49.6 shows the photo converted to black-and-white but with some red color retained to give the photo a toned look.

49.5

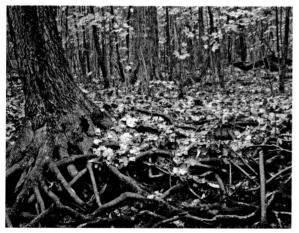

49.4 © 2005 Kevin L. Moss

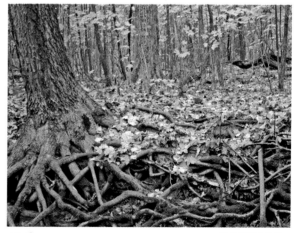

49.6 © 2005 Kevin L. Moss

STEP 5: SAVE THE IMAGE

■ The most important part of any image adjustment in Photoshop Elements 3 is saving your adjusted file. Choose **File ➢ Save As**. Type a new filename for your image. Make sure you choose **Photoshop (*.psd)** or **Photoshop (*.pdd)** as the file type in the **Format** drop-down list. Click **OK** to save the file. More information about organizing and saving files is available in the next technique, Technique 50.

ORGANIZING YOUR DIGITAL PHOTOS

50.1

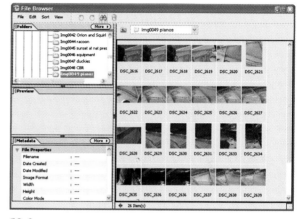

50.2

TIP

To help you easily view your images and keep them organized, take advantage of what the Photoshop Elements 3 File Browser has to offer.

As a photographer, my image library is constantly growing. Depending on what type of subjects I'm shooting at any given time, I could be accumulating from 50 to 200 photos a week. In the past year, I've added more than 5,000 images to my image library — that's a lot of images to keep track of! The key to managing your ever-growing image library is to first plan a file system and then set up folders to keep your files organized. Figure 50.1 shows the Photoshop Elements 3 File Browser. Keeping images organized makes browsing images much easier when you view thumbnails, as shown in Figure 50.2.

STEP 1: PLAN YOUR FILE ORGANIZATION

- No steadfast rule exists for organizing digital images on your computer. Different photographers have different needs. You may have to organize 5,000 images a year; you may have only a few hundred. What is important, though, is to keep the original files you download from the camera to the computer separate from the images you work on in Photoshop CS2 or Photoshop Elements 3. Before setting up folders on your computer to store the files, plan a folder structure that works with how you process your photos:

 - Do you want to keep all your images on your computer permanently? If you shoot a lot of photos, you may want to separate the photos that you download from the photos with which you want to work. Consider archiving all your downloaded images to CD or DVD, and only keep the image files you want to work with in the future on your computer to conserve disk space.
 - How do you want to organize your photos? Evaluate if you want to separate your family photos from other types of photos you shoot, such as nature or action photos. Deciding how you want to divide your photos will determine how you'll want to set up your image folders.
 - What type of output will you produce? If you process photos in your image editor for display on both the Web and to print, consider creating separate folders to save different output files for both of these types of images. For example, save images you have edited for the Web in a Web folder, but save the images you will print to a Print folder.
 - How will you back up your images? Depending on how you back up your image files, whether to an external hard disk, CD, DVD, or a combination of these, consider creating a folder that contains all your working images. This strategy will make backing up your images easier.

STEP 2: SET UP YOUR FOLDER STRUCTURE

Create folders on your computer to mimic how you're actually going to work with image files. As an example, you could have original images, images you work on, and final output images meant for printing or displaying on the Web (or both).

- Open **Windows Explorer** and click the **My Computer** icon, and then click **Local Disk (C:)**.
- Choose **File ➤ New ➤ Folder**. Explorer creates a new folder called **new folder**, which you should rename **Digital Images**.

STEP 3: CREATE ORIGINAL, WORKING, AND OUTPUT FOLDERS

- Following the procedures described in Step 2 for creating folders, create subfolders within the **Digital Images** folder to store different types of files.

WARNING

Never edit original files. Make copies of your original files and edit the copy, not the original file. Having an intact original image file gives you the insurance of being able to go back at a later date to correct mistakes you may make while editing. After opening an image in Photoshop Elements 3 or Photoshop CS2, choose the **File ➤ Save As** command to immediately save the file to a "working" folder in Photoshop (*.psd, *.pdd) format. (PSD or PDD file formats are Adobe's file formats for editing photos.) Saving the file immediately in another folder ensures you don't accidentally save the original file with edits. When you're ready to save edited files for output to the Web or for printing, you can save those output files to JPEG or TIFF at that time.

The three types of folders you should set up are for original files downloaded directly from your digital camera or card reader, working files (in Photoshop format) that you are editing, and files that you use for output to a printer or a Web site (which you can then save your edited files to JPEG or TIFF formats). Figure 50.3 shows the **Digital Images** folder containing the three subfolders **Original Images**, **Output Files**, and **Working Images**.

STEP 4: CREATE SUBFOLDERS TO FURTHER ORGANIZE PROJECTS

■ Following the procedures described to create new folders (subfolders) within another folder, feel free to set up subfolders within the original, working, and output folders for different projects you'll be working on. An example of this would be setting up a separate subfolder within the

Original Images folder to contain images stored on each memory card you download. Figure 50.4 shows an example of a folder structure setup with subfolders for different projects or image types.

Organizing photos on your computer using a structured folder tree gives you the benefit of having a simple filing system to work with every time you download and edit images on your computer. Backing up images is a snap; you only have to copy one folder to a CD or DVD! Get in the habit of keeping your original images *original* by immediately saving original images opened in Photoshop Elements 3 as a PSD file to a **Working Images** folder. Working in an organized file management process makes editing images easier by saving you time when using the Photoshop Elements File Browser or the Photoshop CS2 Bridge when searching for files stored in separate locations on your computer.

50.3

50.4

INDEX

automatic modes. *See also specific modes*
 advantages and disadvantages of, 60
 creative exposure modes versus, 21–23, 60
 exposure bracketing, 63, 80
 exposure meter limitations and, 58, 77, 81
 ISO setting and, 23
 learning what settings are made by, 60
 overview, 21
 selecting exposure modes, 60
 for sports photography, 155
"Award-winning Chicken" (photo), 65–66

B

"Back Door to the Club" (photo), 2, 3, 4
Backdrop Outlet, 131
backgrounds
 backdrop cloth, 131
 for family portraits, 142
 for portraits, 134
 positioning subject in front of, 134
 shooting to capture, 46
backing up images, 255–258, 279
back-lighting, fill flash for, 92
backyard, finding subjects in, 38–39
B&H Photo Video, 130
barrel distortion (pincushion effect), 53
batteries
 carrying spares, 104
 checking before photo shoots, 104
 keeping charged, 266
 LCD monitor and drain on, 27
 older, replacing, 104
black-and-white, converting color to, 273–276
"Blowing Grasses" (photo), 163
blur. *See also* sharpness
 aperture (f-stop) and, 20, 21, 66
 depth of field and, 20–21
 intentional, for bad weather, 166
 intentional, for waterfall shots, 173
 intentional, showing movement, 41, 66
 ISO setting and, 16
 moving subjects and, 41, 66
 shutter speed and, 20, 52
botanical gardens, finding subjects in, 40
bracketing exposures automatically, 63, 80
brightness. *See* exposure; ISO setting; light

C

cable release, 70
"Caitlen" (photo), 145
calendars, camera orientation for, 47
Calumet Photographic, 130
camera bag, 105, 267
camera orientation. *See* horizontal (landscape)
 orientation; vertical (portrait) orientation
camera shake, 66, 79, 230
camera support. *See* tripod
candid portraits
 of adults, 137–139
 of kids, 139
 of pets, 150
Canon. *See also* PowerShot camera
 crw format, 14
 flash equipment, 126
 Macro Ring Lite MR-14EX, 168
 Speedlite 550EX, 126
cars
 caution when leaving camera in, 268
 moving, shooting from, 41
 shooting fast-moving, 41
cat and statue (photo), 37, 39
catch light, 152
CD-ROM with your camera, 4
CDs, copying images to, 256, 257
"CDs, DVDs, and Backup Drives" (photo), 255
celestial events, shooting, 177–181
center-weighted metering mode, 61, 82, 84
checklists
 camera features and specifications, 5–7, 8
 for preparing to shoot, 103–105
"Cheddar Gorge" (photo), 119, 120
children's portraits, 139, 145–147
circular polarizing filter, 117, 162, 204
"City Park" (photo), 211
cityscapes, 41, 185–187
cleaning
 digital SLR camera sensor, 104, 266
 lenses and filters, 266
 scanners, 224
close-up filters, 231
close-ups. *See also* macro mode
 of flowers, 167–169
 macro focus for, 69

Continued

Continued

ABOUT THE AUTHOR

Kevin L. Moss is a photographer, author, and expert in digital photography, personal computing, and the World Wide Web. Kevin specializes in combining his many years of experience in traditional photography and the latest in computer and digital technologies. Kevin is also the author of *Photoshop CS2 and Digital Photography For Dummies*.

Kevin specializes in fine art landscape, abstract, and portrait photography. For more information about Kevin's photographic work or to contact him regarding this book, visit his Web site at `www.kevinmossphotography.com`.

COLOPHON

This book was produced electronically in Indianapolis, Indiana. Microsoft Word 2000 was used for word processing; design and layout were produced using QuarkXPress 4.11. The typeface families used are: Chicago Laser, Minion, Myriad, Myriad Multiple Master, Prestige Elite, Symbol, Trajan, and Zapf Dingbats.

Acquisitions Editor: Michael Roney
Project Editor: Sarah Hellert
Technical Editor: Gregory Georges
Copy Editor: Paula Lowell
Editorial Manager: Robyn Siesky
Editorial Assistant: Adrienne D. Porter
Production Coordinator: Maridee V. Ennis
Cover Art: Daniela Richardson
Layout and Graphics: Jennifer Heleine, Lynsey Osborn, and Amanda Spagnuolo
Proofreading: Laura L. Bowman
Quality Control: John Greenough
Indexing: Ty Koontz
Manufacturing: Allan Conley, Linda Cook, Paul Gilchrist, and Jennifer Guynn
Vice President and Executive Group Publisher: Richard Swadley
Vice President and Publisher: Barry Pruett
Director of Composition Services: Debbie Stailey

Think fast.

Hone your skills with *50 Fast* guides to almost everything from digital photography to operating systems.

0-7645-7212-1 0-7645-7447-7 0-7645-9806-6

Also available:

WILEY

Now you know.

wiley.com